Failing Moms

To Gregory Wright, my partner, and the blended family we are lucky to have, Gabriel Benhaïm-Killian, Noah Benhaïm-Killian, Harrison Wright, and Stella Wright

Failing Moms

The Social Condemnation and Criminalization of Mothers

Caitlin Killian

polity

First published in 2023 by Polity Press

Polity Press
65 Bridge Street
Cambridge CB2 1UR, UK

Polity Press
111 River Street
Hoboken, NJ 07030, USA

ISBN-13: 978-1-5095-5772-1
ISBN-13: 978-1-5095-5773-8(pb)

A catalogue record for this book is available from the British Library.

Library of Congress Control Number: 2023931392

Typeset in 10.5 on 12.5pt Sabon
by Fakenham Prepress Solutions, Fakenham, Norfolk NR21 8NL
Printed and bound in Great Britain by TJ Books Ltd, Padstow, Cornwall

The publisher has used its best endeavors to ensure that the URLs for external websites referred to in this book are correct and active at the time of going to press. However, the publisher has no responsibility for the websites and can make no guarantee that a site will remain live or that the content is or will remain appropriate.

Every effort has been made to trace all copyright holders, but if any have been overlooked the publisher will be pleased to include any necessary credits in any subsequent reprint or edition.

For further information on Polity, visit our website:
politybooks.com

Contents

Acknowledgments

Paradoxically, or not, given the subject of this book, I could not have written it without my mother's death. I dedicated my first book to my parents, Sylvia and Larry Killian. I wrote most of that book during graduate school when I had no children and finished it during the beginning of my career as a sociology professor when I had only one child. Over a decade later, raising four kids, teaching, doing committee work, and juggling other research projects, I had the idea for *Failing Moms*. I wrote part of an introduction, a few pages of chapter 2, and an article with Emma Thomas, now a section of chapter 3, "Fetal Alcohol Syndrome Warnings: Policing Women's Behavior Distorts Science," published in 2020 in the *Journal of Applied Social Science* 14(1): 5–22. That was all I could manage as I bounced from crisis to crisis with my elderly parents. I could do some research during the summers and winter breaks, but I never had a sustained period to sit down and write. Time for the book was in even shorter supply the following year when I suddenly found myself responsible for my mother after my father, her primary caregiver, died unexpectedly. I was the epitome of the sandwich generation. A year later, my mother was diagnosed with cancer. She died a few months later in August, and I had a fall semester sabbatical. A full draft of this book was finished by late December.

I have several people to thank for their support along the way. My partner, Gregory Wright, and my best friend from high school, Anna Boardman, read chapters of the manuscript. My friends Nancy Mahl and Kirsti Morin both read an entire draft of the book and gave me valuable feedback. Alejandra López provided

encouragement and advice and looked over a version of my proposal. Bill Winders jumped on the phone at a moment's notice when I was trying to make some decisions about how to write about a source. I also had a sounding board in colleagues and friends from Drew University in different disciplines, including Christopher Andrews, Angie Calder, James Carter, Christina McKittrick, and Jennifer Olmsted. Reading background literature for the book on the porch of Tina McKittitrick's lake house during a long weekend trip to the Adirondacks was particularly nice.

My friends at Drew and I traded maternity clothes and child care when our kids were little and we were working toward tenure. Especially memorable was the time I watched three toddler boys in Tina's office in the biology department one afternoon when the daycare center closed for a snowstorm but the university remained open. I was the only mother who did not have to work at that time, but I ran out of diapers and had to improvise, so maybe my colleagues were the lucky ones. My friends from college also helped me parent. Kira Vol took a train from DC to New Jersey late at night and watched my eldest while I was in the hospital giving birth to the baby who was already dead. She knitted the blanket Elijah was buried in. Nicole Jassie helped get me through both of my sons' bar mitzvahs. Both Kira and Nicole listened patiently to my complaints about the vicissitudes of parenting a teenager. I also want to thank Lee Akst, Tracy Andrews, Amy Duberstein, and Irene Oh for their ongoing friendship. Even if we don't see each other, or even talk for a while, we always reconnect as close as where we left off. Bisous to Kahina Hadim and Veronique Delmas Ognar for their long – and bilingual – friendship. Darcy Draeger and Stacy Strum, my fellow volunteers for democracy, deserve kudos for all they do working for the greater good while parenting, dealing with relatives' health issues, and managing life in general. My Zumba crew, especially Jane Curtis, Aleida Heiman, Vijaya Kesanakurthy, and Linda Sharland, extended homes and arms (oy, Ana's arm sequence hurts!) when I joined the community. A big thank-you to all my friends not listed here as well. I cherish them. Talking honestly about challenges with kids, having collective outlets, and being there for one another – I wish every mother had the social support I've been fortunate to have.

This book is about the worst things mothers can face and the support moms need and don't get, and Polity believed it was important for people to get this message. I thank Karina Jákupsdóttir,

my editor, for the many meetings and for always genuinely listening as she guided this book to fruition, as well as my copy-editor Gail Ferguson, the design team, and other production and marketing staff at Polity. I am also grateful to the anonymous reviewers who gave of their time, probably while working and possibly while parenting as well. It takes a village of friends and strangers to make a book.

Introduction

It's too risky to become a mom. "I wouldn't do it now," a 50-something-year-old black mother and college student said, after listening to a lecture about motherhood. "And I feel for those of you who are." She's right to worry about those parenting children under eighteen and about those contemplating motherhood. A mother who is perceived to be "failing" not only faces the court of public opinion, she is increasingly likely to confront actual judges and juries who may take her children away and even incarcerate her. For some women, this may seem like a far-fetched scenario, something that only happens to really bad moms, not something that would ever happen to them. For others, this is an all-too common fact of life. Friends, sisters, their own mothers, or they themselves have had their children taken away or been tried and punished for not being a good enough mom. Moms of color, poor moms, disabled moms, very young moms, and parents who are queer and/or non-binary have always been disproportionately surveilled and punished – as well as denied adequate health care and social support. The offenses for which mothers tangle with the law still affect women in these categories at greater rates, but the total number of prosecutable offenses is mushrooming and reaching mothers across the class, racial, and gender spectrums. All moms are in jeopardy, whether they realize it or not.

After the calamitous *Dobbs v. Jackson Women's Health Organization* decision, more people are becoming aware that the systematic discrimination against pregnant people is growing. The loss of decision making and bodily autonomy in the overruling of *Roe*

v. Wade is, indeed, a behemoth, but it is only part of the expanding attacks on women and their reproductive and parental lives. It is this juggernaut that *Failing Moms* exposes. Reproductive justice, as conceptualized by SisterSong Women of Color Reproductive Justice Collective, delineates the intersecting consequences of race, social class, and gender, as well as highlighting the right to be in control of one's reproduction. Reproductive justice advocates mean reproduction writ large, from deciding to use birth control or terminate a pregnancy to being supported not just during gestation but also with healthy, safe, and economically secure conditions throughout parenthood (Ross and Solinger 2017). Grounded in this approach, *Failing Moms* analyzes how and why mothers are increasingly on a precipice, and what must change to prevent undertaking motherhood being outweighed by its risks.

More and more of those women and mothers who never contemplated the hazards of childbearing and childrearing in the United States are finding themselves swept up by the criminal justice system, along with those for whom this was always an ever-present reality. The list of offenses for which this can happen is growing almost daily. Mothers now face shattering social and criminal consequences for actions that were acceptable in past decades. Pregnant women of various ethnic backgrounds and socioeconomic statuses have been interrogated, held against their will, and jailed for: drinking alcohol, taking legally prescribed drugs for a health condition, attempting suicide, falling down the stairs, miscarrying, not wanting to go on bed rest, refusing a cesarean section, being shot by another person, and, unbelievably enough, being dead. Increasingly, they are detained and prosecuted for terminating pregnancies as well as forced to wait an unconscionable amount of time for medical treatment in dangerous situations such as ectopic pregnancies, second trimester miscarriages, and cancer diagnoses.

Yet women are subject to particular discrimination and the risk of criminalization not simply because they are the ones who get pregnant; mothers are also prosecuted for certain "crimes" toward their children that are rarely applied to fathers. It is almost always mothers who find themselves facing serious sanctions for situations in which no harm occurred, such as letting their children play alone in their own neighborhoods or walk to a store by themselves. And in the tragic cases in which men deliberately injure or kill their children or stepchildren, mothers are receiving prison sentences as long or even

longer than the perpetrator under "failure to protect" laws, even if they were not home when the abuse or murder occurred.

When women are admonished not to drink alcohol even with no baby on the horizon, when they are legally threatened for an injury during pregnancy, when they, but not fathers, are investigated by Child Protective Services for acts such as leaving a child home alone briefly, when they seek help for poverty and find their children removed as a result, when they face greater penalties than men who abuse their children, even if they were unaware the abuse was happening, *all* women are in danger. The attacks on women's reproductive rights affect not just pregnant people but women more broadly. Female-bodied Lupus patients in many states are made aware of this when they are denied their routine medicines on the off chance they might be buying them to cause an abortion, rather than using them to manage their documented chronic disease. If we do not stop the rapidly increasing criminalization of mothers, more and more of those with female body parts, including the majority of mothers who try incredibly hard to be good moms, will end up suffering the fate of "bad moms." As Ladd-Taylor and Umansky (1998: 23) warn, "the labeling of the 'bad' mother narrows for all of us the definition of 'good' mothering while luring us to participate in the narrowing of our own options." People must join forces across economic, social, and racial backgrounds to fight back and fight back quickly; otherwise, more and more of us, and our daughters, will be going to jail. This book is a wake-up call for saving mom and anyone who could someday become one.

Soccer mom, dance mom, wine mom, tiger mom . . . mothers are simultaneously venerated and scorned. They are told they are doing the world's most important job and then denied basic resources to parent successfully. We expect mothers to be present, perfect, and put their children first 24/7 for well more than 18 years, and we believe they should be able to control children's outcomes. They are even asked to solve social ills through their own behaviors while pregnant and parenting. Moms buy into these impossible notions as they are surrounded by them in society: subtle messages and blatant advice from loved ones and acquaintances, parenting books, and the media. It begins even before a woman is a mother, even before she is pregnant. And when mothers are unable to meet these standards, they can incur consequences including having their children removed

from their care and going to prison, even for actions where no harm occurred, such as leaving a child alone briefly. This is most likely to happen to those who are poor, but it can happen to anyone. The societal expectations for mothers are so high that even mothers with plenty of financial resources, social support, and the "right" number of planned-for children sometimes feel they are not doing a good enough job mothering, despite trying desperately. Where does this leave all the mothers without these advantages?

That expectations for mothers' behavior are ever-expanding, despite a lack of support for mothers and the Supreme Court overturning women's right to decline motherhood, should worry everyone. Criminalization of mothers is couched in supposed protection of fetuses, children, or even the moms themselves, but these rationales are a thin veil for the real purpose: controlling women. *Failing Moms* analyzes the ever-higher standards to which women and mothers are held from preconception through pregnancy and while parenting, with a particular emphasis on what happens to mothers who are punished for failing to live up to these norms. In this book, I use historical accounts, public health pronouncements, social psychological research, and court cases to examine the burdens on moms. Mothers are set up to fail, regulated in their public and private behavior, and scapegoated. The costs of not living up to expectations for mothers are not only guilt and feeling shamed by others; there are also legal consequences. The mothers least able to meet these standards, those who are poor, abuse drugs, or live with violence, are held to the same standards as all other mothers. While these moms face life-altering criminal penalties at higher rates, all moms teeter on the edge of state sanctions.

Throughout the book, I compare the standards to which women and mothers are held to those for men and fathers. This inequity starts before a baby is even on the horizon with problematic advice to non-pregnant women and an intentional lack of understanding of men's reproductive health. It intensifies once a woman is pregnant, as the chances of devastating consequences, including going to jail, for mothers-to-be who cannot or will not constantly foreground the fetus throughout their pregnancy are rising in the United States, as they are for women who have a miscarriage or an accident. Women are finding themselves in court for letting their child sit in a car or walk to the park alone. And in the truly dire cases, those in which a child is actually beaten, burned, or killed, a non-abusive mother can go to

prison for as long as or longer than the man who injured her child. When we demean all mothers and vilify the most vulnerable among them, we only succeed in hurting children, families, and women in general.

Several books cover some of the specific risks that either pregnant or parenting women face, but few of them bring the issues together comprehensively. An excellent exception is law professor Linda C. Fentiman's (2017) *Blaming Mothers: American Law and the Risks to Children's Health*. Even since the publication of her book, however, the situation for US women has become worse. The expansion of "crimes" that women can be prosecuted for and the increasing rate at which this is happening are alarming. As rights to health and bodily autonomy for women crumble, and we are coping with a worldwide pandemic that has affected the labor-force participation of women, especially women of color and women in certain types of jobs, it is time to reevaluate what we expect of mothers and how we treat them. This book explains how we have arrived at this suffocating state and details how to stop penalizing mothers and help them instead.

In her groundbreaking book, *Of Woman Born*, poet and essayist Adrienne Rich (1976) wrote about motherhood as both an institution and a personal experience. She urged mothers to redefine motherhood outside of the patriarchal bounds of the institution that sought to control and degrade them so that they could experience it on their own terms. Yet, rather than motherhood being freed, women today find themselves required to do more and more. Although most mothers are employed today, and work can have empowering aspects, it also further burdens busy moms trying to be good employees and good parents. And the criteria for being a good mom keep climbing.

In 1996, 20 years after Rich, sociologist Sharon Hays coined the term "intensive mothering" in her book, *The Cultural Contradictions of Motherhood*. She explains that despite the large number of working mothers, instead of being profit maximizing and self-interested, mothers, whether employed or stay-at-home, are expected to be wholly child centered, ready to put a child's needs first and spend enormous emotional, time, and financial reserves to benefit their children. Although intensive parenting can be practiced by any parent, it is predominately moms who are *required* to do this type of childrearing as they have been made to stand in for all human relationships, the bulwark of care and connection in

a driven, get-ahead-by-any-means society (Faircloth 2021; Hays 1996). Certainly, single fathers with primary custody, partnered gay dads, and some married heterosexual fathers can take on this type of parenting. The difference is the amount of leeway that they have compared to mothers when they choose not to do something or not to do something so intensely. When men do acts of nurturance, they are seen as extraordinary. Women are expected to do these same acts "naturally." Fathers too frequently get credit for doing anything at all while mothers must meet a much higher bar lest they face informal or formal sanctions. Even if a father or other family member or caregiver helps, in both dual-sex-couple and single-mother households, it is usually the mom who buys and reads the baby manuals, picks out the child's numerous activities and lessons, organizes the playdates, stays up late researching the best daycare centers and schools, does most of the schlepping, and beats herself up for not doing enough. Women are also responsible for the bulk of the affective labor, not just for the children but for the whole family. It is normally women who write the birthday and holiday cards, issue invitations, and make the meals for family get-togethers. Women are held to higher standards than men when it comes to traditionally "feminine" activities such as cooking and cleaning, and this is ratcheted up in terms of child care. And women are also more likely to care for elderly relatives, sometimes even their in-laws.

Women, gender, and sexuality studies professor Laura Briggs (2017: 190) refers to "time famine," in which the demands of the paid labor force squeeze the time available for providing care to dependents. For far too many, being a mom is physically draining and emotionally exhausting, and the Covid pandemic has only exacerbated these strains. Contemplating the significant rise since the 1970s in women who postpone parenting until older ages, and therefore have fewer children, or who choose to forgo it altogether, sociologist Ana Villalobos (2014: 169) notes the importance of economic concerns but also how "a fear of motherhood and intimidation by the perceived enormity of the task may also play a role in this delay or in the decision not to bear children."

In her book, *Motherload: Making It All Better in Insecure Times*, Villalobos (2014) builds on Hays's work arguing that, for many, mothering is a security project. Lots of individual mothers internalize this. Not only must she provide security for her child, but she sometimes seeks security for herself by fostering the one relationship

that is unlikely to ever dissolve, the mother–child bond, and, beyond her family, it is up to her to mitigate the insecurity of the world, solving social problems through her parenting. Villalobos (2014: 230) calls this the "motherload" and states that while we as a society fail to provide security and resources, we nonetheless perceive that all is protected, albeit artificially, if mothers do their jobs correctly: "Just as an addictive substance may subjectively appear to make it all better, we may feel a decline in pressure . . . by placing impossibly high security expectations on the mother–child relationship. It may help us feel that things are still okay and that, as a society, the mothers are watching our backs." It is ultimately this responsibility for taking care of the world that leads us to react so strongly when a mother cannot or does not want to subscribe to this injunction. Everyone feels harmed when a mother does not live up to her proscribed role.

These modern contentions, that mothers should privilege their child's every need (or desire) and that self-sacrifice is a precondition for motherhood, would sound very odd to past centuries of women, women in many parts of the globe, and, to a lesser extent, women of certain social classes and particular ethnic backgrounds in the United States today. The idea that a child always comes first would not resonate with a mother 2,000 years ago who committed infanticide rather than care for a newborn. Mothers in the Middle Ages watched children leave home in someone else's care for training as an apprentice as young as age seven. A mother in the late 1800s or early 1900s could breathe a sigh of relief when her ten-year-old son's labor in the mine allowed her to finally quit her factory job and stay at home. Less than a century ago in the United States, the general duties of parents were to feed and clothe their children, to deliver discipline when needed, and generally also to provide spiritual guidance. Our modern way of doing motherhood is just that, modern. And our views of mothering are far from universal. Infanticide still occurs. Boys are taken out of school and sent to work while mothers are housewives in numerous countries. And the idea that a mother should always watch her children like a hawk, rather than leaving them alone or letting an older one supervise a younger one, is ahistorical and highly debatable.

As Sharon Hays writes about parenting in the West five hundred years ago:

The ideology of childrearing flowed directly from the values, beliefs, and hierarchical organization of society as a whole . . . Parents (including mothers) spent only as much time, energy, and money on children as children promised to give in return: as soon as they were able, the young were obligated to contribute to the family's subsistence, wealth, or status and were enlisted in the armed protection of the family and community. (Hays 1996: 24–5)

Thus childhood was not a privileged time for games and growth but rather a time for training and contributing to society, including contributing to the family economically. In the nineteenth century, affective ties began to take on more importance, and public figures were more open about their feelings for their spouses and children, although this, and how much children were viewed as little innocents rather than wicked, varied by religion and geographic region (deMause 1974; Hays 1996; Shorter 1975).

Sociologist Viviana Zelizer's book (1985), *Pricing the Priceless Child*, examines how western children went from working on farms and in factories and mines to children who rarely work prior to high school and usually only part-time even then. Today's children routinely cost their parents hundreds of thousands of dollars (depending on parents' means) and, when lost in a preventable accident, today's negligently killed children elicit juries to award millions to compensate for parental suffering – rather than lost income to the family from the child's expected contributions. Paradoxically, Zelizer argues, as children became economically useless (and even a massive financial liability), they became "emotionally priceless." This was a radical shift. Not only did children gain more years of childhood, including adolescence, but society slowly became more child-centric in ensuing decades.

Lest we think that all the motivations for getting children out of factories and into schools in the early 1990s were purely about children's best interests, however, it is important not to forget that a desire to distance "good," Anglo-Saxon, Protestant, financially secure, American mothers from ill-bred and ill-behaved immigrants shaped the anti-child labor movement (Coontz 1992). New arrivals, among other supposedly un-American activities such as practicing Catholicism, sent their wives and children into the labor force. Anti-child labor activists mixed concern for children's welfare with high doses of xenophobia and classism. Just as the stay-at-home-mom

family was more difficult to achieve for immigrant families, it was also more challenging for the descendants of enslaved people who were forced to play catch-up. Low wages for black men and their position of being last hired and first fired kept high numbers of black wives in the labor market. Nevertheless, within a few decades of children's official exit from the workforce, the booming economy of the 1940s–1970s allowed one adult breadwinner in many families, especially white ones, to support a spouse and children on one income. Women who previously worked until a child could replace them in the paid labor market now stayed at home while kids were young and went to work only when they were older, if at all.

> Work as a goal had not only disappeared as a natural part of childhood, but even household chores receded, as middle-class mothers took over almost all household tasks so that their offspring could freely enjoy a childhood defined by play and school . . . [B]y the middle of the twentieth century, it seemed finally within the grasp of the majority of Americans to make this kind of childhood available to all of their children. (Fass 2016: 188)

Still in the 1950s, even with stay-at-home mothers, expectations of parents were much more limited than today. Parents rarely organized today's ubiquitous "play date." Children simply played in the street or backyards with other neighborhood children. There were far fewer organized lessons for children outside of school. Other than the boy/girl scouts and a few activities organized by houses of worship, there were fewer opportunities like summer theater camp or schools on sailing ships to send the child off to in order to practice special talents and add a line to a college essay or résumé. Yet as economic conditions changed in the latter decades of the twentieth century and expectations for college soared, views on parenting underwent a major shift. As sociologist Annette Lareau (2011 [2003]) explains, middle-class parents were no longer responsible just for their kids' physical needs and making their children attend school and religious services. Instead, the good parent became one who practiced "concerted cultivation," endlessly engaging with her child and planning and driving to and from all sorts of beneficial after-school and summer activities.

Mothers went from spending 54 minutes a day on childcare activities in 1965 to 104 minutes a day in 2012 (Dotti Sani and

Treas 2016; May 2016). Today, mothers rarely, if ever, wax floors, and, if they have the means, they outsource some cooking and other household tasks such as ironing, but they invest more time with each child. Motherhood scholar Andrea O'Reilly (2021a: 485) writes that "[r]aising one child today . . . demands more time, energy, and money than the raising of four in the postwar period. Indeed, the demands made on mothers today are unparalleled in history." Even those with the most means and hired help feel outpaced. As sociologist Marianne Cooper (2014) explains, today's most well-off parents sometimes experience as much anxiety as their economically struggling counterparts, but the stress comes not so much from worry about the bills as a worry that they cannot keep up with the require-ments to get their child into a "good college" or provide them with a leg up (fluency in a foreign language, an unusual travel experience, virtuoso status with an instrument, or an amazing internship in high school) that the neighbor's child/competitor for their kid's college admissions spot hasn't also already had.

Indeed, the uber-mothering that some extreme parenting propo-nents engage in can be viewed as a manifestation of social class, as both sociologist Jennifer Reich, author of a book on parents who are anti-vaccination, and JJ Keith, social commentator and humor writer, assert. Keith writes:

> My theory about what drives parents to do time-consuming and ultimately unnecessary things like trying to create germ-free environ-ments or make their own baby purées is that it is always about either control or social class, and usually a mixture of the two. Part of what wigs new mothers out about formula is that it seems déclassé. That's why the most fervent lactivists like to compare formula to fast food – fast food is "trashy." Likewise, purées: They show that mom has the time to do stuff like that, and free time is a signifier of social class . . . And likewise germs. Germs seem dirty. Dirty people are poor. *Nice* people are clean. (Keith 2014: 132–3)

Reich (2016) writes about parents who refuse pediatricians' immuniz-ation schedules and believe that by purchasing (expensive) organic food and keeping their children away from the wrong (read dirty = poor) people, they can keep them healthy "naturally," without vaccines, and thus do parenthood better than other people. Of course, this is usually really about doing motherhood better than other mothers, exactly what Keith (2014) critiques as "mompetitions."

While there are a few fathers who figure in Reich's book, the predominant drivers of the middle-class anti-vaccine movement are mothers. Villalobos (2014) gives examples that transcend social class, especially in terms of attachment breastfeeding and co-sleeping, but she agrees about control and argues that these moms are attempting to accomplish their security projects through their actions. While ostensibly aimed at keeping children safe and healthy, a lot of these behaviors are more about the mothers' own insecurities and attempts to manage them than children's actual needs.

In addition to the ratcheting up of perceived or real experiences and skills needed to get into college and land a successful career, today's parents face other societal changes that color their approach to parenting. Instead of raising a brood, changing norms and effective, accessible birth control have led to parents replacing themselves. Today's smaller family size means that parents pin hopes and dreams on only one or two children instead of six or eleven. A prodigal child among several may be a family embarrassment, but there is likely another sibling to take over the family business. Children without brothers and sisters are on the hook.

Along with the growing expectations for parents, sociologist Joel Best (1990) argues that a rising tide of fear about possible harms to children dictates how we treat them. Our precious one of two is not likely to die from pertussis or tetanus in the twenty-first century (at least, not if properly vaccinated), but most parents worry that a white van waiting to abscond with Junior could easily be parked down the street. News stories about bad things happening to children downplay real and common dangers, such as toddlers ingesting household cleaning products, and make parents think that rare dangers, such as stranger kidnappings, or pseudo-dangers, such as children being poisoned by neighbors on Halloween, are real threats to their kids (Best 1990; Furedi 2002; Glassner 1999). Overblown dangers to children work their way through the media and eventually spread to politics and law enforcement. Whereas once it was perfectly normal for a parent to leave a child with a book or toy in the car outside the grocery store, doing that today can lead to charges of child endangerment or neglect in many states.

What is expected of mothers is constantly changing, and mothers in the past did things that seem bizarre and often detrimental to mothers today.

As the primary caretaker of children during most of history, [the mother] has been variously obliged to nurse and not to nurse; to facilitate expression and to suppress it; to cuddle and to avoid contact. During the Middle Ages, she might have overlaid her child in bed; in the eighteenth century, she might have exiled the infant to a wet nurse in the country; in the late twentieth century, she is probably cognitively stimulating *ad infinitum*. (Thurer 1994: 299–300)

However, as psychologist Shari Thurer points out reassuringly, even though the mode of parenting swung dramatically across centuries and locations, it seems that the incidence of mental illness has been pretty constant; "whether they were sternly disciplined or spoiled, they managed to thrive. Apparently ordinary mothering does not cause psychological problems" (Thurer 1994: 300). This undermines a clear conviction that what modern moms are doing is the only or the best way to mother.

All this casts serious doubts on the validity of our current image of the ideal mother. Perhaps she needn't be all-empathic, after all. Perhaps she can be personally ambitious without damaging her child. Perhaps she does not have unlimited power in the shaping of her offspring. Good mothering, history reminds us, is a cultural invention – something that is man-made, not a lawful force of nature. (Thurer 1994: 300)

Failing Moms has a double meaning. No matter the extreme and exhausting lengths to which women go in order to try to be the good mother, the mother who puts the child first at all times and can never give enough time, sleep, money, and worry, she will always fail on some level. As Rich (1976: 223) wrote, "[t]he institution of motherhood finds all mothers more or less guilty of having failed their children." While many perceived "failures" are minor, there are real costs to be paid when women don't live up to societal expectations of mothers. A woman who takes drugs during pregnancy, even legally prescribed ones, can not only lose her newborn, she can also end up in jail. At the same time, my argument is that more than mothers failing their children, it is society that is failing moms (and by extension their children) by not providing the resources necessary to mother well. Far too many women who "fail," often to a negligible extent, or sometimes through no fault of their own, are being punished.

If it were truly about children's health and well-being, there would be more equity between parents of different sexes; but it is not. Fathers

are not held to nearly the same bar as mothers. A father is more likely to escape many of the multiple expectations of parenting and can usually still be seen as a successful father for simply bringing home a paycheck (and maybe making it to a school event a couple times a year). Coleman (2015: 393) writes that "[w]here prior generations of children were expected to earn their *parents'* love and respect, today's parents are worried that they won't have their *children's* love and respect because they're not good *enough*: not psychological enough, not sensitive enough, not fun enough, not 'there' enough." Although to some extent this is increasingly applying to fathers, it is still mothers who are asked about on Freud's proverbial couch. In a dual-sex family, a father typically isn't expected to be the counselor for the high schooler's friend problems and the baker for the middle schooler's seventh-grade cupcake sale. A mother is. Mothers don't get to do just one thing. In fact, employed mothers sleep six or fewer hours per night (Bianchi, Robinson, and Milkie 2006), and the caretaking burden only got worse during Covid, with schools and childcare facilities closed and family members quarantining (Green and O'Reilly 2021). And when parents do something truly awful, mothers still draw more attention and opprobrium than fathers (Goodwin 2020). With a few exceptions, such as when he's murdered a pregnant wife, a father who shakes his infant daughter to death or shoots and kills his teenaged son can still be hidden deep in the newspaper in a short blurb, whereas mothers who kill their children are more likely to make the front page and be in the media spotlight for months.

Sharon Hays (1996) begins her book with the example of a mother who insists that she must take several days off work to spend with her sick child in the hospital. The child is not at death's door . . . and also has a father. Yet the father can choose whether or not to miss work to be at the hospital, whereas the mother is compelled to be at her bedside at all times. Hays argues that it is precisely because we have overinvested the mother–child bond as the stand-in for all of life's affective non-transactional relations that mothers must be self-sacrificing and ever-giving. She underscores that we place mothers as the counterweight to the selfish, get-ahead logic of the marketplace and society in general. As other bonds, those with extended kin, friends, and even spouses, weaken, we, as a culture, look to the mother–child bond as proof of goodness and connection: "To the extent that the valorization of nurturing mothers and innocent children is meant

to protect us all from the full impact of the dog-eat-dog world, the opposition is crucial" (Hays 1996: 177–8). Consequently, all of society stands to crumble into competitive chaos if each individual mother does not do her part to shore up sentiment and sacrifice. It is this burden placed on mothers, an outgrowth of a larger constellation of sexism and social control, which leads us to castigate those who will not, or cannot, comply. Whether publicly judged or not, no mom can live up to the demands of intensive mothering, and women who do the labor of motherhood live under the constant, crippling weight of perceived lack and failure (O'Reilly 2021b).

Women are not the only group losing ground in the third decade of the 2000s. The Supreme Court put in place by President Trump had its sights on women but also on anyone whose gender or sexuality is non-traditional in some way. Lesbian, gay, bisexual, pansexual, and omnisexual people, as well as gender nonconforming individuals, are all under attack; laws targeting transgender people have multiplied across states. In *Failing Moms*, I focus on the different standards to which women are held even before pregnancy through parenting, with special attention to the increasing number of ways mothers are punished when they don't meet our current norms for motherhood. I use "mother," "woman," and "she" because my focus is how society and the law treat people who are classified as mothers versus fathers, and to match the historical accounts, public health pronouncements, and court cases to which I refer. The law has not caught up to social scientists', progressive feminists', and an increasing number of young people's more expansive understanding of gender. I follow past usage conventions despite recognizing that they are problematic, given that gender is a social construction and even biological sex is based on "socially agreed upon biological criteria" (West and Zimmerman 1987: 127). Many people do not fit neatly into the gender binary for a variety of reasons, including their bodies or their self-identification. In making the point that women are called upon to become mothers and reproduce the nation, I use the typical convention of referring to pregnant people as "women." I acknowledge, however, that this leaves out people who do not self-define as women (non-binary people, trans men, etc.), those who are already resisting deeply entrenched norms about what women and men should and can be. Gender-fluid people and trans men who do the work of bearing and raising children face a special set of circumstances beyond those of the majority of moms I reference in this

book, as well as encountering many of the same issues. I urge readers to explore the work of non-binary and (gender) queer authors such as teacher and writer Krys Malcolm Belc's (2021), *The Natural Mother of the Child: A Memoir of Nonbinary Parenting*, sociologist Raine Dozier's (2015) autobiographical article "The Power of Queer: How do 'Guy Moms' Disrupt Heteronormative Assumptions about Mothering and Families?", and cartoonist A. K. Summers' (2014) graphic memoir *Pregnant Butch: Nine Long Months Spent in Drag*.

The particular issues involving gender fluid, non-binary, and transgender people point to the importance of an intersectional lens (Crenshaw 1994). Multiple identities interact to shape how people are perceived, how they perceive themselves, how they are treated in society, and how they experience their lives. Racial- and ethnic-minority women have different experiences from white women and from men in their racial and ethnic groups. While poor women all face some of the same challenges, poverty differs for those who live in rural versus urban areas and those who are stigmatized in another way, be it race, religion, immigration status, sexuality, gender identity, or disability. The nexus of different characteristics is important to keep in mind in a discussion of how we treat mothers because they are not all viewed the same way. This can affect the choices they make, how they feel about themselves, and how much risk they incur if they deviate from expected parental norms. As Fentiman (2017: 142) points out in her book, "[s]tereotypes of 'good' and 'bad' mothering are also deeply embedded in Western culture and have the potential for outsize influence on the decisions of jurors and judges."

Failing Moms elucidates widespread, persistent inequalities resulting from class, race, and gender, questions what is really best for moms and their kids, urges us to think about how the system fails, and presents solutions that would help mothers, children, and families. If women's reproductive lives are not respected, if the standards to which mothers are held are not changed, and if moms are not given more tangible support, not only will moms and their children continue to flounder, but more and more women will end up suffering the fate of "bad moms."

Chapter 1, "All Moms Are Bad Moms," sets up the book by revealing how no mother can do it "right" all the time. The modern ideology of intensive motherhood has only become more ubiquitous

since Hays wrote her book, spreading from middle-class moms to working-class moms. Mothers are expected to be well read on child development and psychology, prepared to put a child's needs first at all times, and committed to spending inordinate emotional, time, and financial resources to benefit their children. All mothers are supposed to be ever vigilant, knowing exactly what is going on with their children at all times. Women trying to live up to this ideology of motherhood of the ever-giving, all-knowing mother not only find themselves exhausted and resentful, but, no matter what they do, they also see themselves being accused of failing their children by the media, by other mothers who parent differently, or even by the police. Women are still judged for working or for staying home. They are critiqued for being helicopter parents or for giving their kids too much independence. They are castigated for bottle-feeding or for breastfeeding too long. A mother can never do it right. This creates anxiety for all moms, but some mothers face reproach simply for who they are: a mom of color, a queer mom, a mom who is disabled, or a teen mom (O'Reilly 2021b). Increasingly, any mom who is not meeting all expected norms can find herself entangled with social services and the criminal justice system. If her child is injured in a fall in the backyard while she is inside on the phone, for instance, a mother could see all of her children removed from her care.

Men are let off the hook, whereas women are targeted and made responsible from the outset. Chapters 2 and 3 elucidate the differences for men and women before actual parenthood begins. Chapter 2, "Preconception Discrimination," analyzes the distinct climates for the sexes prior to conception. Women who have not entered menopause are considered to be in a pre-pregnant state at all times and are told to act accordingly, whereas the health and behaviors of men, even those actively trying to conceive, are typically ignored. We overlook men's role in reproduction despite evidence that sperm can be affected by cigarette smoke, lead, and other chemicals. I explain factors such as age, substance use, and exposure to toxins at work. While men benefit from not having their reproduction policed, they also suffer from not being informed and not having their health, and that of their offspring, protected. And it is women, privately and publicly, who pay the price for men's infertility and role in pregnancy loss and birth defects. In infertility clinics and sperm banks, men's health is considered. However, there are real dissimilarities between egg and sperm donation, in which women, but not men, are subject

to psychological screening, and donor eggs come with more information than donor sperm, even though both processes produce the same thing, gametes, a genetic contribution.

Chapter 3, "Criminal Pregnancies," explains how the creation of the fetus as a legal person has led to prosecutions of pregnant women for a variety of behaviors such as taking drugs, illicit or prescribed, and refusing cesarean sections. These laws, expanding exponentially with the overturning of *Roe v. Wade*, are not only manifestly detrimental to women, they are also bad for fetal outcomes. Many of them are also based on faulty science. The fact that many women are prosecuted after the birth for their behaviors during pregnancy points to these measures being more about punishing "bad" mothers, and the message this sends to all women than being about helping babies. Women are criminalized for their actions, or lack of them, even when there is no proved harm to the baby, and they can even be incarcerated for refusing medical treatment or be operated on against their will – a situation that men never face. While it is easy to assume that these cases are rare, all women are at risk, as the woman who fell down the stairs while pregnant and was almost prosecuted found out. On another level, this surveillance of pregnancy trickles down to the mundane, as women who are expecting are increasingly told, even by strangers, not to engage in certain kinds of exercise or not to eat certain foods. Women have been denied coffee by baristas during pregnancy. All of these examples remove autonomy from women we presume will be fully capable mothers who make decisions for themselves and their children after giving birth.

Chapters 4 and 5 are about mothers who "fail" in their parenting. Chapter 4, "'Neglectful' Mothers," explores cases of mothers who are arrested for sending kids to the park or leaving them in the car to run an errand and differences between middle class moms versus poor women who have no child care and have to leave their son or daughter in order to work. Black and Native American women are especially likely to be reported to child welfare services. Often, kids are removed from their moms, not because the mother is abusive but simply because she is poor. I begin this chapter with a section on parenting in different European countries in comparison to the United States, including, for example, how in some countries children are given more independence sooner and how the expectations of mothers differ. In parts of Europe, it is common to leave babies and toddlers in baby carriages outside the supermarket, something that

was acceptable in the United States 70 years ago. In the United States today, however, a woman could be prosecuted for endangerment or neglect for leaving a child unattended briefly. In this chapter, I also discuss research that shows that in hypothetical situations, fathers who leave children alone (for work, to have an affair, etc.) are given more leeway by subjects than mothers in all scenarios. That norms have changed so rapidly, and much more so for mothers than for fathers, tells us more about society's perceived need for mothers to uphold a certain role than about the actual safety of children.

"Occupying the bottom rung of the hierarchy are mothers who murder or abuse their children, or who allow such acts to occur" (Kinnick 2009: 10). Chapter 5, "Mothers of Maimed and Murdered Children," looks at tragic cases where a child is killed or seriously hurt. Sometimes it is the mother who commits the crime, and there are gendered patterns that distinguish mothers and fathers who commit filicide that tell us about the socialization of women versus men. Sometimes the mother did not harm the child, but someone close to the family did, usually a boyfriend or stepfather, and the mother is sent to prison, convicted under "failure to protect" laws. These laws posit that a woman is equally or more culpable for not stopping a man from injuring or murdering her child than the man who actually did the act, and thus there are numerous cases where women have received lengthy sentences, sometimes as much time in prison as the murderer or an even longer period of incarceration than the perpetrator of severe abuse. Fathers are almost never tried under failure-to-protect laws. It is women who are supposed to know better and to do better by their kids. All too frequently, prosecutors misattribute rational action by an abused woman using her previous experience to cope with a violent situation as a mother callously and willfully neglecting her child's best interest because she does not care. This chapter shows the terrible consequences for some of the most suffering mothers, outcomes that are a result of our inherent distrust of mothers in general.

This double standard is real, and it has real-life consequences for women and their families.

Feminist criminological theory shows us that crime is an inherently gendered concept. Women who commit crime are "doubly trans-gressive" in challenging both the criminal law and their gender role (Carlen and Worrall 1987; Worrall 1990). Thus, when women commit

crime, they are tried as women and mothers, not as autonomous legal subjects (Nafinne 1997: 144). Consequently, mothers accused of crimes are effectively convicted or acquitted according to their adherence to maternal ideology, rather than their actions and omissions. (Singh 2021: 184)

Aside from gross miscarriages of justice and the harms they cause, one of the recurrent themes in this book is that these double standards affect all women, not just those who find themselves in the back seat of a police car. Ultimately, *Failing Moms* underscores the shadow under which moms mother. As some privileged moms stress about providing their child the best opportunities, moms who struggle financially fall ever further, given the huge holes in social safety nets. This leaves them more likely to run afoul of the law and lose their children. The treatment of society's most vulnerable is a harbinger of what lurks even for those who do not expect it. As more and more mothers are discovering, particularly with the loss of *Roe v. Wade*, it is not only society's most vulnerable moms who are at risk of intervention in their lives and even criminalization. All moms, by virtue of being a female parent, can be denied necessary medication, forced to carry a pregnancy longer than desired, required to justify themselves to Child Protective Services, and can go to jail for a parenting decision.

The concluding chapter, chapter 6, "Fighting Back, Fighting for the Future," argues that there is little real support for mothers. Most women need to work while still shouldering the majority of the second shift, even if they have male partners, and progress in these domains has been seriously set back by the Covid pandemic. Systematic discrimination, such as women being underpaid at work, compounds cultural norms, reinforcing the primary role of mothers as caretakers. Rather than demanding that structural issues be addressed by the government, people typically deal with problems, such as finding suitable care for children during working hours, as individuals. They are too politically disempowered and also too tired from trying to cope on a daily basis to do so – even if they realize the pressing need for collective action and systematic solutions.

Crises like political instability and raging disease, as menacing as they are, can also open up spaces to rethink what we are doing, disrupt the status quo, and implement change. The attacks on reproductive

justice by the Supreme Court and politicians are horrific; they are also galvanizing people. While challenging beliefs about mothering is an uphill battle, we need to look at actual data rather than making assumptions about the effects of moms on children. Intensive parenting is not necessary for children's well-being and is detrimental to mothers. Social science researchers have found that time spent with children does not matter as much or in the ways that most people think it does, for example (Huston and Aronson 2005; Milkie, Nomaguchi, and Denny 2015). On the other hand, removing children from their parents' care is deeply traumatic for the children and carries long-term sequela. It should be avoided in as many cases as possible, particularly cases in which the only "abuse" is a result of poverty.

It is high time to reduce expectations of mothers and engage in less criticism of other people's parenting, but there are other concrete steps to take. We must fight in our communities and in Congress to protect the rights of those who are pregnant and mothers. Pregnant people must have the legal protections that all other adults have, without undue interference, and thus it is critical to challenge legal efforts to turn them into fetal incubators. We need to put more attention and resources toward real dangers to children and mothers, such as the crisis of black maternal mortality and attacks on trans/ gender fluid children and their mothers, rather than obsessing over pseudo-fears that are more about the social control of mothers than about children's actual needs. We must offer actual help, rather than criminalization, to mothers who are struggling with poverty, substance abuse, or violence in their homes. The mothers caught in the legal system are more likely to be poor and/or women of color, although, as I demonstrate throughout the book, the net of charges and the women subjected to it are ever-expanding.

Developing a culture that expects fathers and other caregivers besides mothers to play a larger role in children's upbringing would take some of the burden off mothers' shoulders and also give children broader networks; this should be encouraged politically with programs including subsidized child care. An emphasis on childrearing as a collective responsibility, supported by national initiatives such as effective protections for workers during pregnancy and paid family leave, and Covid family-friendly policies including more flexible schedules, would reduce the draining expectations of mothers (and their guilt, stress, and lack of sleep) but also ultimately

help us move forward toward a better society that supports all types of families. We have to help mothers climb out from shouldering the weight of a rapidly changing society, one in which the expectations of mothering continue to expand unchecked. We have to strive for "empowered mothering" in which moms have "the agency, authority, authenticity, autonomy, and advocacy-activism that are denied to them in patriarchal motherhood" (O'Reilly 2021a: 610). It's time to stop blaming moms and demand for them the respect and support people claim mothers deserve. Not flowers, not lip service. Real respect, real support . . . and real justice.

1

All Moms Are Bad Moms

All moms are bad moms. Today's "good" mom would not have been a good mom in the 1700s and vice versa. Parenting standards change. The ideal is generally also based on the norms that the higher social classes in society project. Yet most people are not well off. When people of color, immigrants, and poor people are added together, the group used as the standard is a rather small one. And even those mothers who seem to best fit society's ideal conception of a mother – white, middle class, heterosexual, married, and the "correct" age to be a mom – mess up. Feminist author Angela Garbes (2018: 5) writes about the impossibility of living up to all the expectations: "[y]ou are a 'bad mom' if you have the occasional glass of wine during pregnancy, experience anxiety or ambivalence about having a baby, look forward to an epidural, feed your baby formula, or take a pull off a joint once the kids are in bed because children are exhausting." No human being can be perfect constantly for years. What mother has not stood up to grab something a few feet away only to turn around and find that her baby has rolled off the couch in a split second? Or insert equivalent situation. Thankfully, most of the time, the child is fine. But in the cases where they aren't, where the baby broke a bone, or worse, no one realizes a bone got broken until months later at the ER for something entirely different, that good mom could face an abuse investigation.

As historian Paula Fass (2016) reminds us, parenting was never easy. Mothers died in childbirth. Parents of both sexes died from diseases, spoiled food, and accidents. Young children died from childhood diseases and diseases that struck everyone, unclean water,

contaminated milk, inadequate milk replacements, and accidents. Mothering has also never been monolithic. The conditions of a southern enslaved woman and her child and those of her well-off owners differed dramatically, as did those of poor, immigrant white women who settled in northern cities, although all were at the mercy of the tragedies mentioned above. Many women, by accident of birth, could never meet the archetypes of the mother held out before them. In the latter part of the nineteenth century, this meant that only well-to-do mothers, often with servants, could live up to the separate spheres ideology which kept them in the home and out of economic transactions including paid labor. Women who had to work to support themselves and their families had few protections from economic and sexual exploitation.

In the 1900s, advances in science changed mothering. Advice books for mothers took off, yet the guidance not only varied by decade but also from author to author, leaving even middle-class women from similar backgrounds following different trends in childrearing. By the end of this century, attachment parenting versus letting a child cry it out was far from resolved and, even though numerous studies pointed to children of working mothers being just fine, the press continued to harp on the so-called "mommy wars" and debate the merits of moms in the labor force. This history should leave us suspicious of modern advice books, even the ones we like, and help us recognize that there is not just one way to be a good mom.

Post World War II, mother blaming was rampant because society viewed mothers as responsible for their children's psychological well-being. When a child or adult had issues, it was always the mother's fault. This created a new kind of anxiety for moms, one that only deepened as mothers took on more and more roles for their children as the century progressed, including prepping them for academic achievement. Fear of strangers and other dangers led moms to keep their children barely further than arm's length, rather than allowing them to play with other children or to be supervised by older siblings, and this, along with a decrease in chores for kids, further burdened mothers. By the last decade of the twentieth century, the ideology of intensive mothering was so pervasive that it was slipping beyond the confines of middle-class white moms to all mothers of different ethnicities and socioeconomic statuses, even those who had fewer resources with which to provide it (Ishizuka 2019).

While most moms have internalized some degree of intensive mothering, the diversity in particular parenting styles continues to create divisions among moms today (Crane and Christopher 2018). Some mothers, including moms of color, teen moms, moms living with a disability, and moms who do not fit traditional gender and sexuality categories, face more opprobrium than others (O'Reilly 2021b). All moms encounter challenges with their children, blame when things go wrong, and lack of political support for combining work and family.

Nineteenth century

As industrialization diversified people's labor and cities swelled, the family also changed. Families became more nuclear, affective ties within the family became more important, and the broader community commanded less influence (Shorter 1975). The late 1800s ushered in the idea of separate spheres for men and women. Mothers became the guardians of morality, and as such were cast as too pure to be sullied by economic and political matters. Thus women were confined to the home while men dealt with commerce, at least in well-to-do families. The separate-spheres arrangement left out not only most black women but also poor white women while simultaneously depending on their labor to keep middle-class and wealthy women comfortably at home.

Slaveholders sought to keep enslaved women alive and *sometimes* procured medical help for them, but most enslaved mothers suffered from overwork, poor foodstuffs, corporal punishment, rape, and forced pregnancy, and losing their children when they or their offspring were sold or inherited by another owner (Cooper Owens 2018; Roberts 1997). In spite of, or because of, the sexual abuse they endured, black and some white immigrant women were portrayed as licentious, uncontrollable "breeders," and even as "missing links" between animals and humans who could be used for medical experimentation (Cooper Owens 2018). White, US-born women from "good" families were viewed as chaste and driven by maternal instinct. Only bourgeois women were seen as respectable, given their ability to be fully devoted to domesticity.

Unlike black women in the decades that followed slavery, white immigrant women were eventually able to change their status. While

numerous immigrant women from Ireland, Italy, and elsewhere faced grueling toil outside their homes or prostitution to support themselves, some managed to marry US-born white men, as did their daughters. Marriage was the ticket to status for many white women, but it was also a golden cage. Some women, however, used this status to their advantage to lobby for causes that mattered to them. In the late 1800s and early 1900s, mothers transformed their private power as guardians of hearth and morality into public power through political action *as mothers*. Fighting for temperance, social welfare, labor standards, and health initiatives were all the domain of women protecting the health of the nation's citizens, young and grown. In the late 1800s and early 1900s, reformers pushed for child protections and the increasing involvement of public institutions and the state in children's lives.

Previously largely confined to the interior, and well away from politics, especially if she was "well bred," a woman could now legitimately spout public policy demands from a stump if those demands could be attached to caretaking and morality, her designated role expanding to ensuring the protection of all and not just her family. Women seeking suffrage turned the argument that they could not vote because of their morality on its head: "Women deserved the vote because they were virtuous, sober, devout, respectable, and *maternal*" (Thurer 1994: 215), and their votes would make society better. The National Congress of Mothers, founded in 1897, which became the Parents and Teachers Association of America, initially connected being a good mother to caring for all children from all homes, tying advocacy for one's own child to concern for everybody's children (Fass 2016).

Twentieth century

Advances in science and industry dramatically influenced mothering in the 1900s. During the twentieth century, physicians and psychologists became the experts, and mothers were expected to trust them and avail themselves of their knowledge, including parenting how-to books, rather than turning to female relatives for advice (Fass 2016). Thurer writes that

> "scientific" motherhood upgraded mothers' domestic tasks and endowed them with an aura of professionalism . . . The bad news was

that much of the science was questionable; it undermined mothers' confidence in themselves; and it placed mothers under the thumb of self-appointed – usually male – experts. It also needlessly complicated inherently simple tasks – feeding, for example, became clock-bound; burping a baby was elevated to a fine art; providing fresh air became a complex exercise – all of which may have enhanced motherhood's mystique, but was pedantic, superfluous, and just plain silly. (Thurer 1994: 226)

The questionable scientific ethos of the early twentieth century included eugenics. Although Irish women and later Eastern European and Italian women progressively acceded to the privileges of white women, including society seeing value in their pregnancies, black women remained non-white, and their pregnancies were no longer valuable post-slavery. Eugenics led to forced sterilizations which were carried out on poor and disabled white girls and women, such as Carrie Buck, a 21-year-old mother from Virginia whose case went to the Supreme Court prior to her sterilization in 1927, but which were much more frequently perpetrated on black girls and women, such as the Relf sisters from Alabama, sterilized at ages fourteen and twelve in 1973. Forced sterilizations of women of color were not only prevalent in the South; in the 1970s, numerous Latina women were sterilized against their will or without consent in California. This is not a thing of the past. In 2019, at least five Latina women were forcibly sterilized in an immigration detention facility. The differential value of women's lives by race is also evident in research. Puerto Rican women were used in the first trials of the birth control pill in the 1960s, and deaths of test subjects on the island did not deter the manufacturers from selling it across the United States. It was only after white women in the United States mainland died that the dangerous doses of hormones in the early pill were lowered to safer levels.

For women who were mothers in the post-World War II United States, the baby was king. From Dr. Spock onward, mothers were to give their infants their undivided attention and be at their beck and call. If they failed, it was not only materially that their child would suffer, they could be psychologically damaged for life. "Ironically, this hyperempathic ideology of mothering was foisted on women . . . just as they were going slightly mad under the pressure of social isolation, routine chores, conformity, and circumscribed options, just as they were losing their status as skilled homemakers, having been

made redundant by labor-saving technology" (Thurer 1994: 256). At the same time, moms were told that if they were too involved, overprotective, or domineering, their child would have psychiatric problems as a result. It became a fine line to walk between being rejecting and overly coddling, as moms could be blamed for either.

Mothers became increasingly anxious trying to follow new and changing standards, and the trope of the "bad mother," who did too little or, frequently, too much for her children gained popular currency (Fass 2016). "Bad moms" were often portrayed as overprotective, infantilizing, and smothering. Sometimes, this was supposedly because their own sexual problems manifested in psychological unhealthy behaviors with their children, especially their sons, leaving the nation with young men incapable of fighting enemies and/or gay (Ehrenreich 1983; Fass 2016). "[F]emininity in men or women themselves – most often mothers – could psychologically damage citizens and thereby weaken the nation" (Feldstein 2000: 72). Philip Wylie's 1942 book *Generation of Vipers* epitomized this idea but was not the only one of its kind. While Wylie critiqued "momism," others argued that women were turning away from their natural roles and consequently damaging their children. Ferdinand Lundberg, a sociologist and journalist, wrote *Modern Woman: The Lost Sex* with Marynia Farnham in 1947. A practicing psychiatrist, Farnham apparently did not see the irony of being filmed in a lab coat in front of her office door in post-World War II propaganda telling other women to remember their primary role as mothers at home and stop undermining the family. Like Wylie, Farnham and Lundberg blamed women for men's problems.

> The bad mother, however, was a contradictory and even ironic figure. Certainly, texts like *Generation* and *Modern Woman* revealed overt misogyny and efforts to regulate women. Nevertheless, it is important to consider both the premises on which mother-blaming was based and what its ethos enabled. For one, images of women as bad mothers functioned in close relation to a celebration of motherhood that also prevailed in this period. (Feldstein 2000: 43)

Women were supposed to be enthralled by all things domestic, the *Feminine Mystique*, as Betty Friedan titled her groundbreaking 1963 book. In the 1950s, anyone, female or male, who did not marry was considered stunted or mentally off. As countless novels

and films convey, women who went to college for a "Mrs." degree did not always end up living happily ever after. While the divorce rate did decline in the 1950s, it started going up again in the 1960s, and almost one-third of marriages contracted in the 1950s eventually failed. Betty Friedan called the malaise that women corralled at home were feeling "the problem that has no name," indicating how taken for granted it was that women were supposed to be completely fulfilled by cooking, cleaning, and child care.

Although "[the scientific motherhood of the early 1900s] was labor intensive, it was concrete and had a defined endpoint. It was, therefore, not nearly so guilt-inducing as childrearing was to become in the second half of the twentieth century, when the rules changed and the instructions became much more ambiguous" (Thurer 1994: 226–7). Around 800 books about mothers were published in the last two decades of the twentieth century, and they gave contradictory advice (Douglas and Michaels 2004).

> [A]ttachment parenting is considered de rigueur one year and overbearing three years later . . . cry-it-out is all the rage one moment and then, after a couple seasons, considered cruel . . . organic, home-milled purées suddenly supplant jars of Gerber's, though an entire generation has done just fine on Gerber's and even gone on to write books, run companies, and do Nobel Prize-winning science. (Senior 2014: 136)

Variations in modern parenting leave us without norms and scripts for exactly how to do it, and that leads to "personal and cultural distress" (Senior 2014: 7). It also widens the door for critiques of other moms. Breastfeeding or bottle-feeding, working or staying home, and countless other mothering differences were supported by some and dismissed, or aggressively critiqued, by others.

One of the most burdensome new theories for raising children in the late twentieth century that has not entirely left us is attachment parenting. In 1975, Jean Liedloff, a model from New York, wrote *The Continuum Concept: In Search of Happiness Lost* having spent time with the Ye'kuana of Venezuela after she initially encountered them during a diamond-hunting trip. Her theory was that people living in the jungle were naturally evolved and that they parented their children more effectively than parents in industrialized countries because they aided them through their own sort of evolution as they progressed through infancy and childhood. Liedloff focused on how

these babies were carried or held almost constantly and co-slept with parents until as children they chose not to, and she argued that because of this (and not, say, other cultural factors) they were better adjusted and well-behaved children. Pediatrician William Sears and his wife Martha, a nurse, seized on these ideas. The Sears wrote several books in the 1980s, 1990s, and 2000s popularizing what they called "attachment parenting." A religious couple with eight children, one of the books, *The Complete Book of Christian Parenting and Child Care: A Medical and Moral Guide to Raising Happy Healthy Children* (1997), made faith central to the parenting process. Critically, according to the Sears, this 24/7 hands-on parenting was supposed to be done by the mother as the "natural" caregiver. Mothers were urged to nurse on demand, breastfeed past the first year, carry the baby around all day, and co-sleep at night. This, obviously, makes having a job at a location away from the child difficult and does not work well for all women, even stay-at-home moms. It also downplays the role of a dad. What are single dads or gay-partnered dads supposed to do?

Obstetrician/gynecologist Amy Tuteur, who is highly critical of attachment parenting, "lactivists," and natural childbirth proponents who tell others how to give birth and parent, argues that these trends have been pushed by men and religious fundamentalists who are not supportive of women's rights, and that they make women feel special by telling them that their power comes from their childrearing role and from their bodies, specifically their breasts and uteruses (Tuteur 2013b). Liedloff, who was not an anthropologist, obviously romanticized the Ye'kuana and developed questionable evolutionary psychological theories. In places where mothers' own food intake is low, women are likely to not resume menstruating for the duration of time that they breastfeed. This gives mothers without birth control a means of spacing their births. In developed countries where even poor people tend to consume a lot of calories, albeit not necessarily very healthy ones, women often get their periods even while breast-feeding, and therefore lactating does not work very well as birth control. So while western women who advocate nursing for two or more years, well after their children eat solid food, claim it is natural and the best for children because that's how it used to be done or is done elsewhere, they may actually be making false assumptions based on a practice that was primarily for the mother's health as much or more than for her child's.

Tuteur makes clear that she has no problem with unmedicated childbirth and many of the practices of attachment parenting *if* mothers want to do them, and she notes that she engaged in some of them herself with her own children. What she criticizes are "sanctimommies" and others who force an agenda on pregnant women and mothers of babies and toddlers when women who do not adhere to these practices can also be successful moms.

> It is a sad fact of history that men have spent a tremendous amount of time policing women's bodies. And an even sadder fact is that women have often been the prime enforcers in this effort . . . There are now entire movements devoted to policing women's bodies: the natural childbirth movement, the lactivist movement, and the attachment parenting movement. (Tuteur 2013b)

The groups are notable for their "insistence that women use their bodies in the 'proper' way. These philosophies . . . function in large part to keep women trapped in the home, invisible, and incapable of pursuing the same goals as men" (Tuteur 2013b). Tuteur decries those adherents trying to shame women's mothering choices as anti-feminist, believing that "women's bodies should be controlled by women themselves, not by groups who prescribe the 'correct' way to give birth, the 'correct' way to nourish a baby, and the 'correct' way to nurture a baby" (Tuteur 2013b). She and others, like Reich (2016) in her work on vaccine refusal, argue that these pronouncements are in a deep way more about mothers' presentation of self than about actual benefits for the child, despite vigorous claims to the contrary by their proponents. "Parental tribalism involves constructing an identity around parental choices, or rather constructing an identity centered on differentiating themselves from parents who make different choices" (Tuteur 2013a). While Villalobos (2014) finds that type of parenting practice, including attachment parenting, does not determine how onerous one's "motherload" is, at least in terms of everyday psychological burden, mothers who adhere adamantly to one parenting style and claim others are detrimental all have a heavy motherload.

Warner (2005) points out that early psychological work on deficits for children with insecure attachment were developed from extremes – homeless children and children being raised in orphanages – not from normal children. There are also problems with the ways attachment

has been measured in studies on babies and young children. Do children ignore mom, or run to mom, when they are insecurely attached or when they are securely attached? Does it depend on the child? Some of the claims made by Sears and others who profess attachment parenting have no data to back them up, such as the idea that if a baby cries too long it can cause brain damage or inhibit growth. Their advice tends to gloss over difference between various children and mothers. Some babies need less stimulation and some need more. Co-sleeping works well for some mothers and seriously interferes with the sleep of others. Children have survived and done well under many philosophies of parenting.

Certainly, allowing fathers into the delivery room and giving women more options during birth were good changes in the 1970s. There has also been a more generalized move toward authoritativeness, being more flexible, thinking about kids' perspectives, and negotiating with them, rather than the authoritarian parenting style of previous generations. Baby boomers lived as young adults in an era in which youth increasingly questioned authority and championed rights, and as parents they wanted to raise their children differently from their parents.

> Boomers took a more involved role in the lives of their children . . . Boomers tried to control and ensure outcomes for their own kids and become their strongest advocates. Whereas Boomers' parents adhered to hierarchy, structure, and authority, Boomers questioned these things with a vengeance . . . often supplanting themselves as a buffer between their kids and the system and its authority figures. Even when their child is grown. (Lythcott-Haims 2015: 5–6)

This has upsides and downsides. Instead of trusting teachers, pediatricians, and other authority figures in their children's lives, moms were now supposed to question these experts and make more of their own personal decisions about the best learning techniques or appropriate medical care. This can feel empowering, but it also created additional responsibilities and work for mothers.

The last decades of the twentieth century were not kind to mothers. Warner (2005) argues that the inner-child concept in psychology, the adult who has unresolved issues because of problems during their childhood including poor parenting, and the "recovery" movement of the 1980s and 1990s only augmented the emphasis on the effects

of deficient mothering and, consequently, mothers' guilt in general. Additionally, by the 1980s and 1990s, consumerism and competition had been added to the burden of motherhood. As well as ensuring their children's psychological well-being and doing more than half of the cooking, cleaning, and child care, moms were now supposed to buy their babies flashcards and toys to jump-start their brains and teach them how to read before preschool. A "good" mom had to stimulate her child's cognitive development constantly through activities and opportunities. Smart children became more important than happy children (Wall 2010). In tandem, children were doing fewer and less time-consuming chores. Kids in the first half of the twentieth century made substantial contributions to household labor but, in the 1960s through the 1980s, children's chores dropped precipitously (Lythcott-Haims 2015). Part of this is because of the zeitgeist of catering to kids, and part of it, especially in middle- and upper-middle-class families, is that parents feel that children are already busy with academics and activities they need for college (sports practice, music lessons, etc.) and don't want to overburden them (Lythcott-Haims 2015).

Anxiety in twenty-first century mothering

What Lythcott-Haims, former dean and vice-provost at Stanford University, is describing above is, of course, an aspect of the intensive mothering that took off in the late twentieth century. As described by Sharon Hays, intensive mothering is an ideology that is consuming of mothers' time, material resources, and emotions. The child always comes first. If a busy working mom does most of the household tasks with little help, so be it. Junior is busy with violin practice. Mom may well have worked before Junior started school too, but if she did, she invested countless hours into getting recommendations and inter-viewing childcare providers. She did not simply choose the cheapest or the closest. And, working or not, she took time to research, buy, and read several parenting books.

By the last decades of the twentieth century, after the rapid advance of the birth control revolution, within the context of legalized abortions and the advent and development of DNA science, and at a time that almost all children survive birth and early life, many privileged parents

have been absorbed in illusions of control and ideals of perfection. These illusions affect the middle and upper-middle classes especially, because they have the resources and access to professionals that allow careful supervision of nutrition during pregnancy, monitoring by genetic tests, and knowledge provided by the latest and best childrearing advice, now available free and at a moment's notice online. In all this, the sense of control becomes the defining illusion of our time. (Fass 2016: 225)

In investing so much, moms expect the outcome they desire. Moms are used to working hard to prove themselves, given that there is still gender discrimination in the workplace. Momism, as described by Douglas and Michaels (2004), developed because women in the 1970s were pushing to be the best to get access to jobs previously held by men, and they were trying to be overachievers at everything they set out to do and this translated to their parenting as well.

Trained to succeed and to be rewarded, educated women put as much "work" and effort into raising their children as they do in demanding jobs and also expect to reap the rewards. Once having children is defined as an individual choice, American parents often imagine that when they do not succeed or are less than completely successful, or their children are disappointing, it is somehow their fault. Having made the choice, they are obligated to do it right. Rather than being natural, it is seen as a strenuous battle. (Fass 2016: 221)

Fass's point that moms blame themselves when their children don't fulfill expectations is very important. It's not genetics, or personality, or influences beyond the home; it has to be mom. Even if something traumatic occurred in the child's life, it's still mom's fault for (a) not preventing it from happening, and (b) not getting their son or daughter the proper help to get over it in a resilient manner.

Clearly, moms cannot control everything. A child can be seriously injured or develop cancer. But more and more we see everything as something mom has to not only worry about but be responsible for. Even cancer. Because research posits that it could be attributed to things she did before or during pregnancy, it could be her doing. Or she used the wrong type of sunblock or Tupperware or fell for flame-retardant baby clothes because previously she was told that buying those clothes was the safe thing to do. She can't ever mother well enough; even if she couldn't know better, she should have. "The projection of harm also extends into the future adult life of the child

with long-term health outcomes increasingly attributed to infant diet and future emotional and social success attributed to parental behavior" (Macvarish 2010: 4.6).

Furedi (2002) calls this parental determinism, the idea that every choice parents make has a direct outcome. He says this makes parents anxious, but it also causes us to judge other parents. "[A]lmost any childhood dysfunction is likely to be presented as the consequence of some parental act. Although conventional wisdom dictates that parenting determines every aspect of a child's future, this perception is a recent invention of society's imagination, developing along with the emergence of the nuclear family" (Furedi 2002: 60).

As mentioned above, in this era this extends to academic achievement.

> Those who fail to get involved [in their child's education] are stigmatized for letting their children down, dooming them to a life of failure. The cumulative effect of all these pressures is to expand the meaning of parenting. Parents are burdened with the new and often unreasonable expectations. Parental determinism expands the concept of parenting until it becomes an impossibly burdensome task. No normal father or mother can undertake responsibility for everything that affects their child. Moreover, even if this were possible, it would not be desirable. It complicates the task of child rearing and places an intolerable emotional load on the entire family. With so much at stake, no one can be a "good enough" parent. (Furedi 2002: 76)

In her book, *Perfect Madness: Mothering in the Age of Anxiety*, Warner (2005: 192) gives examples of how moms get overwhelmed with choices big and small:

> Occupational therapy and speech therapy. Gluten-free birthday cakes and organic apple juice. Leapfrog toys and bow-tying boards and black-and-white baby toys. No TV; only a half hour of TV; only educational TV. No sugar. No trans fat. No Disney. No pizza.
> [W]e act as though, through sheer force of will (and good planning), we can sway the gods that master our children's fates . . .
> . . . We can send them to Just the Right School . . .
> . . . We can enroll them in Just the Right Activity . . .
> . . . And if all this doesn't work, then the fault lies with us. So we must try harder. Do better. Be *there* more – and more perfectly. (Warner 2005: 192)

The perceived stakes are indeed high, but as Hays, Thurer, Warner, and countless others aver, this pressure is worse for mothers. "To be sure, contemporary moms and dads feel enormous (if not total) responsibility for their children's emotional well-being. To the mother especially, how her child turns out becomes the final judgement on her life" (Thurer 1994: 161). She is the one with the final account. Warner concurs (2005: 191): "[W]hat's really unique about maternal anxiety today is our belief that if something goes wrong with or for our children, it's a reflection on us as mothers. Because we believe we should be able to control life so perfectly that we can keep bad things from happening. We micromanage. We obsess."

When mothers drop the ball society tells them to carry, they can pay a steep price – and one that fathers rarely do. As the stories in chapter 4 reveal, a mother's decision to leave a child alone in a safe car, house, or neighborhood, even briefly, can lead to criminal charges. These cases are overwhelmingly about "dangerous moms," not dads. Expecting mothers to keep tabs on their children constantly and be responsible for absolutely everything in their lives has serious consequences, even when the results are not as dire as a Child Protective Services investigation or a criminal sentence. By internalizing impossible standards of intensive parenting, women hold themselves and other women back, diminishing women's opportunities, self-actualization, and even political power.

> The upshot of all this is that, for all that progress, for all the advantages and opportunities we've had in our lives, many of us live motherhood as though we were back in the days of the Feminine Mystique . . . We have resurrected the idea of making our children our "life's work." And even more bizarrely, in many of our marriages we are reliving many of our patterns of sex roles and power that we thought would retire with our parents' generation. (Warner 2005: 143)

Multiple studies (Fox 2009; Rizzo, Schiffrin, and Liss 2013; Wall 2010) detail how subscribing to intensive mothering detrimentally affects women's mental health by causing guilt and stress. Women who said parenting was challenging had more depression and anxiety, and women who believed that moms are the essential parent reported less life satisfaction. "Media depictions of maternal bliss also mask the fact that, in reality, the incidence of depression is estimated to be three to five times higher in mothers than in other

populations" (Kinnick 2009: 5). Motherhood, and "the morality play version of modern motherhood that we see performed – and debated and discussed and dissected and critiqued – all around us every day" is literally making us sick (Warner 2005: 143).

The rising tide of expectations just keeps getting worse. In the early 2000s, Douglas and Michaels (2004: 7) explained that:

> [t]here have been, since the early 1980s, several overlapping media frameworks that have fueled the new momism. First, the media warned mothers about the external threats to their kids from abductors and the like. Then the "family values" crowd made it clear that supporting the family was not part of the government's responsibility. By the late 1980s, stories about welfare and crack mothers emphasized the internal threats to children from mothers themselves. And finally, the media brouhaha over the "Mommy Track" reaffirmed that businesses could not or would not budge much to accommodate the care of children. Together, and over time, these frameworks produced a prevailing common sense that only you, the individual mother, are responsible for your child's welfare: The buck stops with you, period, and you'd better be a superstar. (Douglas and Michaels 2004: 7)

By the 2000s, the spread of social media made one's mothering even more visible to others and invited more blame, sometimes from thousands of strangers. That modern motherhood is anxiety provoking is understandable. Of course, failing in public not only brings shaming; it can lead to being turned in. Even when the fault lies in institutions, such as the educational or healthcare system, the mother is usually blamed. Chapter 5 details the case of Tabitha Walrond. She was found guilty of negligent homicide after her breastfed baby starved to death, despite the fact that she tried to take her son to the doctor twice and was turned away for lack of insurance. Despite learning that Ms. Walrond had never been warned that her breast-reduction surgery would diminish her milk supply, the judge said "The mother is the bottom line."

In recent work, communications and gender, women's studies, and sexuality professor Natalie Fixmer-Oraiz (2019: 23) argues that, post 9/11, "homeland security culture" reanimated outdated gender norms. Heroic men took center stage, while all but grieving women were relegated aside. The message was that independent career women should go home and make babies, and then mother them by "stockpiling food and obsessing over their children's safety." The

reeling nation wanted traditional mothers. In his book, *Paranoid Parenting*, Furedi (2002) encourages parents to ignore much of the advice they are given. He argues vehemently that children today are not less safe or more vulnerable to kidnappers than they were fifty or sixty years ago, and that we are not only making ourselves anxious but limiting our children's development and independence by acting as if this were true. Lythcott-Haims (2015) asks mothers and fathers to consider what we want to be as parents – fearful, controlling people who won't let our children grow up?

Obviously, mothers can't be superstars, superheroes, or perfect, despite all the talk of superwomen. And trying to be those is all the more tiring and frustrating, given the lack of support. Child care has been scarce and underfunded, leaving too many working moms trying to do it all.

> If you don't obsessively campaign to get your child into the ideal preschool, there is no adequate daycare in your area; if your toddler doesn't go to baby music class and pre-pre-Olympic tumbling and Mommy & Me, you will go insane because you are home all the time and your husband works until 8:30 at night . . . If you don't read every baby book cover to cover, scour the Internet for information, obsess on food labels, and put a *cordon sanitaire* around your child, you will wallow in ignorance and potentially allow your child to come to harm, since your pediatrician doesn't take phone calls and won't waste your ten minutes of appointment time on answering questions. Because you have no family nearby . . . because the responsibility for absolutely *everything* is resting on your shoulders, and this responsibility is so overwhelming that you have to shut the awareness of it down . . . It starts to seem something like a necessary way of life. (Warner 2005: 43)

As if they aren't already struggling and feeling badly enough, mothers are constantly guilt-tripped, especially by conservative pundits but also by other mothers. Media and cultural messages keep setting higher and higher standards for modern mothers. The internet has ratcheted everything up because of the vehemence of conflicting advice and the public performance of parenting online. "Because [the virtual] world is interactive, mothers (and fathers) can support and/ or blame each other for their failures and reflect on them publicly. It also increases the barrage of both advice and complaints" (Fass 2016: 226). Moms want to show others that they are doing a good job of parenting, but there are other reasons that it is so competitive:

"Turn-of-the-millennium parenthood is all about performance. Our performance and our kids' performance. And there's a reason for that. We are living in an age of incredible competition and insecurity – financial insecurity, job insecurity, *life* insecurity, general – that it often feels as if you have to run twice as fast just to stay *relatively securely* in place" (Warner 2005: 197). No wonder moms exhibit such high levels of anxiety and distress.

A big chunk of the puzzle is the slipping middle class. Fewer and fewer people believe that they can do as well or better than their parents, and they are probably right. Income inequality and rising housing, health care, educational, and childcare costs in the last few decades have made people, understandably, feel insecure.

> [T]hat frightened feeling is at the parental heart of this academic arms race. A New Yorker explained the panic as he sees it. "We live in a time where we feel scarcity. We're no longer living the American dream. If *your* kid gets that job or that college spot, it's not there for *my* kid. In that environment parents will go to any lengths to make sure their kid can get into that Ivy League School." (Lythcott-Haims 2015: 68)

So when mom does all the chores and lets Junior practice the violin, if Junior doesn't get first chair, she may call the orchestra director and complain on Junior's behalf. After all, Junior has worked so hard, and not getting first chair might be emotionally devastating as well as affect Junior's chances of getting into Harvard. Clearly, she's not thinking about the other children in Junior's school who play violin. Maybe they practice as hard or even harder. Maybe, as well as practicing a lot, they are musically gifted. Maybe they want to go to Harvard, too. Or maybe she is, but she's hoping their parents won't complain as vociferously as she does about their child not getting first chair. Recent admissions scandal in which elites, such as actors Felicity Huffman and Lori Loughlin, people whose children already have opportunities and an economic safety net, went to jail for falsifying information about their kids and paying large sums of money to get them into certain colleges show how far parents will take their efforts to advantage their own offspring. It is a sorry state of affairs indeed when even rich celebrities are stressed about their children's prospects.

In the past two decades, parents have not only become overly involved in getting their children admitted to college, they have also

started interfering in their employment as adults. They are increasingly sending out their children's résumés, making interview arrangements, negotiating salary and benefits, complaining to the company when their child is not hired, and, on occasion, even attending the interview (Lythcott-Haims 2015). With her experience as a dean at Stanford, Lythcott-Haims is understanding of these parents but tries to nudge them away from such behaviors. She argues that kids are not being taught to "adult" because parents keep doing everything for them instead of letting them try on their own and risk failing.

Some of these parents are the notorious helicopter parents. Foster Cline and Jim Fay coined the term "helicopter parent" in their 1990 book, and it had negative connotations from the beginning. It meant swooping in to fix any problem on behalf of the child. Now there is lawnmower parenting (or bulldozer or snowplow parenting), where parents intervene even earlier to make sure their children will not face any type of adversity in the first place. Despite the warnings of psychologists and educators, these parenting styles have become more and more pervasive, especially among well-educated parents. Undermining children's sense of autonomy and competence ultimately results in higher anxiety and depression and leads to extrinsic rather than intrinsic motivations for academic performance (Schiffrin and Liss 2017; Schiffrin et al. 2019; Segrin et al. 2013).

Even though helicopter and lawnmower parenting tends to come from a place of concern and wanting to help, it hurts both children and parents. "They are giving children, even older children, what they believe is autonomy without a real sense of responsibility. And they do not do this because they are bad parents, but because the circumstances have made their hovering and supervision seem necessary. This translates into children who are over-controlled and over-indulged at the same time, while mothers are run ragged" (Fass 2016: 240).

Fass appreciates Americans' flexible parenting style, explaining the country's history of raising children with independence, fluidity, and some amount of leniency mixed with discipline in order for them to be adaptable and pioneering (both literally and figuratively). Like other authors, including Lythcott-Haims, she argues strongly that where US parents have gone wrong is keeping their children in extended childhood and doing too much for them. Children need to be trusted and given responsibility to become independent, responsible, successful adults.

Of course, children need guidance and protection, but today's middle-class parents may be over-doing both. In fact, Americans today may need a vision that is both larger, so that it embraces all the nation's children, and full of a sturdier confidence in our own progeny. Otherwise, we may provide a narrow success that stymies our children's growth while ignoring the degree to which our children's future depends on the common good of all. (Fass 2016: 272)

Allowing children more age-appropriate responsibility and independence is good for both kids and mothers but, as we will see in the chapter on "neglectful" moms, giving these opportunities to kids is easier said than done in the modern context ready to cuff the wrists of mothers trying to help their children grow up. Meanwhile, lots of moms just keep trying to do it all, trying to be supermom.

Images of modern mothers

Despite the difficulty of this role, people take great pride in their identity as moms and, increasingly, this self-categorization is becoming more and more specific. "Soccer Mom, Organic Mom, Helicopter Mom, Warrior Mom, Cool Mom, Pinterest Mom, Supermom, and the list goes on. On social media and the blogosphere, there are endless internet mom categories from 'Coupon Mom' to 'Hot Mess Mom'" (Napierski-Prancl 2019: 20). The problems with these labels are twofold. First, labels can become self-fulfilling prophecies as they become identities, either chosen or imposed. Second, they create artificial divisions between moms from different categories. In the so-called "mommy wars," you are damned if you do and damned if you don't. If you work, you had children only to let other people raise them, and if you don't work, you are lazy and unproductive, even wasting your education if you have a college or advanced degree. But people, including mothers themselves, judge one another on more than deciding whether or not to go back to work. Regular or cloth diapers? Bottle-feeding or breastfeeding, and, if breastfeeding, for how long? Tribalism in parenting is about parents seeking identity and belonging with a group that differentiates itself from the parenting practices of others, and this trumps the needs of the children, even though parents claim it is all for the children. "[T]here is a frailty and sometimes hostility in real or imagined encounters

between parents, where the parenting behaviour of one can either reinforce or threaten the identity of another" (Macvarish 2010: 3.1). These are the sanctimommies that Tuteur upbraids and the mompetitions that Keith makes fun of. Napierski-Prancl (2019) talks about how divisions among women are detrimental; they are contrived to divide and disempower women. She critically underscores that moms are so angry and tired that they take it out on one another. Infighting only prevents women from working effectively to solve real problems, such as the slipping standard of living. She urges us not to judge one another.

Author Kim Brooks talks about her foray into parenthood: "I ate it up. The competitiveness, the performance, the fear" (Brooks 2018: 46). However, after being charged with contributing to the delinquency of a minor for briefly leaving her four-year-old in the car while she bought one item, Brooks changed her views. She realized that instead of helping moms, we actually have it in for them.

> Middle- and upper-middle-class women can be excoriated for failing to appreciate the support that so many others lack. Working-class and poor mothers can be pilloried for their ignorance and inattentiveness and inability to provide the kind of care middle-class children receive. And those who criticize them can rest assured it's not women they hate, or even mothers; it's just *that* kind of mother, the one who, because of affluence or poverty, education or ignorance, ambition or unemployment, allows her own needs to compromise (or appear to compromise) the needs of her child. We hate poor, lazy mothers. We hate rich, selfish mothers. We hate mothers who have no choice but to work, but also mothers who don't need to work and want to do so. You don't have to look very hard to see the common denominator. (Brooks 2018: 159)

Lenz (2020) agrees. She points out that even society's ideal moms get criticized, and that the consequences are so much worse for people who don't fit the white, middle-class, cisgender, heterosexual, able-bodied, biological mom image of the right kind of mother.

> Corporations will penalize you for taking time off. Childcare will be unaffordable. If you're a white woman with a white smile, ruffly blouse, impossibly lean white jeans, a sign that reads "Live, Laugh, Love" on your wall, and perfect blonde curls cascading down your back . . . strangers will smile at you and tell you you're blessed. But people will

also tell you to use cloth diapers. Or disposable. Whichever one you are using is wrong. Whatever you do is wrong. You are exactly what society has told you to be, and yet, you are still wrong.

And if you don't look like that woman – if you are black, gay, trans, Asian, brown, Muslim, disabled, divorced, if you are a step-parent or you adopted, if you ever had an abortion, if you are on food stamps . . . your body has now become a war zone. It will be legislated, stared at, debated in public. People will ask who the father is. People will ask how you manage, how you cope. Maybe they'll tell you that you are a "hero," . . . Or worse, they will say you aren't a real mother. You'll be excluded from the narrative . . . (Lenz 2020: 2–3)

Motherhood, as we have seen, is not lauded equally for all groups (O'Reilly 2021b). Dow (2019) writes that the experience of motherhood does not transcend class and race lines, and Lenz is correct that mothers who are disabled or who are not cisgender or heterosexual face additional challenges. "Intensive mothering feeds acute and exacting demands, but it also functions powerfully to codify the trope of the 'bad' mother as its constitutive outside. Put another way, ideologies of intensive mothering sculpt a different world for those pregnant and parenting outside of wealth, whiteness, US citizenship, or heteronuclear family formation" (Fixmer-Oraiz 2019: 13). In the United States, with its poor social safety net, women from lower socioeconomic brackets are seen as doing something wrong simply by becoming mothers, a basic human right. They "fail" before they even begin:

[M]otherhood is a class privilege, properly reserved only for women with enough money to give their children "all the advantages," a deeply undemocratic idea. Here we can see how the nobility of white, middle-class maternity depends on the definition of others as unfit, degraded, and illegitimate. In turn, poor mothers have been branded illegitimate because they do not have the resources that middle-class mothers do. (Ross and Solinger 2017: 4)

What seem like archaic notions are alive and well in the modern period. "[R]acialized and gendered double standard[s] . . . continue to inform the treatment and expectations of women from different racial and economic groups in the United States, with African-American women cast as promiscuous, unworthy, and bad mothers, while white women are considered worthy, morally superior, and

'good' mothers" (Dow 2019: 126). Sadly, research shows that black women are less happy about their pregnancies, even intended ones, than white women (Hartnett and Brantley 2020). A combination of factors, many related to structural racism, accounts for this. Black pregnant women face more economic problems, less support from male partners, and fears, particularly among those mothers already parenting sons, that their children will face danger and criminalization (Hartnett and Brantley 2020).

In her groundbreaking book on black feminism, sociologist Patricia Hill Collins (2000 [1990]) exposed the controlling images of black women: mammy, jezebel, welfare mother, matriarch, and the later addition, professional black woman. In these images, black women are never acceptable. Their sexuality is always wrong, too little or too much, and they all fail at motherhood. The matriarch, for example, is too strong and drives her man away, single-handedly ruining the black family and, by extension, the whole community. Instead of being lauded, the professional black woman is taken to task for being too educated to find a suitable mate and therefore remaining overly devoted to her career and childless. Despite the weight of these cultural images, black women continue to try to live their own identities and give their children a healthy sense of self.

In sociologist Dawn Marie Dow's (2019) study of middle-class black mothers, *Mothering While Black*, her interviewees felt many of the same pressures as white moms, including the profound weariness of combining work and family, worrying about their children's educations and futures, and feeling consternation over problems such as climate change, but in addition to all this, unlike the majority of white moms, they had to help their children navigate a racially fraught world. The black women interviewed by Dow were concerned about their daughters' self-image and their sons being subjected to violence, given stereotypes of black females and males, the media, and past and current events. All middle-class black moms took pains to ensure that their children were not surrounded only by white kids at school and in extracurricular activities. They paid attention to the racial cognizance of their children's caregivers and teachers, they banded together to sign their children up for activities such as dance lessons or sports at the same time so there would be more than one black child in the room, and they tried to balance enrolling their kids in schools with a high record of achievement with making sure their children were not the only kids of color. "[P]arents'

endeavors often required them to engage in hours of invisible labor and then make compromises in each category" (Dow 2019: 31).

Trying to keep their children safe physically and healthy emotionally is even more challenging for parents of color when options are limited by financial constraints. Women's paid labor is a way to try to help children move up the ladder in the United States in spite of race or foreign parentage. In Garcia's study of working-class Latina mothers and daughters, employment outside the home "was understood as integral to what it means to be a 'good mother'" (Garcia 2015: 414). Clearly, mothers adapt to do the best they can for their children. Good parenting is socially constructed and varies from group to group and place to place.

Similarly, the age at which it is appropriate to become a mom varies cross-culturally and has varied within western nations over the course of the last hundred years. Macvarish and Billings (2010) explain that while, in the past, the fears about teenage mothers were linked to "immoral" unwed sexuality and the detrimental effect on society as a whole, contemporary discourse focuses on harms to the mother herself and to the children of mothers who are deemed incapable simply because of their age. This is in part due to our increasingly prolonged stage of adolescence. After all, older teens having babies in the 1940s and 1950s were not seen as aberrant as long as they were married. Like Luker (1996) and others, Macvarish and Billings argue that outcomes are more about socioeconomic status *prior* to pregnancy than the mother's age. Some innovative research, including that in which one sister had a baby as a teen and the other did not, and a comparison of 17-year-olds who miscarried and those who had their babies, found that the subjects in either condition were in similar economic positions years later (Hoffman 1998). While not without some limitations, these studies should give pause to blanket critiques of teen pregnancy. Based on interviews conducted with pregnant and parenting teens, Macvarish and Billings note that policies point to risks and dysfunction and ignore the satisfaction, moving life forward educationally and job-wise, and meaning that come with choosing to parent at a young age. Mothers in their late teens face fewer chromosome abnormalities and miscarriages than older women. Teen mothers also get more support from their families, something that might diminish with older childbearing when their own mothers age and are starting to suffer from health problems, and holding off on becoming a mom for someone from a

poor background will not necessarily guarantee her more economic success in the future (Geronimus 1997).

Like women of color and teen moms, women with disabilities struggle against stereotypes that seek to deny them the right to bear and parent wanted children. A common refrain is that others view them as asexual; they frequently find themselves pressured by society not to reproduce. Even doctors fail to see them as sexual and sexually attractive people capable of bearing children and sometimes fail to provide them with information or contraception. Women and girls with intellectual disabilities and those in institutions are at particular risk for sexual abuse and rape. When women living with disabilities choose pregnancy, they are stigmatized for their choice as well as their disability. "'While a nondisabled woman's pregnancy is considered a miracle, a disabled woman's pregnancy is considered a crime against society' [Waxman 1993: 6])" (Kallianes and Rubenfeld 2015: 226). The crime is supposedly both against society and the child. "There are two misrepresentations at play here: that a child will inherit a disability and that a disabled woman cannot possibly be a 'good' mother" (Kallianes and Rubenfeld 2015: 224). While many disabilities are not heritable, some are. Mothers with these congenital problems are castigated for being selfish and willing to harm their offspring (Kallianes and Rubenfeld 2015). Because women with disabilities are seen as unfit parents, they risk losing their children, especially after a divorce or the death of their partner.

Another group who has had to fight cultural denigration is homosexual, bisexual, and non-gender-conforming parents. Because bisexual parents, lesbian moms, and gay dads were seen as sexual deviants for much of the twentieth century, they routinely lost custody of their children in divorce proceedings (Briggs 2017). This was somewhat mitigated for mothers, who were still seen as deviants, but at the same time viewed as the "natural" caregiver for young children. Fears that lesbian moms could not raise boys ignored the fact that plenty of single heterosexual moms were raising boys successfully on their own. As time went on, more and more kids were intentionally born or adopted into queer families rather than experiencing the divorce and subsequent coming out of their parents. Yet, until a decade into the twenty-first century, multiple states banned adoption by gay parents, and religious organizations that help with adoptions can still legally discriminate against gays and lesbians. This prejudice is based on religious and social beliefs, not actual data.

By the late 1900s, there were studies that addressed the concern of whether children raised by gay and lesbian parents would be damaged psychologically. A meta-review of previous research and a recent study from the Netherlands show this is not the case (Mazrekaj, Fischer, and Bos 2022; Stacey and Biblarz 2001). Children of gay dads or lesbian moms are also more likely to be accepting of children with other kinds of differences, such as having non-English-speaking parents or living with a disability. These kids also exhibit fewer gender stereotypes than their peers with opposite-sex parents (Stacey and Biblarz 2001).

Opposing transgender people's rights, both those of adults and gender-nonconforming children, is a preoccupation of the political right. Some politicians claim that parents allowing their child to express their chosen gender identity is child abuse, despite the fact that it is young people with gender dysphoria or who are non-binary and lack supportive parents who are at particularly high risk of suicide. Others accuse gender-fluid parents of harming their children by not making gender norms clear. A growing number of non-binary and trans men are birthing babies, and research is beginning to look at how these gestating people navigate conception and pregnancy (Riggs et al. 2021). Of course, how gestating trans men are treated in the press is another matter.

This is not surprising because we cannot even get our popular cultural images of cisgender women in childbirth right. In her article "Giving Birth Like a Girl," Karin Martin (2003) elucidates that while the media portray women as screaming and swearing during childbirth, most women are quiet, polite, and more concerned about the feelings of those around them, including hospital staff, than their own during birth. This over-socialization of women, and their silent suffering, is prevalent in many domains, especially when it comes to motherhood.

Adrienne Rich (1976) writes of the freedom she felt being a "bad mom" when allowing her children to stay up late for a movie while on vacation. Despite the temporary joy of sharing with her sons a moment of being "outlaws from the institution of motherhood," Rich quickly conformed, reinscribing herself into the dictates of a "good mother" at the end of their vacation, notwithstanding her "resentment of the archetype" (Rich 1976: 195). As *Failing Moms* shows, mothers, and those who love and support them, must make noise rather than protect the interests of those who call the shots. For

there to be protest, however, there must first be recognition: "We do not think of the power stolen from us and the power withheld from us in the name of the institution of motherhood" (Rich 1976: 275). We need to question, as Rich urges, whether

> the laws which determine how we got to these places, the penalties imposed on those of us who have tried to live our lives according to a different plan, the art which depicts us in an unnatural serenity or resignation, the medical establishment which has robbed so many women of the act of giving birth, the experts – almost all male – who have told us how, as mothers, we should think and behave . . . (Rich 1976: 274–5)

are to the benefit of moms, their families, and their children. To embrace the freedom from the patriarchal institution of good motherhood, we must embrace the bad moms around us and in us.

2
Preconception Discrimination

The differences in the standards to which mothers are held compared to fathers begin long before a new baby is birthed into the world. Once the sex act is over, men's contribution is viewed as finished, while women are seen as "nurturing" the growing pregnancy. Given that women gestate visibly, they are held accountable for pregnancy and its outcome in ways that fathers are not. They are also expected to prove that they are fit mothers by their actions during the gestation period. "Promoting moral motherhood and maternal love through social and health practices is not new . . . Pregnancy is, for instance, an obvious visual depiction of a fertile body, a body that tempts monitoring by society and experts" (Waggoner 2017: 165). As bearers of the next generation, the state claims vested interest in women's bodies.

This burden on women begins even before children are conceived, and it affects even those who do not wish to become parents. Indeed, all women, from their teenage years through menopause, are seen as possibly pregnant at all times. Girls and women have to jump through additional hoops when they want to access certain treatments, like Accutane for acne, and, increasingly, female patients are outright denied specific medications for chronic illnesses such as methotrexate for Crohn's disease or lupus, because the fetus, whether en route or nonexistent, takes center stage. Women's health pays the price, as do their rights to bodily autonomy and medical decision making, even for the many women who will never be pregnant or who have finished childbearing. As Rich (1976: 13) so astutely explained, women are alienated from their own bodies

because the social institution of motherhood imprisons women within them.

For those who do wish to become pregnant, "[t]he future fetus is now an object of consumer culture. The pre-pregnancy care model pronounces that to engage in the healthiest pregnancy possible, women should plan well ahead, have an identifiable reproductive life plan, and buy advice books and products that will position them in the 'responsible' category" (Waggoner 2017: 147). The public, the government, many parents, and even some physicians, however, fail to understand or routinely forget that much of the outcome of pregnancy, including miscarriage and birth anomalies, is determined by the father's behavior, age, and genes.

In much of recent history in the United States, fathering was primarily accomplished through providing financial support to dependents. A father could be more active and present in his children's lives than being just a paycheck, but he could not make that his primary occupation and forgo earning a living without opprobrium. Throughout much of the twentieth century, providing financial support was necessary *and* sufficient. And still today, no one looks down on men who do not quit their jobs and stay home for months or years after they have or adopt a child. "The idea that allotting time to paid employment outside the home does not mean a lack of devotion to family is accepted without controversy when the focus is on men instead of women" (Dow 2019: 191). This notion of fatherhood, men as providers, is reified at the highest levels internationally; writing about United Nations' International Labor Organization (ILO) policies, Whitworth recounts that:

> Men are workers first and fathers only secondarily, while female workers are protected when they find themselves in non-traditional employment or when they are having babies. Women are ignored and not provided protection when they are no longer easily situated within the role as real or potential mother. It is in these ways that the particular ideas associated with women's and men's role in reproduction, along with the actual conditions of those roles, are reflected and legitimized in ILO policies. (Whitworth 1994: 397)

On the other hand, women are classified as mothers, even when they are not yet. International and government entities routinely reduce women to their reproductive capacities.

From past monarchies blaming queens for not bearing royal sons to the modern tendency to attribute gender characteristics to gametes, everyday understandings of reproduction are deeply flawed and deeply gendered. As Cynthia Daniels (2006: 87) writes in her book *Exposing Men: The Science and the Politics of Male Reproduction*, "the presumption . . . that women are more central to human reproduction than men is reflected in the disproportionate social value, and human attribution, given to egg and sperm." Men who "donate" sperm are seen as doing a job. Women, on the other hand, are encouraged to think of their egg donations, despite vastly larger paid compensation, as gifts, reinscribing their actions that could be seen as profoundly anti-maternal as kind behavior that connects those in need with help (Almeling 2011). This mitigates the deviation from gender norms that construct females as profoundly committed to their offspring and their role as mothers and makes this lucrative and medically valued endeavor seem less threatening. Threat mitigation is not necessary for men who donate sperm as they are not viewed as attached to their sperm or their future children.

Egg versus sperm donors

Gametes are cells that enable sexual reproduction. An egg is a gamete. So is a sperm. People regularly gender gametes in the way they think about them. They view eggs as women, or baby girls, and sperm as men, or baby boys. In fact, men's testes are sometimes referred to as "boys" and by extension the sperm produced by them is seen as male. But half of those sperm, if involved in conception, would produce female fetuses. Sperm do not exhibit male characteristics and eggs female ones, yet people think of them as doing so. In her book, *Sperm Counts*, sociologist Lisa Jean Moore (2007: 16) points out that this is how we introduce it to kids in children's books: "[S]perm is 'taught' to young children by representing them as heroically masculine characters. In children's books, . . . [i]llustrations use facial characteristics or clothing to make the sperm look more human and especially more father-like . . . Children are encouraged to see sperm as an extension of men: as capable, competitive, cooperative, fast, and active."

Even scientists who know that gametes are not gendered fall into the trap of imbuing sex cells with character traits and sperm in particular

with agentic goals. The classic article by feminist anthropologist Emily Martin (1991), "The Egg and the Sperm: How Science Has Constructed a Romance Based on Stereotypical Male–Female Roles," details how biology textbooks portray the egg as waiting passively to be saved by the brave, driving sperm who charges forward through darkness and peril to rescue her from certain death that would occur if he did not come along. Yet the sperm will likewise die if it does not fertilize an egg. The sperm is also much smaller than the egg, and therefore could easily be seen as less strong and more fragile, and yet it is the egg which is portrayed as weak and vulnerable. Some sperm never even go the right way or don't swim at all because they are misshapen or lack a tail.

The overall narrative has changed over time from something akin to a rape to a romantic rescue to, more recently, a partnership – in part because of discoveries about the chemical interaction between the egg and a particular sperm that make the egg seem less "passive," and in part because of a cultural zeitgeist that favors equality in adult male and female dating relationships. Of course, the egg and the sperm do not date. Nor does one rape the other. Nor is one a princess in a tower and the other a brave knight. But people's language to describe biological processes is colored by their own culture and historical time period. Pure objectivity is an unattainable goal, even for scientific researchers. Well acquainted with Martin's essay, I was still shocked to hear the manner in which during a talk a cutting-edge reproductive endocrinologist described the intracytoplasmic sperm injection (ICSI) technique in which the nucleus of a sperm is directly injected into an egg's cytoplasm, rather than putting both whole gametes in a Petri dish to accomplish *in vitro* fertilization. He described this medical technique as "invading the temple."

Even people undergoing infertility treatment, who often know a great deal more about how reproduction works than most people, get confused about gametes and think of them as gendered. This is fostered by fertility clinics that market donor eggs and donor sperm as different entities, even though they are the same in terms of their reproductive contributions. While many sperm banks list extensive (and questionably relevant) information about donors, such as their hobbies, this information is standard for egg donors. In addition, egg donors are routinely asked to provide a photo, information that some sperm donors are not obliged to provide.

If a donor's profile is deemed unacceptable by staff, or if she sends in unattractive pictures, agencies will delete her from the database. [An egg donation clinic] office manager explains, 'We have to provide what our client wants, and that's a specific type of donor. Even though [the recipients] may not be the most beautiful people on the face of the earth, they want the best. So that's what we have to provide to them.' In contrast, sperm recipients are not allowed to see photographs of donors, and thus men's physical appearance is not held to the same high standard as is women's. (Almeling 2009: 50–1)

Of course, while we expect that physical traits are passed to offspring (despite some understanding of recessive traits and that not all siblings with the same parents have the same skin shade or hair color), it is quite questionable how much of personality is inheritable. Other factors, such as hobbies and experiences, may be much more about social class status and opportunities growing up or current financial circumstances than about personality. However, increasingly even sperm banks ask donors to fill out extensive forms about their interests. One doctor, whom sociologist Rene Almeling interviewed for her book, *Sex Cells: The Medical Market for Eggs and Sperm*, used to run a now defunct sperm donor clinic for a university. He stated that:

[t]he bells and whistles are for the patient, not for me. What do I care if the guy is a violinist or not? It's a marketing tool. It's got nothing to do with the medicine. It has nothing to do with the quality of the sperm. . . . [In contrast, the commercial program] has much more information, but it's commercial, so they're selling a product. We were providing a medical service. (Almeling 2011: 34–5)

Yet prospective recipients of donated genetic material desire this information. Sperm recipients pay extra to read the long form about personality and future goals after initially reviewing a short template that mainly includes phenotypical information, ethnicity, and medical background (Mamo 2005). When men do list more extensive details, they are far more likely to mention "masculine" hobbies such as "male" sports, carpentry, and fishing than "feminine" hobbies such as cooking, or more germane, caring for children (Daniels 2006: 97). Males who are too short, below 5'7" or 5'8", or sometimes extremely tall are excluded.

The fact that redheaded egg donors are acceptable but that consumers have less demand for sperm from redheaded male donors

(Bleakley 2011) demonstrates the point that people equate eggs with women and sperm with men, or eggs with girls and sperm with boys. A redheaded egg donor can lead to a redheaded male child. A tall sperm donor can lead to a daughter who is taller than most girls. Egg donors are less likely to be excluded based on height, and yet a short egg donor can result in a boy who grows up to be short. The identification of gametes with particular gendered traits doesn't make sense, given that parents rarely know which sex child they will have (only with further fertility interventions). And getting the information on only one gamete, and hence only 50% of the genetic material, doesn't ensure that parents can control their offspring's traits.

Why so much greater interest in egg donors than sperm donors when they serve exactly the same function? Egg donors end up standing in for mothers, and just as mothers carry more of the burden of reproduction, their replacements are more valued and more scrutinized. In essence, the industry reproduces what is seen as the natural order of reproduction: a father can make a quick biological contribution and then walk away, but not the mother. As Daniels (2006: 111) argues, in society there is a pervasive "idea that men are distant from the children they father." A sperm donor's (or other biological father's) job can be accomplished in 20 minutes. But just as the mother is on the hook, a much higher level of commitment is expected from, or assumed about, the egg donor. Certainly, due to its invasive process, the procedure for donating eggs is more involved and medically risky than that of donating sperm, due both to stimulation with hormones and the surgical retrieval of eggs. Yet this does not explain why egg donors undergo psychological screening.

From the beginning, and unlike sperm donors, egg donors were assessed psychologically, in part to determine their motivations for donating (Almeling 2011). Tellingly, the American Society for Reproductive Medicine (ASRM) put out guidelines that egg, but not sperm, donors should be screened for "emotional stability, history of personality disorders, current interpersonal relationships, traumatic reproductive histories, current life stressors and coping skills, legal history, psychopathology, history of sexual abuse, marital instability, and evidence of financial or emotional coercion" (Daniels 2006: 99). Daniels argues that the presumption is that men can create babies they will never know with less risk of trauma than women. Therefore, she needs psychological evaluation by the fertility clinic before she is allowed to donate.

These gendered expectations correspond to traditional norms of women as selfless caregivers and men as emotionally distant bread-winners, a link between individual reproductive cells and cultural norms of motherhood and fatherhood that is made especially clear in the psychological evaluations which are required of egg donors but not sperm donors. In addition to being evaluated for psychological stability, women are asked how they feel about "having their genetics out there." Sperm banks do not require that men consider this question with a mental health professional, which suggests that women are perceived as more closely connected to their eggs than men are to their sperm. (Almeling 2011: 59)

The irony is that sperm donors are more likely to make a connection with fatherhood; egg donors detach the meaning of the egg from progeny. When Almeling asked donors about their offspring, sperm donors said they were fathers, but egg donors distanced themselves. They said they gave an egg, but the woman who carried and/or raised the child was the mother. This reinforces the idea that men's contribution is through sex/biology, whereas women see motherhood as a social bond and the work of nurturing.

One corollary to the view that fathers are creators and mothers are nurturers is that men who do not nurture are still fathers, yet women who do not nurture are censured as bad mothers. Emotionally distant fathers, absent fathers, and other "deadbeat dads" may not be held in the highest regard, but they are still fathers. In contrast . . . [t]hose women who do not nurture their children, and particularly those who are distant or absent, violate the cultural expectation of maternal instinct and are considered nothing less than unnatural. (Almeling 2011: 162–3)

Perhaps in part to neutralize this "unnaturalness," women are supposed to be motivated by altruism rather than money, even though they earn far more than sperm donors. And women, compared to men who are donors, are in fact more likely to view their transaction as a gift. Once the fee negotiation is over, the clinic encourages this view. Egg recipients are coached to write their donor a thank-you note, and some also buy her a gift to express their appreciation.

In stark contrast, sperm banks do not encourage such displays of gratitude. Men are far more likely to be perceived as employees, clocking in at the sperm bank at least once a week to produce a "high

quality" sample . . . These gendered expectations of egg and sperm donors mirror traditional norms of selfless motherhood and distant fatherhood. Though women are expected to reproduce well-worn patterns of "naturally" caring, helpful femininity, guiltily hiding any interest they might have in the promise of thousands of dollars, this same "emotional labor" is not required of men donating sperm. (Almeling 2009: 56)

When Almeling questioned why altruism was an important component of egg donation, given that it is a biological process and a healthy donor could conceivably be enough, a doctor told her it would ensure that the woman was being honest about her medical history and, therefore, prevent her from lying in order to obtain compensation: "In providing a rationale for the expectation that women have altruistic motivations, this physician uses altruism as a proxy for honesty about medical information, which, as he notes, there is no way of verifying. This is also true of sperm donors' medical history, but there is no such expectation that men be altruistically motivated" (Almeling 2011: 37–8).

Male donors are encouraged and do usually see their donations as work. Almeling (2011: 69) points out that the way clinics distribute compensation reifies this because "[m]en are paid every two weeks, mimicking the schedule and format of a paycheck that one would receive as an employee in a workplace." Men sign a contract that they will donate once a week for a year, and the length of this commitment, compared to a female donor's two- or three-month commitment, may also make it feel like regular employment. If men do not produce enough sperm in a given session, they are not paid at all, unlike women who receive the negotiated compensation regardless of how many eggs are retrieved. So pay for men is more closely tied to production. Egg donors' pay varies, given her individual characteristics such as her ethnicity and whether one of her previous donations has produced a pregnancy. This individualized compensation may further her belief that her donation is a specialized gift. Women who try to donate more than a handful of times are looked down upon, even though their contributions will produce far fewer offspring than sperm donors donating once a week for a year. While it is true that, unlike male donors, they are exposing themselves to repeated hormone stimulation, it is also because their motivations are questioned, unlike men who are "allowed" to donate for the money.

It is not just that individual women have fewer eggs than individual men have sperm, or that eggs are more difficult to extract, that results in both high prices and constant gift-talk in egg donation, but the close connection between women's reproductive bodies and cultural norms of caring motherhood. In contrast, men are much more difficult to recruit, but are paid low, standardized prices because sperm donation is seen as more job than gift. As a result, both eggs and egg donors are more highly valued than sperm and sperm donors in this medical marketplace, where it is not just reproductive material, but visions of middle-class, American femininity and masculinity, and more to the point, motherhood and fatherhood, that is marketed and purchased. (Almeling 2011: 83)

Men's neglected role in reproduction

The value of women's contribution to reproduction is a double-edged sword, as is the neglect of men's. One-fourth to one-third of infertility is related to male causes. This is the same as women; the rest is a combination of the two or unexplained (Swan and Colino 2021). Despite this, "women overwhelmingly bear the blame of infertility and the brunt of more invasive treatments" (Moore 2007: 25). Women who are pregnant, and even simply those of childbearing age, are surveilled and policed. Mothers are deemed bad if something goes wrong with their pregnancy or their baby is born with a problem, but fathers are "blameless" (Campo-Engelstein et al. 2016). Meanwhile, scientists and medical practitioners continue to ignore men's contributions to reproduction, and "[s]ocial policy as well often designates women as the sole bearers of fetal safety" (Waggoner 2017: 142). As legal scholar Michele Goodwin underscores, "[w]hen the state uniquely and exclusively burdens women in the advancement of fetal health, but not men, it does so under the flawed theory that women alone determine fetal health" (Goodwin 2020: 179). While this means that, unlike women, men are rarely told to ask for a job reassignment or not to drink when they are trying to conceive, it also means that men's reproductive health is largely ignored. This is bad for men, their female partners, and their progeny.

Fathers' drug habits, smoking, alcoholism, reckless driving, and psychological and physical treatment of pregnant wives are part of the fetus's "environment," too – sometimes indirectly, through their effect

on the mother's well-being, but sometimes directly as well (through the effects of secondhand smoke and crack dust in the air, physical abuse, and alcohol's deleterious effect on the quality of sperm, to give a few examples). But fathers are nonetheless off the hook. . . . (Bordo 1993: 83)

In terms of these deleterious effects on sperm, "[t]here are no medical specialties devoted solely to men's reproductive health, the researchers who study it are few and far between, the media rarely run stories, and health officials hardly mention it" (Almeling 2020: 119). This is perplexing because "[e]vidence also appears to indicate that fathers are more vulnerable to toxic harm than mothers in the sense that they are more likely to pass on to the developing fetus damage from such exposures, even if the exposures occur long before conception" (Daniels 2006: 44). And yet men are viewed as distant from the pregnancy they helped to create, even though their health contribution to the developing embryo/fetus is real and consequential, affecting whether the pregnancy progresses or miscarries, as well as the health of any resulting baby.

In Cynthia Daniels's (2006) trailblazing book on men and reproduction, she argues that men who ejaculate are *portrayed* as virile reproducers. Yet ejaculation does not equal healthy sperm or even sperm capable of conception. Men are viewed as less likely to experience reproductive harm than women, and, typically, it is women who are blamed for birth defects. Overall, men are seen as occupying a secondary role in producing new human beings. Almeling and Waggoner (2013) point out that it is a man's sperm, not a woman's egg, that is typically designated the key ingredient for a pregnancy, as in the phrase "he got her pregnant," but "[w]hile men often receive credit for establishing a pregnancy, they are not assigned much responsibility for fetal health . . . As a result . . . researchers have to work to create a conceptual link between men's behavior around the time of conception and pregnancy outcomes" (Almeling and Waggoner 2013: 829).

The assumed reproductive distance from the health of the fetuses and babies they create has limited researchers' interest in men's role in reproductive outcomes. While men's reproductive health and contributions were misunderstood and downplayed until the late twentieth century, in the last couple of decades research has increasingly shown the detrimental effects of "bad sperm." The study of paternal effects

on pregnancy and offspring is only recently joining the few previously familiar areas of men's reproduction: pregnancy prevention, infertility, and sexual health, including sexually transmitted infections and erectile dysfunction. The best known link is to infertility.

> For example, some diseases lead to male infertility; these include cystic fibrosis, sickle cell anemia, and some sexually transmitted diseases. Environmental factors such as pesticides and herbicides (including estrogen-like chemicals), hydrocarbons (found in products like asphalt, crude oil, and roofing tar), heavy metals (used in some batteries, pigments, and plastics), and aromatic solvents (used in paint, varnish, stain, glue, and metal degreasers) have all been suspected of lowering sperm counts and damaging morphology. Furthermore, men and boys may lower their sperm count through tobacco exposure, whether chewing or smoking, and prenatal exposure to tobacco has been shown to lower sperm counts in male offspring. Excessive alcohol consumption, marijuana smoking, and obesity also affect sperm counts and sperm performance. Endurance bicycling has been shown to significantly alter sperm morphology. (Moore 2007: 25)

Men experiencing infertility are told to keep their laptops on their desks and to avoid relaxing in hot tubs in order to keep the temperature of the testes conducive for sperm production. Yet infertility is not the only consequence of abnormal sperm. Although it was initially thought that damaged sperm were incapable of successful egg fertilization, this turns out to be wrong (Daniels 2006). Fertilization by defective sperm can cause miscarriages, low birthweight infants, and anatomical anomalies and neurological/psychological effects in children. In addition to overheated testicles, scientists have been looking at drug use, both legal and illegal, alcohol consumption, smoking, exposure to various chemical compounds, and the age of fathers as affecting their offspring.

Alcohol, marijuana, cocaine, and anabolic steroids have all been found to impair sperm. When the DNA of sperm is damaged, pregnancy can still occur, but may result in miscarriage, birth defects, and childhood cancers. Much as for pregnant women, prescription drugs, and even over-the-counter supplements, are not necessarily safe for men who want to have children. Frey and colleagues advocate that:

> [t]he patient's past and current medication use, including prescription, nonprescription and herbal products, should be reviewed. A number of

medications can affect sperm count and quality, including alkylating agents, calcium channel blockers, cimetidine, colchicine, corticosteroids, cyclosporine, erythromycin, gentamicin, methadone, neomycin, nitro-furantoin, phenytoin, spironolactone, sulfasalazine, tetracycline, and thioridazine. Any medication use, including over-the-counter medications, should be guided by a risk-benefit calculus weighing benefits for men's health against known or potential risks to offspring. (Frey et al. 2008: 390–1)

While men are warned that smoking is noxious to their own health and are likely to hear that they should not smoke around their pregnant partners, they are not often made aware of the effects of their smoking prior to conception on their fetuses, children, and even grandchildren.

There is now enough evidence for scientists to state unequivocally that paternal cigarette smoking prior to conception poses a serious risk to children. It not only impedes male fertility; it also increases the risk of genetic damage in sperm. In particular, fathers who smoke are more likely to develop what are called "germ-line mutations," which are then passed not only to their own children but also to their descendants. There is also scientific consensus that men who smoke cigarettes before conception increase the chances their children will develop cancer . . . [particularly] childhood leukemia and hepatoblastoma. (Almeling 2020: 83)

The research that men's smoking affects their grandchildren matches older work conducted on rodents demonstrating the effects of smoking on multiple generations (Daniels 2006). Smoking marijuana is not necessarily safe either. For men who consume marijuana more than twice a week prior to conception, miscarriage odds double (Smith 2019). One lab technician at a sperm bank quoted by Almeling and Waggoner (2013: 829–30) reported, "I can tell if they've gone out and partied the night before. If they have increased alcohol consumption, or cigarettes are another big one, they create round cells, and it's like immature cells or white cells in their specimen. One of the doctors I spoke to in California said [she's] noticed [it] with marijuana smokers too."

It is not just social and medical behaviors such as smoking, drinking, and taking drugs that can alter the sperm DNA. Occupational risks are critical too. Male anesthesiologists, operating room technicians,

and dentists have children with lower average birthweights, if they manage to have them at all, as anesthesia also causes a higher miscarriage rate (Almeling 2020; Daniels 2006). Hydrocarbons, encountered at work by painters, mechanics, and miners, contribute to childhood cancers, as does exposure to carcinogens for laboratory scientists (Almeling 2020). Pesticides used in agricultural work are also dangerous.

> According to the National Institute for Occupational Safety and Health, male reproductive health can be negatively affected by the following workplace exposures: lead, dibromochloropropane, carbaryl, toluenediamine, dinitrotoluene, ethylene dibromide, plastic production (styrene and acetone), ethylene glycol monoethyl ether, welding, perchloroethylene, mercury vapor, heat, military radar, kepone (in large doses), bromine vapor (in large doses), radiation (in large doses), carbon disulfide, and 2, 4-dichlorophenoxy acetic acid. Additional substances have been identified as potential causes of male infertility, including chlordecone, beta-chloroprene, lead azide, lead II thiocyanate, manganese, manganese tetroxide, tetraethyl lead, and tetramethyl lead. Physical exposures like heat, sedentary work positions, and radiation have the potential to affect male fertility, though the evidence supporting a direct effect remains unclear. (Frey et al. 2008: 393)

Men seeking to conceive also need to think beyond work to recreational activities:

> Certain hobbies may expose the patient to reproductive hazards. Hobbies that involve refinishing furniture, repairing cars, painting, building models, or anything that requires the use of strippers, degreasers, or nonwater-based glues or paints may expose the patient to organic solvents. Hobbies that involve painting, pottery, making stained glass windows, or handling, shooting, or cleaning guns may expose the patient to lead or other heavy metals. (Frey et al. 2008: 391)

Basic items around the house can also cause problems: "An increasing number of environmental exposures, including phthlates (a type of plasticizer used in food-can linings and many household products), acrylamide (produced during frying, baking, and overcooking), and pesticides and dioxins, have also been shown to cause sperm DNA damage" (Frey et al. 2008: 393). Shampoos, creams, air fresheners, and numerous other products people use routinely may affect reproductive health, possibly for multiple generations (Swan and Colino

2021). While women who are trying to get pregnant or already expecting are more routinely on the lookout for information about what exposures to avoid, men are rarely aware of this information.

Another factor is age. Both men and women are having babies at older ages, but given that, unlike women, men do not stop producing gametes in midlife, men are increasingly having babies in their forties and fifties (Cassella 2019). Older sperm has more DNA fragmentation, and the older the sperm, the more *de novo* mutations. Children of older dads are more likely to be small at birth, experience newborn seizures, and undergo admission to the neonatal intensive care unit (Cassella 2019). Their female partners are more likely to give birth prematurely and to suffer from gestational diabetes and preeclampsia. There are positive correlations between father's age and congenital heart disease and other birth defects (Cassella 2019). Childhood cancers, including leukemia, retinoblastoma, and early-onset breast cancer are more common among children born to older dads. Chromosomal aneuploidies, including Down syndrome – previously thought to be linked only to older mothers – and several mutations linked to growth problems of various parts of the body including Marfan syndrome, Crouzon syndrome, Pfeiffer syndrome, and achondroplasia, a type of dwarfism, are statistically higher among the offspring of older fathers (Almeling 2020; Swan and Colino 2021).

> One retrospective cohort analysis of around 5 million births in the United States demonstrated that paternal age over fifty was associated with a 15 percent increased risk of birth defects. Another recent cohort study followed 1.5 million children born to fathers older than forty and found they have a greater risk of dying before age five, due to the higher incidence of birth defects and other malignancies in this population. (Almeling 2020: 81)

The problems for the kids of older men are not only physical. Psychiatric disorders such as schizophrenia, bipolar disorder, obsessive compulsive disorder, and autism affect these children at higher rates (Almeling 2020; Cassella 2019). Whereas one out of 141 offspring of dads under 25 are diagnosed with schizophrenia, this jumps to one in 47 for dads over the age of 50 (Cassella 2019). There are similarly scary studies about autism (a 1.78 times increased risk for fathers in their forties and a 2.46 increased risk for fathers in their fifties) and

bipolar disorder (1.37-fold increased risk for fathers aged 55 and above) (Almeling 2020).

The American Society for Reproductive Medicine recommends a maximum age of forty for sperm donors, and sperm banks now typically exclude men over thirty-six (Almeling 2020). Yet average prospective fathers and mothers tend to be unaware of the risks involved when older sperm leads to conception. "A simple Google search for 'maternal age and pregnancy' will bring up roughly 65 million results. Swap 'maternal' with 'paternal', however, and you'll get nearly four times less information" (Cassella 2019). And even among professionals who do know about the effects of age, recreational substance consumption, and occupational exposures, some medical providers wonder whether it is "reasonable" to talk to potential fathers about making lifestyle changes, given that the evidence remains "thin." "It is worth noting that one would be unlikely to encounter these particular sentiments when it comes to educating women" (Almeling 2020: 82, citing van der Zee et al. 2013).

Why has there been and why does there continue to be so little awareness of men's reproductive contributions? There are several contributing factors, all affected by cultural bias. The history of the development of modern medicine and medical specialties, a lack of funding for research on men and reproduction, doctors' ignorance and the medical establishment's silence, and the failure of the media to give enough attention to the research that is published all play a part. Also critical is that the types of activities that we associate with manhood, risk taking, working, going to war, completing house repairs, and doing yard maintenance, all potentially expose men to damage to their reproductive systems, yet we cannot fathom men not engaging in these endeavors. How do we tell a man not to serve in the military or to quit his job for the good of his future children when these roles are linked to traditional, hegemonic masculinity and the call to protect and provide for progeny?

Almeling (2020) writes that male bodies are fundamentally classified as "standard," while female bodies are seen as "reproductive." Women are not standard, and men are not reproductive in our reductionist binary cultural logic: "men's genitals were never seen as core to their health and psychology like women's genitals were" (Almeling 2020: 43). A urologist interviewed by Almeling (2020) stated that when he was a medical resident in the early 1970s, he was studying

the mechanisms of erection and how sperm left the body as this was not yet known in humans. Even in the 1980s, men's infertility was falling between the cracks of two specialties: urology, which did not normally do much about infertility, and endocrinology, which was predominately focused on women. Today "there is still no cohesive medical specialty devoted solely to men's reproductive health, no recommendations that men have their reproductive organs examined regularly, no public health campaigns about the male biological clock, and no government labels warning men about the toxic effects of alcohol and drugs on sperm" (Almeling 2020: 3).

Late twentieth-century researchers looking at the consequences of men's behavior and health on pregnancy and children encountered skeptical and dismissive colleagues and had trouble obtaining grants and publishing their work (Daniels 2006). In Kr:løkke's (2021) PubMed search, for instance, she found that articles on men's age and fertility mainly occur after 2004. To this day, funding for women's reproductive health far outpaces funding for men's (Almeling 2020). The National Institutes of Health (NIH) has 27 institutes for particular diseases and aging, but it does not have an institute for reproduction. Its Institute for Child Health and Human Development does support researchers working on maternal mortality and birth defects, but not on sperm and men's reproductive health (Swan and Colino 2021).

And even though there are now data out there, individual physicians still miss or dismiss them. For example, after interviewing an obstetrician, Almeling and Waggoner (2013: 833) point out that "[e]ven after listing four specific factors associated with men's bodies and behaviors (exposure to chemicals, family history, age, and medication use), this clinician underscores the connection between women's bodies and reproductive outcomes." An epidemiologist noted that:

> [w]e have to remind ourselves that men are generally involved in reproduction . . . The same epidemiologist explained that the "majority" of articles on preconception care do not discuss men at all, or mention them only briefly. Indeed, in an introduction to a comprehensive supplemental issue of the *American Journal of Obstetrics & Gynecology* (*AJOG*) on preconception health, the authors discussed 84 different risk factors and components of preconception care (Jack et al. 2008). Rather than including men in categories such as alcohol or illicit drug use, they are assigned to a catch-all category at the end labeled "men." (Almeling and Waggoner 2013: 833–4)

Given this, it is not surprising that biomedical organizations are not doing much to spread information about men's reproductive health to the general public.

> Are [federal health agencies and medical associations] posting official statements on their websites about how a man's age, behaviors, and exposures can damage sperm and affect his children's health? Do they generate patient-friendly fact sheets in accessible language? The answer is usually no. Governmental and professional organizations, whether oriented generally to issues of health and medicine or specifically to the topic of reproductive health, devote relatively little attention to paternal effects. (Almeling 2020: 104)

The March of Dimes did do a "Men Have Babies Too" campaign in the 1990s, but in the 2000s the campaign had petered out, and the focus returned almost exclusively to initiatives involving women; no paternal effects are mentioned in their recent brochure (Almeling 2020).

Additionally, as researchers began to publish findings on men's sperms and their effects on miscarriage and birth defects, the media did not do a good job of covering it. Court cases concerning DBPC (2,6-ditertiarybutyl paracresol, an oxidation inhibitor) in the late 1970s and lead in the early 1990s generated some media attention but then waned. While there were some stories about steroids and endocrine-disrupting chemicals in the 1990s, it was not until the 2000s that the press began to highlight fathers' ages, particularly in relation to autism and schizophrenia (Almeling 2020).

> Moreover, journalists tend to limit their reporting to the potential damage to sperm – that is, the effects that a man's age or bodily health can have on sperm count, shape, or motility. Only rarely do they go beyond this to mention the potential effects of men's health on children. And such information is routinely laced with humorous allusions to masculinity and statements about scientists' continuing uncertainty in this realm, both of which serve to minimize concerns about paternal risks. (Almeling 2020: 92)

Daniels (2006) points out that, while news stories about "crack moms" in the 1980s and 1990s showed photos of moms and babies, stories on the potential consequences of men's drug use on their children in the 1990s were illustrated with drawings or photos of sperm but not dads or infants.

Progress certainly has been made. In their content analysis of 64 newspaper articles, Campo-Engelstein et al. (2016) state that, while no articles made a link between paternal age and problems in children in the 1970s or 1980s, 20% did so in the 1990s, and almost 40% did after 2000. Yet, "[d]espite the increase in articles on paternal age and harm, almost one-third included a paternal surprise tone indicating that this news is novel. The high frequency of paternal surprise coupled with paternal reassurance implies that society is skeptical about, or perhaps not yet ready to acknowledge, the relationship between paternal age and preconception harm" (Campo-Engelstein 2016: 61). They also found that women, rather than men or couples, remain the centerpiece. Only one-third of the articles were about paternal effects, and the majority of these mentioned mothers as well. They elaborate, "the primary focus of newspaper articles regarding preconception harm remains concentrated on women and they are more likely to blame women than men for any harm . . . media attention has minimized or ignored the important scientific advances in this area, focusing instead on pregnancy-related harm" (Campo-Engelstein et al. 2016: 60–1). A tone of maternal anxiety was three times more common than paternal anxiety, blame was present four times more often in regards to women than men, and paternal blame was the second-to-least frequent tone in the articles they analyzed. This reveals that:

> authors either do not recognize men's contribution to harm due to ignorance or denial, or do not want to hold men responsible for harm. Even when men's contribution to harm is acknowledged, the authors are more likely to absolve men from responsibility for harm, as seen by the fact that almost half of articles that had paternal information also had a paternal reassurance tone. (Campo-Engelstein et al. 2016: 61)

Consequently, men are not held liable by authorities for reproduction gone wrong.

While men are reassured, often by an article mentioning famous celebrities who have successfully sired children at advanced ages, women are held responsible and treated accordingly, which leads to interference by family and acquaintances and by the state. The media influences people at large, and this includes politicians. In addition to underplaying the role of men in reproductive outcomes, "[i]f women are perceived as in most need of surveillance and protection, then the

media's continued focus on women as being pre-pregnant continues to focus and target women. Without broader social discussion in the mass media, there are limits to the perception changes that are possible" (Campo-Engelstein et al. 2016: 61–2).

There is cognitive dissonance involved when it comes to men's contributions to childbearing. If there were not, our society would face an existential crisis about the role of men as "many of the infertility risk factors cited here involve behaviors, occupations, or activities that are commonly associated with stereotypical notions of masculinity" (Moore 2007: 25). If we won't even post public warnings about men's drinking and smoking, we are unlikely to remove them from work sites or bar them from military service. In addition to writing about chemicals in the workplace, Daniels (2006) details the effects of Agent Orange during the Vietnam War and the numerous substances to which soldiers were exposed during the wars in the Middle East. She enumerates the contaminants they encountered: diesel mist used to control sand dust, burning petroleum from oil-well fires, fuel-contaminated shower water, items, including their sleeping bags, dried with the leaded exhaust fumes from vehicles, pesticides sprayed in their tents to control scorpions and sand flies, human waste and various forms of refuse burned nearby with fuel oil, and uranium from ammunition and armor-plated tanks. "No one knows what happens when one person is simultaneously exposed to viruses, pesticides, solvents, and heavy metals all at the same time" (Daniels 2006: 138). The government did admit that, in the 1991 Gulf War, military members were exposed to as many as 21 toxic substances that are reproductive hazards such as arsenic, ethanol, benzene, and heavy metals (Daniels 2006).

While many interests conspired for years to suppress this knowledge and the potential consequences of subjecting soldiers to these chemicals, sperm banks were reacting so it would not affect their bottom line as savvy parents in need of donor sperm were making connections. A donor manager at a sperm clinic stated:

[w]hen the Desert Storm thing came out . . . there's no known disease, they call it Desert Storm Syndrome. People were starting to freak out. "Is my baby going to be orange because I bought a donor?" So the medical board got together and made the decision we don't want any donor that's been in the Middle East. So that is on the medical history questionnaire. (Almeling and Waggoner 2013: 835)

Currently, there are no hard data on reproductive outcomes from the use of burn pits in Iraq and Afghanistan, but there is some evidence of respiratory ailments and various forms of aggressive cancers. These diseases from toxic exposures take time to develop, which can make lobbying for legislation difficult. While the Occupational Safety and Health Administration (OSHA) calls attention to the dearth of research on the reproductive health safety of many chemicals for both men and women and alludes to potential harms to the children of exposed workers, the Department of Defense (DOD) continues to minimize the effects of Agent Orange and toxins that modern soldiers encounter (Almeling 2020). Yet Agent Orange is acknowledged for its effects on soldiers, and the quest for those seeking recognition that they are affected by burn pits in the twenty-first century wars is benefiting from knowledge about past conflicts and increasingly visible public pressure, forcing Congress to cover the medical costs of veterans with specific conditions tied to burn-pit exposure.

If men's reproductive organs are too vulnerable for them to be sent to war or work with chemicals, what does that mean for society? For manufacturers and the military, it's better not to probe too deeply into the matter lest something has to change. As we saw with the initial resistance to research about sports and the long-term health consequences of repeated concussions, people were slow to believe that strong, male professional athletes could become so diminished from injuries that were not even visible. Stakeholders fought back. The NFL took a long time to acknowledge the truth. They knew what they could lose: compensation money and permanent changes to the game. A payout to former players came to pass. The end of tackling has not. Wishful thinking and willful ignorance are both at play. "[C]ertain myths of masculinity have skewed the questions that have been asked, the research that has been done, and the answers we find acceptable in research on men" (Daniels 2006: 151). If men's reproduction is precarious like women's is, how do we as a society reconcile the trope of male invincibility?

Daniels (2006: 151) astutely highlights that "it is not so much the nature of risk but the nature of the population affected by risk that often determines the public response to potential harm." The fact that studies of alcohol, cigarettes, and other possible teratogens carried by men's sperm were slow to gain scientific acceptance and research support (Daniels 2006) and continued widespread ignorance in mainstream society of men's contributions to the health of their

offspring lends further credence to the real impetus being that of making women behave, rather than actual health concerns.

Preconception care – for women only

Sociologist Elizabeth Armstrong titled her book about fetal alcohol syndrome (discussed in the next chapter) *Conceiving Risk, Bearing Responsibility*. Conception always involves risk, given the high rate of pregnancy loss (15–20%), the fact that a certain percentage of babies will be born with birth defects (1 out of 33), and the risks of childbirth that result in unconscionably high maternal mortality for some groups of women in the United States (12.6 to 44 per 100,000 births, depending on the racial/ethnic group).

Miranda Waggoner (2017) writes about the "zero trimester," the three months before birth when a woman is encouraged to be "responsible" by planning her pregnancy and getting her health in order ahead of conception. This "anticipatory" motherhood, as she calls it, is not even just an extra three months, however, as increasingly public health officials, worried about the high rate of unintended or mistimed pregnancies, paint it from the time she is fertile until she has gone through menopause. Campo-Engelstein et al. (2016: 57) underscore that "[i]t is also clear that the social pressures on women to live in a 'pre-pregnant' state are a complicated web of science, social norms, policy, and structures within society that may or may not look at all women the same."

Despite evidence that prenatal care (during pregnancy) has little bearing on pregnancy outcomes, except for women with very specific health conditions, such as an active infection, or problems that develop late in pregnancy, such as preeclampsia, medical practitioners advocate preconception care (prior to pregnancy) as common sense. Other than the case of women with diabetes and the recommendation that all women take folic acid to reduce the chance of neural tube defects in the fetus (Waggoner 2017), there is little medical advice that aids pregnancies. Unfortunately, despite gains in hi-tech infertility treatments and better support for infants born preterm, not much is known about why many perfectly healthy women miscarry, go into labor too soon, or have a child with birth anomalies. And numerous women who have health issues manage to have totally normal pregnancies that result in a healthy newborn.

With the exception of folic acid, which does have documented support specifically for the beginning of pregnancy, other recommendations for preconception care are the general advice that anyone should take to be healthy: eat well, maintain a healthy weight, don't smoke, don't use "street" drugs, and don't drink (too much). This last one is the one that is more complicated, as *no one* should drink too much, but, starting in 2016, women who were not trying to conceive but were not on birth control were advised not to drink at all. Low to moderate amounts of alcohol consumed *by women* prior to pregnancy have no effect on the fetus. As we will see in the next chapter, low levels of drinking are not a problem during pregnancy either, despite the common perception – one routinely advanced by the medical world without solid evidence – that it could lead to poor outcomes.

"The emergence of pre-pregnancy care is a case of knowledge construction and political maneuvering in which understandings about risk were bound by persistent cultural and medical tropes about women and maternal responsibility. To govern risk was to govern women. To promote anticipatory motherhood was to promote social order" (Waggoner 2017: 176). Waggoner analyzed the Centers for Disease Control and Prevention's (CDC's) 2013 "Show Your Love" campaign which was designed to encourage women to get healthy so that their future babies would thank them. "The campaign's message touted self-love and baby love simultaneously, conflating womanhood and motherhood. The 'Show Your Love' campaign built on previous tropes of maternal love, devotion, and sacrifice," but extended it beyond pregnancy and motherhood to women who were not even pregnant nor even sure they ever wanted children (Waggoner 2017: 153). It also presented white and light-skinned women as planners, and black and Latina women as non-planners. Planning in the campaign only referred to actively thinking about conceiving, not other plans such as pursuing a degree.

The photos for the campaign reinforced stereotypes of struggling single moms of color. Certainly out of 53 black and Latina women pictured, some of whom were shown with children, at least some would be living with men involved in childrearing, but only light-skinned and white women appeared in photos with partners. The portrayals of women of color in a public health campaign are telling and contribute to conservatives' fears about minorities' inability to provide for their children and their consumption of public resources,

while reinforcing the idea that white women never need this assistance because they naturally make good choices about childbearing. Calling women hoping to get pregnant "planners," and women not intending to conceive soon "non-planners," linguistically dismisses plans that are not about motherhood, such as educational and work plans. Planning is considered a good thing, as is motherhood (at least for white women), and the two are put on the same plane. The campaign thus subtly conveys to viewers that women of color should not bear children, or more children, while white women are always ready to do so and do so conscientiously, even though the campaign is ostensibly supposed to be about women making empowered decisions and taking control of their lives and health. "This campaign's rhetoric perpetuates the idea that women of color need to be told to plan their fertility, use contraception, and change their behaviors, and white women are situated as model citizens, ready to hone their future baby love. This discursive arrangement reveals how women of color continue to be on the margins of 'good' motherhood" (Waggoner 2017: 165).

Men, on the other hand, don't have to start performing "good fatherhood" prior to conception. This is paradoxical because, while women carry their eggs within their bodies from the time of their own gestation inside their mothers, men make new sperm every 42–76 days, and therefore a behavioral modification can lead to healthier sperm three months later, exactly the time of a zero trimester (Waggoner 2017). Yet almost no public health initiatives target men for healthier behavior during a zero trimester.

> Even in sites where such information is crucial, such as preconception care and sperm banks, we find that the mutually reinforcing processes of inattention and lack of research contribute to ongoing ignorance and uncertainty, both at the levels of knowledge and practice. Among the scientists and clinicians actively involved in designing the framework for preconception health care, the overwhelming focus is on preparing women's bodies for reproduction, one result of which is a profound inattention to men. (Almeling and Waggoner 2013: 833)

While in the minority, a few researchers are attending to men's reproductive health needs and urging more public attention and clinical interventions. One public health researcher interviewed by Waggoner stated that:

> We really need to really try to engage men in the arena of pre-conception care. Men who drink, men who use drugs, men who smoke all pose risks to a healthy pregnancy. And, you know, even if they're not the ones who get pregnant, it's still a two-person act and really engaging the boys and men around sexual health, sexual responsibility, and the full spectrum of care and preparedness – planning for eventual pregnancy – is absolutely essential. (Waggoner 2017: 143)

In 2014, *Men's Health* ran an article, "5 Reasons She's Not Getting Pregnant," advising readers, among other things, to keep laptops on desks and not on laps. Yet numerous clinicians fall back on the "It's the woman who is pregnant" line or state that it's too hard to reach men, as even during their partner's pregnancy men do not always come to medical appointments (Waggoner 2017).

In a study of 132 men seeing medical providers at primary care offices, the researchers found that although 93% of patients thought that taking care of health was important before pregnancy, only 15% knew that tobacco use could affect sperm, and only 8% had a conversation about preconception health with their doctor (Frey, Engle, and Noble 2012). Choiriyyah and colleagues discuss a sample of 10,395 men aged 15–44, asserting that 60% are in need of preconception care: "Men in need of preconception care reported the following health risks: 4% have poor/fair current health status; 57% are overweight or obese and 2% underweight; 7% use marijuana daily; 58% binge drink ever [sic] in the last year; 7% use cocaine, crack, crystal/meth, or an injected drug in the last year; and 21% have high STI risks" (Choiriyyah et al. 2015: 2361). Yet, in another study of 2,736 Americans in 2007, "[o]nly 11.1% of men and 22.2% of women reported receiving preconception health (PCH) information from their health care provider" (Mitchell Levis, and Prue 2012: 33). Mitchell and colleagues (2012) note that, in general, men have routine wellness visits less frequently than women, and, even when they do go, "[m]any clinicians who provide care to men are not trained to provide preconception care; most obstetricians-gynecologists are not trained to provide care for men" (Frey et al. 2008: 393). And while the Affordable Care Act removed copays for preconception health appointments for women, "preconception care for men is not currently a billable diagnosis under most health plans" (Frey et al. 2008: 393). As Almeling and Waggoner (2013: 838) point out, "excluding men from such coverage continues to obscure their role in reproduction."

The CDC and the Office of Population Affair's Quality Family Planning guidelines have only made recommendations for preconception care services for men in the last few years. Choiriyyah and colleagues explain that men's preconception care is important because:

> (1) it is critical to ensure all pregnancies are planned and wanted; (2) it can result in improved pregnancy outcomes by enhancing men's biologic and genetic contributions to the pregnancy conception; (3) it can result in improved reproductive health biology for women through, for example, sexually transmitted infection (STI)/human immuno-deficiency virus (HIV) screening and treatment; (4) it can result in improved reproductive health practices and outcomes for women and men through shared health promotion practices; (5) it can result in improving men's own capacity for parenthood and fatherhood; and (6) it can serve as an opportunity to enhance men's access to primary health care. Accumulating evidence already demonstrates that men's health conditions (e.g., diabetes, obesity) and involvement in risk behaviors (e.g., drug abuse, alcohol, smoking) impact not only their general health but also their and/or their partner's reproductive capacity. (Choiriyyah et al. 2015: 2359)

Paradoxically, it is in sperm banks, where men are selling their genetic material to another party, rather than in general practitioners' offices that men are instructed on the ties between their general health and their sperm.

> If men had several failing samples in a row, bank staff sometimes inquired if anything had changed or offered pointers. Most donors found this advice helpful and altered their behavior, which included taking vitamins and other supplements, drinking more orange juice, eating more protein, or reducing alcohol consumption. Greg, a college student who donated twice a week, said he started drinking more beer over the summer and as a result was only passing 25% to 50% of his samples. He asked a donor friend as well as the donor manager and the bank's physician how to improve his pass rate, and, in response to their advice, was "changing a lot of my eating habits and a lot of my other habits so I can get more money" [laughs]. (Almeling 2011: 107–8)

It is interesting that men commodifying their gametes are aware of how their behaviors affect sperm health, but not the average man trying to conceive.

It is also telling that providers and public health officials push pre-pregnancy care as a way to get more support and funding for women's health care in general. When it is called women's health, politicians read reproductive health, which they then equate with contraception and abortion. Preconception care is an easier sell to conservatives than reproductive care or women's health, which have traditionally been cut under Republican administrations (Waggoner 2017). Thus, while the focus on *all* women, desirous of conception or not, needing pre-pregnancy care seems pernicious, and in some ways is, it is also a calculated attempt to get around the devaluation and defunding of women's health initiatives in a hostile political climate (Waggoner 2017). "By reminding politicians and the public that women's bodies are potentially maternal bodies, maternalism was strategically used by experts to bring enhanced attention to women's needs" (Waggoner 2017: 115). As one public health researcher told Waggoner (2017: 115): "[Legislators] have very little support for uninsured women until they get pregnant because then it's about the baby. It's not about the mother . . . But, you know, there's just no general primary care money for women . . . because [women] don't have value unless they've got a belly." Of course, once the baby is born to an unhealthy woman, that baby will be cared for by an unhealthy mother, but just as the focus is not on women's well-being, it is not actually on children's well-being either. What matters to many conservatives is the fetus, and the fetus alone.

Beyond the individual

Not only do we need to understand that children are cared for by the people around them, but we need to take into account the living conditions of those caretakers. We hold women responsible for pregnancy outcomes, even when they don't have clean water or air where they live, if they labor in harsh, unsafe conditions, or if they struggle to afford and access healthy food. As Waggoner (2017: 174) highlights, "[w]e are willing to ask women and physicians to do quite a lot in the name of gendered clinical interventions; we are less willing to call on broad-based social changes that would give *all* people greater health security and put them at less risk at the outset." For example, in the infamous Johnson Controls case in 1991, the Supreme Court decided that forcing female employees to show proof of sterilization

to keep their production line jobs was illegal because it constituted gender discrimination. In addition to women workers, one of the plaintiffs in the case was a man whose wife experienced miscarriages. Like other employees in the plant, his body, and his sperm, was full of lead. While the court ruled that women could not be barred from working in the part of the factory where workers are exposed to toxic chemicals, no one thought to tell the company to stop using the toxic chemicals and injuring the health of their employees. In her book, *How All Politics Became Reproductive Politics*, women, gender, and sexuality studies professor Laura Briggs (2017: 45) points out that "[t]he courts had found, in effect, that industrial workplaces were free to poison fetuses, children, women, and men. From a position like that, how would you argue that workplaces had to change to make them compatible with reproduction?"

A "good" mom is supposed to inform herself of all potential toxins in her environment and then conscientiously try to avoid them both before and during pregnancy. California Proposition 65 mandated a warning on buildings and products that are not tested for, or exceed safe levels of, chemicals known to cause cancer or reproductive harm. Designed to increase competition for businesses that use harmful chemicals and shame them into changing their materials, businesses all posted the signs, making them so ubiquitous that no one could take them seriously anymore and the businesses collectively did not have to stop using, making, or selling hazardous products.

> [T]he signs imply that reproductive risks are more important than other health risks, thereby singling out pregnant women as having a unique responsibility to make risk-minimising choices. They locate responsibility for foetal risk management in pregnant "consumers," rather than on those responsible for creating safe public spaces . . . they offer pregnant women a choice between excluding themselves from public spaces and forgoing basic services and dimensions of civic life, or taking on the identity of reckless mothers willing to "voluntarily" impose "unnecessary risks" on their future children . . . [O]ur practices for managing and communicating reproductive risk have helped build a social space that positions pregnant bodies as special sites of risk and responsibility, thereby imposing unfair burdens and exclusions and often impossible choices upon pregnant women. (Kukla 2010: 332)

We are back to the responsibility being on pregnant women alone. This is both part of the culture of individualism, and also linked to

gender norms which allow men to engage in a certain amount of risk taking but put women in charge of caring for others, even if they have to self-sacrifice to do it. As Bordo maintains, "at the same time as supererogatory levels of care are demanded of the pregnant woman, neither the father nor the state nor private industry is held responsible for any of the harms they may be inflicting on developing fetuses, nor are they required to contribute to their care" (Bordo 1993: 83). Yet fathers do play a tremendous role.

[M]en who abuse their female partners can not only directly injure the fetuses the women are carrying . . . but also push the women into drug use as a form of escape. When fathers buy or use drugs, they often encourage their pregnant partners to indulge as well, sometimes under a threat of violence. When fathers smoke cigarettes, the second-hand smoke reaches the fetus via the mother, contributing to premature births, lower birthweight, and poor lung development. (Fentiman 2017: 113)

Waggoner entreats us to think about public health interventions that focus on "reducing poverty- or race-based disparities for at-risk women rather than pursue policies that ask all women of reproductive age to change their behavior and plan their pregnancies without the supports they might need to do so" (Waggoner 2017: 19). She explains that:

An individual-level intervention . . . appears to highlight individual actions, choices, and desires, which might on the surface appear helpful but, at the same time, does not target root changes or social justice. If every woman is optimized and every risk anticipated, certain populations will still be at disproportionate risk due to other underlying causes, such as pollution, structural racism, lack of access to quality, stable health care, family planning services, or nutritional foods. (Waggoner 2017: 132)

While higher socioeconomic status (SES) people can afford to live in neighborhoods that are less polluted and run "Not in My Backyard" (NIMBY) campaigns with more resources that other communities, poorer people and black and indigenous people are those most likely to live near toxic waste and to have lead in their water. Fentiman (2017) notes that when lead paint companies have been taken to court, even with proof that they continued to market lead paint

after they knew it was dangerous, they were rarely held responsible for hurting children. A successful technique by lawyers protecting landlords and manufacturers has been to argue that the child was probably harmed by the mother's poor care and/or low IQ rather than by the lead paint (Fentiman 2017).

Our resistance to fixing problems structurally is about individualism, but it is also about our political economy. "Neoliberalism is . . . a system that holds individuals fully responsible for their conditions and ailments. This framework has permeated the health realm, in both health programs and messaging, most clearly by emphasizing the role of individual behavior for health outcomes" (Waggoner 2017: 146). For instance, "posters from the CDC Office of Minority Health, 'A Healthy Baby Begins with You' . . . emphasize things like eating well and managing your stress," as if stress were the fault of the person experiencing it and not tied to racism and economic insecurity which are the real culprits in poor pregnancy outcomes (Briggs 2017: 137).

Government must take a more concerted role in fixing structural problems. As politicians and government entities take proactive measures to address income inequality and discrimination, low-hanging fruit can also continue to be targeted with real impacts.

> Even when it comes to health behaviors, which are typically perceived as individual-level choices, regulatory and organizational efforts can have quite an impact . . . These kinds of structural approaches have been adopted when it comes to women's reproductive bodies, such as the 1998 federal requirement adding folic acid to commonly consumed grain products (e.g., cereal, bread, pasta) in an effort to reduce the risk of certain birth disorders. (Almeling 2020: 103)

Ideally, government regulation would also make the workplace safer and ban toxic products sold to consumers. They could do this for the population at large, helping not just men and women trying to conceive or waiting for a baby but also people who do not intend to parent, as well as children and the elderly. A healthier citizenry seems a laudable goal, but in the United States this is a particularly difficult goal to reach. While Europeans are making more strides in requiring companies to report information about the chemicals in their goods before they release them, and, consequently, prohibiting more toxins, the US political football of regulation/deregulation, and the power

of lobbyists who present their industry's side of the story to politicians, makes protecting people from chemicals challenging. Swan and Colino (2021) argue that rather than testing chemicals after they come to market, we should follow the "precautionary principle" and not allow potentially harmful substances, such as endocrine-disruptors, to be sold until the manufacturer proves their safety.

Almeling (2020) urges us to think more broadly about reproductive bodies, arguing that the cascade of effects would be good for us all.

> Reframing reproductive health as not just about women and not just about individuals would entail nothing less than a paradigm shift. What if all bodies – female, male, trans, gender nonconforming, intersex, and so on – were conceptualized as (potentially) reproductive? And what if structural and environmental sources of risk were emphasized alongside individual factors? How might these twin developments shift our understandings of reproductive responsibility? Rather than placing the onus on individual women to eat right and avoid toxins, would officials redouble their efforts to ensure that everyone has access to healthy food and that nobody is exposed to harmful chemicals? (Almeling 2020: 172)

People need the opportunity to be healthy before conception, during gestation, and after parenthood begins. And beyond focusing on fetuses, we need real reproductive justice that goes beyond rights and access to contraception and pregnancy termination to making sure that babies who are born live and grow in a healthy environment and that as adults, if they so choose, they have the capability to reproduce. In the last section of this chapter, I discuss how to rewrite the messages about reproductive health, taking into account these systemic issues of health justice and gender equality.

How to do conception right

While the female body is the most visual site of human reproduction, as well as the physical site for gestation and giving birth, men contribute half the genetic material that makes up the embryo and resulting fetus/baby. If we were truly interested in improving the health of babies/future citizens, we would treat men the way we treat women, pressuring them to protect their sperm production the way we pressure women to prepare their bodies for pregnancy.

Our willful ignorance belies concerns about healthy outcomes and points to the real primary goal being the coercive socialization of mothers, present and future. It maintains a status quo where men can still engage in "manly" behaviors as workers and warriors without having to foreground their role as nurturing caregivers. This both frees and harms men. As Whitworth (1994: 402) argues, "protective legislation ignored men because their roles in childbearing and childrearing were not considered as important, or as fragile, as that of women. . . . It is part of the contradictory nature of the way in which gender is constructed that this is both a privileged and invisible situation in which to be."

Obviously, we need to involve men and treat them similarly to women in terms of reproductive health, but first we must rebalance what we expect of women. We should simultaneously back off women and further engage men. Women have always been blamed for bad outcomes in childbearing. We have to strive to give them information without conditioning them to bear the brunt of responsibility for reproductive outcomes and without sending the message that all women are expected to become mothers or are only valued for their baby-making potential. The same goes for men.

We can talk to men about the effects of obesity on sperm and offspring and encourage men to eat well and exercise, but we must also acknowledge that weight problems are tied to numerous societal factors, such as increasingly sedentary lifestyles, the inexpensiveness of processed foods compared to healthy options, and food deserts. Just as women cannot solve American obesity simply by breast-feeding, men cannot solve a societal problem individually. We need to take collective responsibility for improving these factors for everyone, regardless of location and income. We must continue to fund research and publish results about men's reproductive health. Certain vitamins may improve men's fertility, but high doses of other vitamins can damage sperm DNA (Frey et al. 2008: 392). If we can get to the bottom of what is helpful and what is not, we can make public health announcements as we did for women with folic acid. Men need to be educated that their own and their family's health history, the months leading to conception, and their current behaviors matter. Then they can make their own decisions about acceptable risk given their life circumstances.

But conception is not only about personal endeavors. It is high time to address the environmental conditions, such as our use of plastics

and pesticides, which impair fertility, gestation, birth outcomes, and parents' and children's health (Swan and Colino 2021). This is a societal and political responsibility, not individual women's or men's. Workplaces should be safe for all employees, and, if companies will not ensure that they are, politicians must pass regulations and government agencies must enforce them. Other measures, such as subsidizing daycare, providing generous paid parental leave for parents of both sexes, and encouraging companies to provide flexible work options could help people of both sexes to initiate childbearing younger, avoiding the poorer quality eggs and sperm that come with aging (Campo-Engelstein et al. 2016).

Waggoner (2017) provides an illuminating example of the right way to handle threats to fetuses by comparing the case of the Zika virus outbreak to that of warnings about alcohol. First, in the Zika case, the threat was made clear to women *and* men. Both were encouraged to refrain from childbearing if exposed to Zika and if living in a highly Zika-affected region. Second, the time frame was presented accurately. Zika is understood to not hurt a baby if the mother contracted it and recovered from it prior to pregnancy, unlike alcohol which is presented as dangerous to a fetus even before pregnancy, even though it is not. Third, public health officials were honest that there is a lot about Zika that they do not understand. On the other hand, these same officials present warnings about alcohol as if the dangers are clear-cut, despite contradictory and missing data on the effects of alcohol on fetuses, as will be discussed in the next chapter. "Whereas the alcohol warnings were disingenuous and paternalistic, the Zika recommendations could be interpreted as informative and empowering" (Waggoner 2017: 186).

> It is imperative that public-health messages include reliable infor-
> mation about health risks, including being clear about the temporal
> and causal direction of risks, acknowledging how much we really
> know (or don't know) about specific risks, accounting for the fact that
> risks are experienced by both men and women, and understanding
> that profound risks are often beyond an individual's control. It is also
> crucial to document that some individuals – women and men – are at
> greater risk than others and to spend time working toward the difficult
> system-level solutions that might offer bigger rewards to maternal and
> child health than will deficient messages of behavior change. To govern
> reproductive risk is not necessarily to govern women. (Waggoner
> 2017: 186)

Almeling (2020) begins her book, *GUYnecology: The Missing Science of Men's Reproductive Health*, by walking us through the day of a man seeking to become a father who worries about medications and checks with a doctor before taking any, avoids chemicals in his clothing detergent by buying "natural products," and showers in lukewarm rather than hot water in order to protect his sperm while trying to conceive. The narrative seems ludicrous primarily because it is a man doing these things rather than because the number of actions and the extent he takes them to are, arguably, ludicrous. Indeed, a woman doing these same behaviors would be extolled by many for her commitment to being a good mother. As Waggoner (2017: 187) urges, "[w]e owe it to women to be forthright about reproductive risk and to let them experience life without thinking about their maternal status at every turn." No one, female or male, can achieve perfect reproductive safety. We are all exposed to pollutants and other chemicals that we cannot control; in a certain percentage of pregnancies, the chromosomes do not come together correctly after fertilization, and sometimes the placenta or the umbilical cord is in the wrong place, even if we have done everything right. We ought to further incorporate men into understanding and taking responsibility for pregnancy outcomes, but without guilt-tripping them or redefining them exclusively as baby makers in order not to repeat the mistakes we have made with women.

3

Criminal Pregnancies

Catholic Ireland legalized abortion in 2018 at a time when restrictions on abortion were proliferating in the United States, despite its supposed separation of Church and state. Ireland took this step in part due to the resounding outcry when medical professionals allowed 31-year-old dentist Savita Halappanavar to die of sepsis after she suffered an incomplete miscarriage at 17 weeks, rather than removing the doomed fetus. Despite the *Roe v. Wade* Supreme Court decision in 1973 permitting abortion throughout the United States, poor girls and women, many of them black, Latina, and Native American, were already suffering from mandatory waiting periods between receiving information and getting the procedure, having to travel long distances to reach a provider, and the cost of the procedure, barriers that pushed them further along in pregnancy when abortions become more expensive or unobtainable altogether. Given the Supreme Court's 2022 decision in *Dobbs v. Jackson Women's Health Organization*, more and more girls and women who cannot travel out of state, or whose neighboring states also forbid abortion, cannot access abortion at all. And for those living where abortion is still legal, the Hyde Amendment, which was passed in 1976 and enacted in 1980, continues to deny abortion to people who receive federally funded health care, including Medicaid and Medicare recipients, people serving in the Armed Forces, federal employees and their family members, people in detention centers, and the population of Washington, DC.

Rupp (2019) reviewed the text of abortion legislation in Indiana and how it eradicated references to women or girls once an abortion

is performed. Pre-procedure, the term used is "woman," but once she undergoes an abortion, the references to woman and girl are all replaced with "patient" and "minor." "Only when she is still pregnant or engaging in behavior that does not potentially threaten her continued pregnancy is she permitted to [sic] a gender. Thus asserting an implicit valuing of certain actions – good women do not have abortions" (Rupp 2019: 100). Rupp argues that this is to codify that only women willing to sacrifice and bring children into the world regardless of the situation (including forcing women whose fetuses have lethal defects to go to term) are worthy of being women. "This manifests as a selective erasure of womanness from any discussion of abortion, such that there is no reference to a woman who has had an abortion only patients" (Rupp 2019: 97). This furthers additional legislation.

> By creating value as denoted by successfully enacting the state's biopolitical power, and by defining femininity within the bounds of bearing children, the state can pigeonhole selective populations to be legislated upon. Such narratives and rhetoric of who deserves or gets to be a woman and what that means to the state creates populations that are forced to live in constant precarity. (Rupp 2019: 101)

Precarity indeed. As the progressive banning of abortion in the United States underscores, the battle over women's bodies and autonomy is a never-ending struggle.

> Nations, political parties, religious and ethnic groups, and other entities claim a stake in reproduction – who should have sex, who should give birth, who should be born, and who should not. These claims turn an intensely private human activity into a matter of public concern, sometimes a public obsession. As a result, motherhood is not an isolated, individual experience. Motherhood is deeply politicized, both as a means to control women and a means by which women seek to gain control over their lives. (Ross and Solinger 2017: 168)

Whether politicians are banning abortion (and possibly contraceptive use as well) to increase the population for a steady supply of workers and soldiers, as feminist activist Jenny Brown (2019) argues, or simply to reassert patriarchal control over women's place in society, US women are clearly losing their rights to bodily integrity and living with undue government interference in their lives. More and

more people will tragically lose their lives not just from abortions carried out in unsafe ways but also from medical complications during wanted pregnancies, such as happened to Dr. Halappanavar in Ireland.

Activist Loretta Ross of SisterSong Women of Color Reproductive Justice Collective and others on the forefront of reproductive justice point out that women's reproductive rights are not just about terminating a pregnancy. Women must have the power to make their own reproductive decisions, be that ending a pregnancy or starting one, and the government has a responsibility not only to not interfere with their self-governance but also to facilitate the exercise of those rights, including the right to parent, regardless of income, race, age, etc. (Ross and Solinger 2017). As we saw in the previous chapter, however, the United States does not provide conditions for healthy conception, pregnancy, and parenting to far too many of its inhabitants. This chapter looks at the increasingly criminalized consequences for women who do not do pregnancy the "right" way.

Fetuses over women

Prior to 1946, women who were injured could only seek damages for their own injuries, such as a broken leg that led to a limp, but not damage to their unborn babies, even if they had been intentionally attacked while pregnant. Before a live birth, there was no legal standing for the fetus other than inheritance rights. A woman could only sue for assault on her person but not for the outcome of her fetus, even if it was gravely injured or she miscarried. In 1946, a father successfully sued a physician for injuries caused at birth. While this opened the door, cases for the next 14 years involved gestating babies that had reached viability prior to being harmed. In 1960, a suit was successfully brought for a car accident that occurred before the fetus reached viability. Damages were still contingent on permanently disabled babies eventually being born alive, however (Daniels 1996). This changed in 1984 when a fetus was recognized as a murdered person in the case of a car accident. Feticide laws began to proliferate. By 2020, 38 states had feticide statutes (Goodwin 2020).

Initially, these new laws that treated the fetus as a separate individual while *in utero* seemed like a good idea because they helped women get restitution and allowed society to punish drunk drivers

who hit pregnant women and husbands who assaulted pregnant wives, even if these events occurred very early in pregnancy. Yet, Daniels (1996: 15) warns, "[a]s the language of the law shifted attention away from the loss experienced by the parent or parents to the loss 'experienced' by the fetus, it began to create the legal fiction of the fetus's existence separate from the woman's body." Although originally designed to be beneficial for women, these laws proceeded to ensnare the very pregnant women they were ostensibly designed to protect. As the entity in question was transformed into the fetus rather than the pregnant woman, prosecutors started charging women with damaging their own unborn offspring. As Daniels (1996: 3) explains, the timing is revelatory: "[p]ortrayed by the fetal rights movement as the tiniest citizen, the fetus is depicted as an independent being with needs, interests, and rights separate from and often opposed to the pregnant woman's. Attempts to 'protect' the fetus against the actions of the pregnant woman did not arise until the legalization of abortion and the anti-abortion movement."

The anti-abortion movement capitalized on technologies that peeked inside the womb. Ultrasounds show the embryo or fetus but not the mother. Her body is erased from view, further contributing to the idea that the unborn baby is an independent individual:

> The body that contained the fetus was just gone, a visual representation of a cultural divide that seeks to project a fetus into a world without the person carrying it, that strips the life from the means of life. In this way, the fleshy reality of the fetus is made more real, more viable, more human than the pregnant person. (Lenz 2020:14)

Opposition between the two entities is lessened if the actual person in the equation can be erased. When she cannot be, she is portrayed as a danger that must be controlled.

> [S]ince the late seventies a dichotomy between the pregnant woman as maternal environment and the fetus as person in its own right has emerged in both popular culture and medical-legal discourses. This then is the 'New Civil War,' in which an erstwhile benevolent, nurturing, and ideal environment has been transformed into a hostile, infanticidal toxic waste dump, from which the autonomous (and, one might infer, autochtonous) "person" must be protected by the paternalistic arm of the government. The articulation of the embryo with victims of racism

and of the Holocaust thus logically – if obscenely – proceeds from this logic. (Stabile 1992: 182–3)

In an interview with Goodwin (2020: 196), Lynn Paltrow, the executive director of Pregnancy Justice (formerly National Advocates for Pregnant Women), stated that "laws that seek to treat fertilized eggs, embryos, and fetuses as entirely separate legal persons provides [sic] the basis for creating a system of separate and unequal law for women." For anti-abortion activists, and increasingly the general public, this is not only about saving babies; it is about punishing "bad moms" lest they harm society itself:

A new social mythology emerged that some women were not just "bad mothers" but "anti-mothers," who violated their most natural instincts and who threatened to destroy the institution of motherhood altogether . . . The broader public discourse on motherhood bred a deep suspicion of women who, if they did not terminate fetal life, might still damage or harm fetal health through their selfish or negligent behavior while pregnant. (Daniels 1996: 3)

Thus legislators in several states styled themselves the savior of babies conceived by irresponsible mothers. But first, in addition to codifying the fetus, or embryo, as a person with its own separate rights, they had to criminalize women's actual behavior as well. This was accomplished through creative uses of existing law, such as delivering drugs to a minor – via the umbilical cord in the few minutes after the baby was born before the cord was cut – and application of child abuse statutes to unborn children, as well as through new laws. This has led to a building avalanche of denial of rights and prosecutions of pregnant mothers for harming, or doing behaviors that could potentially harm, their own pregnancies, from 413 documented cases between 1973 and 2005 to at least 1,254 between 2006 and 2020 (Goldberg 2021; Paltrow and Flavin 2013). The actions that can result in legal intervention and incarceration while pregnant run the gamut from consuming drugs, illegal or legal, to engaging in an argument and therefore provoking harm from another party toward the fetus, to refusing a cesarean section recommended by a doctor. And the severity of charges has also worsened. According to law professor Linda C. Fentiman (2017), while the charge in the 1980s and early 1990s was usually child abuse, by the late 1990s and

throughout the 2000s, women were increasingly being charged with manslaughter and homicide.

At least one woman, Angela Carder, was denied cancer care by doctors and judges. Instead, they forfeited her health for the supposed interests of her 26-week oxygen-deprived fetus who was removed from her body against her will by cesarean section only to die within a couple of hours. Doctors knew this would hasten Ms. Carder's own death, and it did two days later (Daniels 1996; Goodwin 2020; Paltrow 2015). While her family ultimately successfully went back to court and had the decision vacated, it was too late to give Ms. Carder back more time or to allow her to handle her pregnancy and death on her own terms. It also did not prevent all future cases in which pregnant women's health decisions were subordinated to what doctors, courts, and legislators deem is in the best interest of the fetus. They continue to oblige women to self-sacrifice. In fact, the dissenting judge when the appeals court overturned the Carder decision argued that "'the expectant mother,' by undertaking to bear another human being and carrying an unborn child to viability, places 'herself in a special class of persons'" (Paltrow 2015: 212–13). Laura Pemberton was forcibly removed from her home with her legs tied together during transport and forced to undergo a cesarean section rather than the vaginal birth she wanted after a previous cesarean. Unlike Ms. Carder's family's case, Ms. Pemberton lost her subsequent court case against the hospital. She went on to have three more children vaginally despite doctors' claims that it was too risky.

Losing self-sovereignty, through being denied the right to make one's own medical decisions, or being held against one's will for the sake of another being, without having committed a crime, is something that only happens to pregnant women (Bordo 1993; Daniels 1996). Bordo (1993) details cases where non-pregnant people's bodily autonomy has been protected at all costs, including a criminal not being forced to undergo surgery to remove a bullet needed as evidence. Even more egregious given "pro-life" arguments, the courts will not compel a person to undergo minor medical procedures that could save another's life, such as a man not being made to donate bone marrow to his dying cousin. Yet courts are all too ready to drop these protections once a woman is pregnant.

Thus, ontologically speaking, the pregnant woman has been seen by our legal system as the mirror image of the abstract subject whose bodily

integrity the law is so determined to protect. For the latter, subjectivity is the essence of personhood, not to be sacrificed even in the interests of the preservation of the life of another individual. Personal valuation, choice, and consciousness itself . . . are the given values, against which any claims to state interest or public good must be rigorously argued and are rarely granted. The essence of the pregnant woman, by contrast, is her biological, purely mechanical role in preserving the life of another. In her case, this is the given value, against which her claims to subjectivity must be rigorously evaluated, and they will usually be found wanting insofar as they conflict with her life-support function. In the face of such a conflict, her valuations, choices, consciousness are expendable." (Bordo 1993: 70)

Pregnant women continue to be subjected to forced medical interventions and be deprived of their liberty "for the sake of the fetus," despite not having committed any crimes. Angela Carder was denied treatment and had the forced cesarean section that contributed to her death in 1988. In 2004, a court order in Pennsylvania mandated that Amber Marlowe, a pregnant mother of six, remain in the hospital and have a cesarean section against her will, as a doctor feared her baby would be too big to deliver vaginally. Ms. Marlowe had already left the facility before the order was issued and successfully delivered her daughter vaginally at another health center. Samantha Burton did not escape and did not have a happy outcome. In 2010, the Florida mother of two was told by a physician to go on bed rest at 25 weeks. She refused as she needed to care for her children. It turns out that there is no good evidence that bed rest prevents pregnancy loss or preterm labor. Concurring with the American College of Obstetricians and Gynecologists (ACOG), over half of ob/gyns say bed rest is not beneficial, and yet 90% of them sometimes recommend it anyway despite the possibility of blood clots and the problems for pregnant women who need to work or parent other children (Oster 2021). Unfortunately, Ms. Burton was denied a second opinion or transfer to another facility, denied legal representation, and found herself confined to the hospital for three days during which time her children were referred to social services (Goodwin 2020). After three days, the hospital did a cesarean section, but the fetus had already died.

Pregnancy becomes an exercise of caution, restraint, and fear. Too often in pregnancy, the boundaries between "dangerous" and "safe" and between "reckless" and "responsible" are shaped in capricious

and rigid ways. Everyone agrees that pregnant women should have access to information and means to stay as safe and healthy as possible. But during pregnancy, a balanced exploration of risks and benefits is replaced by a flight from evidence in which the admonition "don't – just in case" runs roughshod over the facts, not to mention the circumstances of a given woman's life. (Lyerly et al. 2009: 38–9)

Increasingly, women who experience miscarriages or stillbirths are being investigated, charged, and prosecuted for actions that are not illegal, such as attempted abortion, whether real or alleged, suicide attempts, and even being injured by another person in a fight. Melissa Ann Rowland was given 18 months on probation. She took the plea deal to avoid a sentence for murder after she refused a cesarean section and one of the twins she was carrying died (Ross and Solinger 2017). Kenlissia Jones bought misoprostol online to privately terminate her pregnancy (Ross and Solinger 2017). While abortion was not illegal in Georgia at the time, she was arrested for "malice murder" after she took the drug and went to the hospital. The charges that could have carried a life sentence or even the death penalty were eventually dropped, but Ms. Jones had been incarcerated for several days and not allowed to post bail. Jennifer Whalen of Pennsylvania did not plead guilty to the misdemeanors of assault and endangering the welfare of a child by ordering mifepristone and misoprostol online to help her 16-year-old daughter end her first-trimester pregnancy because she would then be denied the ability to continue her job caring for elderly people in an assisted-living facility. Instead, she took her chances pleading guilty to the felony charge of giving medical consultation about abortion without a medical license and hoped the judge would give her probation rather than sending her to jail. He sentenced her to nine to 18 months in prison. These cases, including one in 2022 of a mother helping a daughter have a second-trimester abortion using abortion pills in Nebraska in which both mother and daughter have been charged with felonies, will proliferate as more states prohibit abortion.

The penalties can be stiff, as cases from Indiana demonstrate. In Purvi Patel's case, it is not clear whether she sought to self-induce an abortion or had a miscarriage/stillbirth. She was convicted and sentenced to 20 years in prison in Indiana for alleged abortion and feticide as prosecutors claimed she did not get the baby help after it was born alive based on a controversial lung float test. Although

Ms. Patel had texted about getting abortion medication from Hong Kong, on the night in question, she texted a friend, "just lost the baby." Ms. Patel claimed the fetus was expelled already deceased, and her defense counsel argued that the baby was born too young to have adequately functioning lungs, while the prosecution argued that the baby was further along. Ms. Patel was incarcerated for a year and a half before her conviction was overturned and she was released from prison. Whatever the truth of this case, whether Ms. Patel lost the pregnancy naturally or induced an abortion, this is a far cry from the original intent of the law which was to prosecute people like the Indiana bank robber who shot a teller in the stomach, killing her gestating twins. He received a 53-year sentence for attempted murder and other charges, including eight years for feticide, four for each twin. Ultimately, the feticide convictions were deemed double jeopardy in his case.

A prior notorious case from Indiana is that of Bei Bei Shuai. Late in pregnancy, her married lover left her, and a distraught Ms. Shuai attempted suicide by consuming rat poison. Although born alive by cesarean section ten days after the suicide attempt, her daughter succumbed a few days later, and Ms. Shuai was charged with feticide. She was released from prison a year and a half later after pleading guilty to criminal recklessness.

Christine Taylor in Iowa was more fortunate. The same year that Bei Bei Shuai was arrested, Ms. Taylor tripped and fell down the stairs after an upsetting call from her soon-to-be ex-husband. At the hospital, after confirming that the fetus was fine, she confided to a nurse that she had mixed feelings about the pregnancy because she was going to be a single mom who already had two children. This led the nurse to call the police who interrogated her and held her for two days before deciding not to charge her with attempted feticide.

A recent example of how ludicrous these charges have become is the case of Marshae Jones in Alabama. At five months pregnant, Ms. Jones was involved in an altercation with a co-worker outside the store where they were employed. The coworker shot her in the stomach, and Ms. Jones lost her fetus. The coworker was found to have acted in self-defense. Six months later, Ms. Jones was arrested for manslaughter. The indictment claimed that she "intentionally caused the death of her unborn baby by initiating a fight knowing she was five months pregnant" (Pascus 2019). After public outcry, the manslaughter charge was dropped.

Several women have been charged with feticide/homicide or lesser charges for the demise of their fetuses *in utero* while they were using drugs such as crack cocaine and methamphetamine. Such was the case of an Alabama woman, Amanda Kimbrough, who could have prevented legal action by having an abortion when a doctor recommended one at 20 weeks for Down syndrome. She could have followed the example of Martina Greywind who saw her charges of reckless endangerment for sniffing paint fumes dropped after having an abortion 12 days after being arrested (Roberts 1997). Kimbrough, however, chose to continue her pregnancy and subsequently went to jail for ten years on a plea deal after her son was born prematurely and died. But even when the baby is born healthy, women can be prosecuted for charges such as child abuse. In certain states, a woman can even lose her liberty during pregnancy for past drug use before the pregnancy occurred. We must question the motives behind the current punishment regime for women who use illicit substances while pregnant. Like forcing women to be confined or have medical treatments against their will, they are ostensibly designed to protect fetal health. But not only does incarceration not solve a woman's substance-abuse problem or make her child be born healthier, it also leads to a slippery slope where *all* pregnant women's behavior is policed. Ultimately, it turns pregnancy itself into a crime as an affidavit in one South Carolina case revealed; it stated "that the woman 'did willfully and unlawfully give birth to a male infant'" (Paltrow and Flavin 2013: 331).

"Chemical endangerment"

While punishment for drug-abusing pregnant women may seem fitting at first blush, it is not. First and foremost, if women know that they risk penalties if caught using drugs while pregnant, rather than fear of punishment being an effective deterrent, they simply avoid prenatal check-ups and sometimes even hospital births. Given that these are the very cases that most need medical help, driving these women away from care is detrimental to them and to their babies. Women are often the most likely to seek help for problems while they are pregnant. Missing the best opportunity to help them and subjecting them to criminalization when they reach out for assistance is malicious. If we wanted to improve maternal and fetal outcomes,

we would allow women to be honest with medical providers about their substance use without fear of losing benefits, going to jail, or having their children taken away from them. We would try to assist them to curb and, ideally, quit their substance use, we would fund more treatment facilities that accept pregnant women and allow them to bring their other children, and we would support them through it all. Despite mandated priority for pregnant women, only 13% of drug-treatment facilities accept pregnant patients, and only 5% of pregnant substance users are able to access treatment (Fentiman 2017).

Second, if a woman is incarcerated while pregnant, she incurs additional risks to her future child. Drugs are easily accessible in prison, so incarceration does not curtail drug abuse. Prisons are stressful, unhealthy places. Food and medical care may be of poor quality. In one Arizona prison, there was mouse fecal matter in the drinking water, and in a NJ correctional facility, rotten meat was being served. Prisons are violent. Women are assaulted by other prisoners and by correctional officers, sometimes sexually. In some facilities, pregnant women are placed into solitary confinement "for their wellbeing," which can lead to pernicious mental health consequences (Goodwin 2020). Women have been denied prenatal care and necessary medications while pregnant in jail. Some women have gone unheard or intentionally ignored when they go into labor and have had to deliver alone in their cells on prison toilets or dirty floors (Goodwin 2020). Miscarriages and stillbirths have occurred in prison that might have been preventable with proper care. When they are taken to a medical facility, birthing inmates in some states are forced to walk in chains and are shackled to the bed, both of which are dangerous for women in labor (Stotland 2015) Babies are usually removed from their mothers within an hour to a couple days after birth. The few children who stay with their mothers in special prison facilities are incarcerated themselves, surrounded by guards and prison fences. Children who are separated from incarcerated parents fare poorly, worse than children whose parents have divorced, died, or have a substance-abuse problem (Goodwin 2020). If a woman does not manage to keep up a certain amount of regular contact with her children while she serves her term, which can be difficult given distance between the prison and their home and high phone bills for prisoners who earn cents an hour, she may legally lose them permanently. When she is released, her criminal record will bar many

types of employment, and she may not be eligible for public housing, student loans, and welfare (Ross and Solinger 2017). She may still be in need of a substance-abuse program. How, then, was she, her children, or society bettered by her incarceration?

Third, we have not yet learned our lesson from the crack baby scare. In the 1980s, the media was flooded with reports of babies exposed to crack cocaine *in utero* who suffered severe sequelae. Supposedly, these children would never be normal and would be a drain on school systems and society in general. As Dorothy Roberts (1997) underscores, "[t]he primary concern of this sort of rhetoric is typically the huge cost these children impose on taxpayers, rather than the children's welfare" (Roberts 1997: 15). Yet, as time went on, research failed to uncover permanent deficiencies in children born to mothers who used crack while pregnant. Some patterns that appeared early on, such as motor coordination problems, disappeared by the time babies were a year old (Douglas and Michaels 2004), and other alleged symptoms reported in the press, such as smaller brains and impaired genitalia, were probably never real. What did affect children's intellectual performance, regardless of mother's crack use or lack of it? Living in a poor neighborhood (Furedi 2002; Glassner 1999; Goodwin 2020). Yet the majority of people who lived outside these neighborhoods did not want to talk about them; they wanted to blame "bad moms":

[C]rack babies served as the most powerful metaphor for motherhood poisoned by the excesses of the 1970s and '80s, like drugs, self-indulgence, and female self-actualization run amok . . . These babies . . . had been contaminated by women so selfish, so promiscuous, so insensitive to human life itself that they served as a powerful warning of where children – and the nation itself – would end up if mothers really "just said no" to their maternal instincts. "Crack babies" served as proof that poor, black, inner-city mothers were "she-devils," the grotesque opposite of caring, white, middle-class mothers. (Douglas and Michaels 2004: 153)

The racial component is vital. The panic was not about just any type of cocaine, but rather was focused on crack, the drug of inner-city non-white women. Professional white women in the suburbs using cocaine at parties were not generating these fears. Nor were white, middle-class women addicted to prescription drugs. Initially, it was almost exclusively poor, black women who were targeted for

shaming and legal consequences. The Medical University of South Carolina (MUSC) provided care to women on Medicaid. It also placed billboards advertising drug-treatment programs (Goodwin 2020). Cruelly, it joined forces with the state prosecutor's office to punish crack-using black moms in the 1990s. Unknown to the patients, medical staff were running toxicology tests on pregnant women and newborns and turning the results and other medical records over to the prosecutor's office, which prosecuted 29 black women and one white woman, regardless of the health of the baby. The one white woman who was prosecuted had a child with a Black man, and the boyfriend's race was noted in her file by a nurse – who called him a "negro," despite it being the 1990s (Goodwin 2020). Another white woman who met the criteria for arrest was not arrested because someone intervened on her behalf and asked that she be given another chance (Goodwin 2020). A MUSC doctor admitted that administrators and physicians were targeting women and babies with cocaine in their blood, but not alcohol or heroin, despite the potential adverse consequences of these substances (Goodwin 2020). One of the specialists who helped debunk the crack baby epidemic, Dr. Claire Coles, found herself anathema in the press for reporting facts such as babies exposed to crack *in utero* do not go through withdrawal. She was not telling the story everyone wanted to hear, so this expert was sidelined (Goodwin 2020).

As law professor Dorothy Roberts (2022: 174) explains about selective newborn screening for substances, "[h]ealth care facilities structure their screening procedures to protect the privacy and integrity of the most privileged families and to invite intrusion into black families." For example, while black and white women use illicit drugs at about the same rate during pregnancy (14% of black women and 15% of white women), black women are reported to authorities ten times more frequently (Goodwin 2020). Latina women, Native American Indian women, and poor women of all races are also more likely to find themselves afoul of the law for drug use during pregnancy (Goodwin 2020). Law professor Michele Goodwin (2020) helps identify multiple reasons why: the illicit drugs associated with some groups are already criminalized, whereas the use of prescription drugs and alcohol by better-off women was largely ignored for a long time; racism, where white women are more likely to be given second chances; and the fact that well-off women can afford better legal representation. Lenz (2020: 176) points out that

[t]he label "bad mother" is used too freely and always carries a sting. But it's more bark than bite for people who look like our culture's maternal ideal . . . For others, if they don't succeed, they risk social alienation, having child services called on them, and being seen as confirming vicious stereotypes about their race, sexuality, gender identity, class, or disability. (Lenz 2020: 176)

Overall, these cases "point to a disturbing pattern of state abuse that especially targets women of color, immigrants and low-income women for pregnancy criminalization and punishment – holding individuals simultaneously *responsible for* and *powerless over* their pregnancies" (Fixmer-Oraiz 2022).

Today, even those mothers typically held up as "good" mothers, white, middle-class married women, are increasingly targeted too. In her book, *Policing the Womb*, Michele Goodwin argues that black women are canaries in the coal mine. They may be prosecuted first and most frequently, but their losses are an indicator of what can be extended to all women. More and more poor, white, expecting women find themselves in trouble for alcohol consumption, opioid addiction, or methamphetamine use. As anthropologist and law professor Khiara Bridges explains:

in the 1980s, when faced with the fact of pregnant women who used and were dependent on substances, we chose the path of prosecution. We made this choice, in part, because so many of the women were black. Throwing these women in jail was politically acceptable – and desirable – because they were black. Now, in the early decades of the twenty-first century, we have a racist model to guide us in managing the social problem of pregnant women who use and are dependent on substances. White women facing criminal charges for opioid use during pregnancy may just be reaping the bitter seeds of the racism that the government directed toward – and designed for – people of color. (Bridges 2020: 849)

In 2006, Alabama enacted a chemical endangerment to a minor statute that has been used not only to prosecute people who took children into dangerous methamphetamine labs, but also to punish pregnant women for using the drug. Instead of the lab being the dangerous environment, the woman's womb became the dangerous environment for the minor who had to be protected (Goodwin 2020). Women face up to 10 years in prison if nothing is wrong with

the baby, 10–20 years if the baby exhibits symptoms of exposure or ill effects, and 10–99 years if she loses the baby during pregnancy or at or after birth (Martin 2015).

White women are swept up by this measure, but they are predominately poor. Out of 35 cases in which Howard (2014) could determine type of legal counsel, 33 defendants were appointed indigent defense counsel and only two retained a lawyer. Republican and Democrat lawmakers alike have supported Alabama's Chemical Endangerment to a Minor law (Howard 2014), despite statements against these kinds of laws by the American Medical Association and the rise in the rate of births occurring outside hospitals in the state. Howard (2014: 375) asserts that "the disproportionately white, poor, and methamphetamine-related arrest demographics are reflective of anxiety about perceived white degeneracy – that this population of deviant whites are perceived as polluting the white race and violating the norms of supposed white moral superiority." Yet the swarm of prosecutions facing women is ever-expanding, including for drugs that are legal in some US states. Katie Darovitz, a white woman from Alabama, took marijuana to control her epileptic seizures during her second pregnancy precisely because she feared the anti-seizure medications she took during her first pregnancy contributed to her pregnancy loss as those drugs are associated with birth defects. She gave birth to a healthy son but was arrested when she and the baby tested positive for cannabis (Martin 2015). As Lyerly et al. (2009: 40) argue, "[u]sually, what's best for the baby is what's best for the pregnant woman, and vice versa. Sepsis from a ruptured appendicitis is good for neither woman nor fetus; a hiatus from fish . . . may rob the fetus of nutrients important to brain development; and a mother's struggle with severe depression (not to mention the risk of suicide) has potentially profound implications for her children." Women who take legal, prescribed drugs for legitimate psychiatric or pain-management purposes are increasingly at risk of legal consequences, even though older, white women are the most likely group to take prescription drugs while pregnant (Goodwin 2020).

In Alabama, women were prosecuted even for taking drugs legally prescribed by a physician. Hannah Ballenger had a brain fluid leak caused by a head injury that led to chronic pain. The painkillers were expensive and addictive, so she went on methadone. She continued to take methadone throughout her pregnancy, slowly diminishing her dose under a doctor's care. Nevertheless, she was arrested and

lost custody of her child. "'I got charged for being on methadone, and he's healthy,' Ballenger said bitterly. 'But if I had come off the methadone cold turkey, and he had died, they would have arrested me for killing him. I would have gotten charged either way'" (Martin 2015).

Although Alabama amended its chemical endangerment to a minor law after ten years so that women taking medications prescribed by doctors would not be prosecuted, in 2020, Kim Blalock, a white, married mother of six found herself charged with prescription fraud for taking her own legally prescribed hydrocodone for severe back pain. Ms. Blalock had gone off the pain medicine when she became pregnant, but during the last six weeks of her pregnancy, her back pain, the result of a car accident, arthritis, degenerating discs, and surgery, became excruciating (Yurkanin 2021). With other young children at home to care for, she refilled her prescription. After telling her obstetrician at the birth that she had taken hydrocodone, her newborn son was tested and found positive for opiates. Initially, Ms. Blalock believed she was cleared when she showed her prescription and allowed Department of Human Resource officials to count the pills in her bottle (Yurkanin 2021). Nevertheless, prosecutors decided to go after her. Because they could no longer charge her with chemical endangerment, given that the drug was a legal prescription, they charged her with prescription fraud, asserting that she did not inform her orthopedist she was pregnant and was therefore in the same league as people who fake their identity or forge a healthcare provider's signature to get a prescription. Ultimately, the outrageous charges of fraud were dropped a year and a half after her child's birth, but the fact that prosecutors tried to invent a novel strategy to criminalize a pregnant woman's legal behavior is revealing.

It is worth noting that Ms. Blalock's son was not born with any evidence of opiate use other than his toxicology screening. He was healthy and continues to be developmentally on target. Mothers are frequently prosecuted even in cases without any evidence of actual harm to their offspring; in fact, in only one-third of cases of prosecutions for substance abuse during pregnancy was an actual adverse pregnancy outcome reported (Seiler 2016). This is not new. Ms. Blalock's son was born healthy in 2020; Jennifer Johnson's children were both born healthy in the late 1980s, despite her crack cocaine and marijuana use (Daniels 1996). Ms. Johnson was the first person convicted of delivering a controlled substance to a minor via the

umbilical cord, although the ruling was overturned three years later in 1992.

Seiler (2016: 625), the author of the study on prosecutions for drug use during pregnancy, also found that even in the third of cases concerning a deceased fetus or impaired child, "causal evidence linking the woman's behavior to the outcome was often weak or nonexistent." Goodwin (2020) takes up this issue in the case of Regina McKnight whose child was stillborn. She served almost 10 years of a 12-year sentence for murder before her conviction was overturned, in part because of faulty medical evidence. Despite her unsuccessful pregnancy, there is no incontrovertible evidence that her use of drugs led to the baby's death. Stillbirth can be caused by problems with the placenta or umbilical cord, illnesses and infections, and unexplained causes that may be linked to poverty and stress (Fentiman 2017; Goodwin 2020). Yet women are routinely punished despite this and the reasonable doubt that it should cause. Brittany Poolaw was 17-weeks pregnant when she lost her baby. She suffered from placental abruption, and the fetus also had congenital abnormalities. Congenital anomalies, often due to chromosome problems, increase the odds of miscarriage. But Ms. Poolaw also admitted that she had used marijuana and methamphetamine during her pregnancy. Even though a witness for the prosecution testified that her drug use may not have been a direct cause of the stillbirth, Ms. Poolaw received a four-year prison sentence (Goldberg 2021).

These ongoing prosecutions, despite the track record of several of these cases being overturned on appeal, the easing of the "war on drugs," and the evidence that harsh drug laws for pregnant women do more harm than good for fetal health outcomes, speak to the strong impulse in society to punish women who are deemed to fail at motherhood. Daniels explains:

> The image of the pregnant addict is deeply troubling, representing as it does the paradox of a woman simultaneously engaged in the destruction of life (addiction) and the perpetuation of life (pregnancy) . . . The birth of an addicted baby violates what we think of as an imperative of human society – that we care for and nurture, if not ourselves, then at least our children. When communities are confronted with events that seem tragic and inexplicable, there is a great need to reestablish some sense of order by identifying a culprit. Assigning blame puts disturbing events back into the realm of human control, reestablishing our sense of security by locating a source of disruption.

Our culture and laws encourage us, even require us, to fix blame on individuals and to downplay social forces beyond the individual's control. (Daniels 1996: 98)

In their study of 413 cases between 1973 and 2005, Paltrow and Flavin (2013) found that four-fifths of the time the woman was no longer pregnant by the time the legal intervention occurred. The fact that many women are prosecuted after the birth has occurred points to these measures being more about punishing "bad" mothers, and the message this sends to all women, than being about helping babies. Roberts (1997: 180) argues that "[j]udges . . . are pronouncing not so much 'I care about your baby' as 'You don't deserve to be a mother.'"

In some cases, accused women have no counsel, but their fetuses do. For instance, in Tamara Loertscher's drug use during pregnancy case, the child abuse charges meant that the juvenile court proceedings were sealed and that Ms. Loertscher did not automatically have legal representation while her fetus was given a guardian *ad litem* (Bailey 2017). The American Medical Association (AMA) brief supporting Ms. Loertscher's appeal inveighed that "[t]he State relies on the popular, but scientifically disproven, perception regarding the relative harms of *in utero* exposure to controlled substances . . . 'no one knows what level of drug or alcohol use poses a risk to the child.'" One of the judges in Wisconsin's seventh circuit dismissed the brief from the medical organization as without credibility (Bailey 2017), ultimately proving the very thing that the brief argued, that the law relies on popular notions about drug use during pregnancy rather than actual scientific data. Women who use alcohol, controlled substances, or their analogs during pregnancy were categorized as "uncooperative," despite the fact that Ms. Loertscher sought care from a doctor for hypothyroidism when she found out she was pregnant after believing her condition made pregnancy impossible (Bailey 2017). She stated she wanted to stop using marijuana and methamphetamine after finding out she was pregnant. The state jailed her for 18 days and then mandated that she undergo frequent drug testing for the rest of the pregnancy, none of which came back positive, matching her stated goal when she sought medical care (Bailey 2017).

The Wisconsin law can be used for women with a past history of substance abuse even if they have not used since finding out they were pregnant. This was the case of Alicia Beltran who received a court order to attend an inpatient drug-treatment facility for two and a half

months, even though she stopped using drugs before her pregnancy and had a single Vicodin tablet for pain prior to realizing she was pregnant (Goodwin 2020). Like Ms. Loertscher, Ms. Beltran had no counsel, but her fetus did. After being confined for 78 days, she lost her job and, consequently, her home prior to giving birth. In addition to drugs and past drug use, the Wisconsin Unborn Child Protection Act also includes alcohol, a legal substance. In more than half of US states, a pregnant woman can find herself facing involuntary civil commitment for alcohol or other substance use during pregnancy (Fentiman 2017).

Misguided fears about alcohol use during pregnancy

Sociologist Elizabeth M. Armstrong (2003) details how, until the 1970s, women were not told that alcohol was dangerous during pregnancy; in fact, doctors communicated that it was relaxing and could assist with sleep during pregnancy. Alcohol was even used intravenously by physicians to halt early labor (Armstrong 2003; Golden 2005). By the end of the twentieth century, however, the views on alcohol consumption had changed radically due to concerns about a new disorder, fetal alcohol syndrome (FAS). A constellation of abnormal facial features, growth and developmental delays, and neurological impairments, FAS received coverage in the media, became a new public health threat, and rapidly entered popular awareness. The groundbreaking publication on FAS by Jones et al. (1973) and other 1970s FAS articles drew conclusions based on cases of women who drank so much alcohol that they were chronically ill and often were lost to follow-up or dead within a few years of their children's births (Golden 2005). Surprisingly, however, even among women suffering from alcoholism, not all babies have FAS. Sokol, Ager, and Martier (1988) set a threshold for FAS at 42 or more drinks per week, but that does not mean that all babies of mothers who drink that heavily exhibit FAS. Positive diagnosis is strongly linked to the length of time the mother has been an alcoholic and her social class (Abel and Hannigan 1995; Armstrong and Abel 2000; Bingol et al. 1987). A 1987 study of lower income and wealthier alcoholic women pointed to mediating effects such as nutrition. Despite controlling for level of alcohol intake, Bingol et al. (1987) found that among children born to poor alcoholic mothers, the rate of FAS diagnosis was 71%,

but was only 4.5% for the children of wealthier alcoholic women who drank the same amount. Building on the Bingol et al. study, work by Abel and Hannigan (1995) and others questions whether the pattern of alcohol consumption, in particular binge drinking, may be more likely to have a teratogenic effect on offspring and also points to the cofactors of cigarette smoking, stress, and poverty, as well as the toll on the body from years of alcoholism. Tellingly, despite the gains that would be made if FAS could potentially be reduced by ensuring good nutrition for pregnant women who drink excessively or helping alcoholic women change their patterns of consumption to stabilize their blood alcohol level, surprisingly little work has been done in the past 40 years to elucidate these and other variables that correlate with social class.

What should have happened was the targeting of alcoholic women and trying to assist them through more research on the effects of interaction between alcohol, poverty, stress, nutrition, and binge drinking and by opening more substance-abuse clinics that would take pregnant women and allow them to bring their other children. Instead, warnings were issued to all pregnant women in the 1980s that made no distinctions between low or moderate alcohol consumption and heavy drinking. By 1981, the US Surgeon General had issued an official warning, and girls and women from the 1980s onward grew accustomed to seeing warning signs in restaurants and bars as 24 states currently legally mandate. Alcoholic beverage labels have carried warnings addressed to pregnant women since 1989. In 2005, the Surgeon General released a "Message to Women," declaring that "no amount of alcohol can be considered safe" (US Surgeon General 2005). Concerns around FAS have been stoked again in the past few years due to the promotion of the 2016 Centers for Disease Control and Prevention's (CDC) latest warning that all sexually active women not using birth control should refrain entirely from drinking. This not only echoes the Surgeon General's original warning to "women who are pregnant (*or considering pregnancy*) not to drink alcoholic beverages and to be aware of the alcoholic content of food and drugs" (italics mine), but goes beyond it to women who are not attempting to conceive but simply do not use contraceptives. In a *New York Times* article (Belluck 2018: A16), Dr. Howard Taras was quoted admonishing: "People say, 'Don't be ridiculous, I went to a wine tasting and my kid came out fine' . . . But the CDC is saying 'We don't know. Maybe you just won

the lottery.'" This is a revelatory example of experts disparaging women's lived experiences that match the scientific data about low levels of alcohol consumption being safe and instead favoring unsubstantiated narratives of heightened risk.

Despite increasingly draconian warnings from public health officials, there is no case in which a single drink during pregnancy has had a deleterious effect on a baby's outcome, and there is actually evidence that the children of mothers who drink lightly during pregnancy do better on multiple measures than those of women who abstain from alcohol entirely. Kelly et al. (2009) found fewer behavioral problems in the children of light drinkers during pregnancy than in those of abstainers. Recent research by McCormack et al. (2018: 334) based on a national study of Australian parents and their children not only found that 12-month olds whose mothers drank seven drinks or fewer per week during pregnancy had better cognitive scores than the children of abstainers, but, addressing fears about women who drink before they know they are pregnant, they also found that "[a]lcohol exposure *at any level* [italics mine] in the first 6 weeks of Trimester 1 was not associated with any difference in Bayley cognitive score in unadjusted analyses nor following any level of statistical adjustment." The better scores for children of light drinkers are likely more about the socioeconomic level of the parents, as better-educated people are more likely to drink alcohol, than it is about the drinking itself, but it goes against the prevailing narrative that even light drinking during pregnancy is harmful. And this type of finding is neither new nor unique, as du V. Florey and Taylor (1992) reported similar results on multiple measures of development 30 years ago.

In fact, evidence is debatable that drinking during pregnancy will result in FAS unless the woman is, in effect, drinking to the level that she should be concerned about a possible drinking problem and her own health (e.g., binge drinking). Floyd, Decouflé, and Hungerford (1999) write that "[d]ocumented cases of fetal alcohol syndrome have been found predominately among women consuming heavy amounts of alcohol (i.e., *10 drinks or more per day* [italics mine]), although more recent studies have found measurable growth and cognitive effects among children whose mothers drank at thresholds comparable to an average of six to seven drinks per week" (Floyd, Decouflé, and Hungerford 1999: 105). The articles they cite for cases of deleterious effects at six to seven drinks run into a common

problem, conflating low-level drinking on a regular basis with extreme consumption in one sitting. Given credible questions about negative effects of binge drinking specifically, it could be that having seven drinks in a row every Saturday could be linked to FAS, whereas having one drink a day seven days in a row is not, yet both would fall under the category of an average of six to seven drinks per week (Armstrong and Abel 2000). Jacobson and Jacobson (1994), while unwilling to declare any amount of alcohol safe, repeatedly note that there is little evidence of neurobehavioral effects and no functional impairment below seven drinks per week, and although they report a threshold of seven to 28 drinks per week for neurobehavioral effects, their drinkers who consumed seven or more drinks per week drank an average of six drinks *per day*. Results for neurodevelopmental/cognitive deficiencies at lower levels of consumption are contradictory and hard to tie directly to alcohol rather than to class level of parents, genetic factors, etc. May et al. (2018: 481) admit that "in the absence of a definitive biomarker for fetal alcohol spectrum disorders, it is impossible to know what proportion of these deficits was caused by fetal alcohol exposure. Therefore, prevalence estimates, particularly for alcohol-related neurodevelopmental disorder, could be overestimated."

Due to a different historical relationship and social norms around alcohol consumption as a complement to meals and convivial social events, even after the advent of FAS, Europeans initially tended to be less categorical on the issue of alcohol during pregnancy than Americans, who typically take the puritanical approach of total abstention. More recently, however, there has been a worldwide move to caution women not to drink at all, despite a lack of evidence warranting complete abstention. In the United Kingdom, for example, health officials reversed themselves repeatedly over a short period of time (e.g., "Women told glass of wine a day is fine during pregnancy – and too dangerous": Rose 2007, *The Times*, United Kingdom). One exception of a public health notice that matched the actual evidence and respected mothers-to-be was the one that Singapore's Ministry of Health posted in the mid-2010s, where women were more honestly advised: "If you have one or two drinks of alcohol (one or two units) once or twice a week, it is unlikely to harm your unborn baby. However, the amount of alcohol that is safe in pregnancy is not definitely known. Heavy or frequent drinking can seriously harm the baby's development."

Ultimately, most of these warnings have more to do with the social than the biological. In exploring why researchers continually misrepresent findings that low levels of drinking during pregnancy are not dangerous, it becomes apparent how the gendered component of these warnings is a primary cause for the ongoing admonitions aimed exclusively at women based on weak or nonexistent evidence. The real goal is less about safeguarding children and more about ensuring women's compliant behavior. Some doctors claim that women won't understand the difference between a little and a lot, and therefore permitting some alcohol could give women license to think they can indulge as much as they want. Oster (2021: 39), who heard this repeatedly from physicians she spoke to, states that "I'm not crazy about the implication that pregnant women are incapable of deciding for themselves – that you have to manipulate our beliefs so we do the right thing."

FAS is a telling example of how the social control of women is so strong that it seeps from societal norms and subjective politics into scientific fields that claim objectivity and conclusions based on facts. "One or two weak studies can rapidly become conventional wisdom" (Oster 2021: xxiv). Beyond slights such as turning "frequent drinking" into drinking *any amount*, health researchers also mix behaviors that society deems undesirable with behaviors that are actually dangerous. In a revealing CDC report, Tan and colleagues (2015: 1042) define excessive usage as "binge drinking (≥4 drinks on an occasion for women, ≥5 on an occasion for men), high weekly consumption (≥8 drinks a week for women, ≥15 drinks a week for men), *any alcohol consumption by pregnant women, or any alcohol consumption by those under the minimum legal drinking age of 21 years*" (italics mine). Clearly, an 18-year-old having one beer at a party is not at risk of cirrhosis of the liver, even though s/he may be breaking the law. The authors therefore confuse laws and, in the case of pregnant adult women, norms with actual detrimental health outcomes.

Like the crack baby scare, overblown warnings and press coverage of FAS are a classic example of a moral panic (Armstrong and Abel 2000; Bell, McNaughton, and Salmon 2009; Cohen 1972). Sociologist Barry Glassner (1999) explains how the construction of social problems follows set patterns, such as experts who make a name for themselves in their careers or in the media through their claims about an issue extending the scope of the problem beyond

the original parameters and relying on misleading statistics. The continuing insistence on FAS as an epidemic warranting media attention and federal dollars, despite evidence to the contrary, is bigger than the careers of individual scientists and advocacy organizations that stand to gain from increased interest in their specialty. As pointed out by Gray, Mukherjee, and Rutter (2009: 1270) in an article about the dearth of convincing data that low-level drinking during pregnancy is dangerous or whether it is a significant factor in neurodisability, "evidence alone is rarely sufficient to guide policy, which is shaped by culture and politics as well."

Glassner (1999) makes the case that the advent of a social problem based on pseudo-dangers does not occur in a vacuum but rather emerges at a given point in time because it resonates with specific cultural anxieties. Others have argued that FAS arose in the 1970s precisely because it was a moment in which environmental toxins reached public awareness, concerns about protecting precious children were heightened, and, perhaps most importantly, women's roles in society were changing leading more and more women to work outside the home and lobby for greater rights, including the right to legally terminate a pregnancy (Armstrong 2003; Best 1990; Golden 2005). As discussed at the beginning of the chapter, abortion raised the issue of a pregnant woman and a fetus potentially having an antagonistic relationship, and a doubling down on messages about what it means to be a good mother can be seen in that moment as a form of backlash to women's increased independence.

As it was some 40 years ago, the current misplaced emphasis on FAS risk prevention aimed at all women is not simply a natural outgrowth of doctors' desire to protect patients and policy makers' desire to protect the public, but rather is situated in a larger social context. The 1970s and 1980s saw a conservative political swing, in part focused on personal responsibility, that sought to counteract the social progress and rights for minority groups of the 1960s (Armstrong and Abel 2000). A recent return to conservative ideology resulting in, as well as fanned by, the election of President Trump in 2016 in the United States has led to attacks on women's health and rights that mimic arguments made in the 1970s. The result has been the upending of Roe v. Wade, previously thought to be settled law, by the Supreme Court and numerous states enacting laws to stop abortion after six weeks or altogether.

While certainly not all, or even most, of public health researchers, ob/gyns, pediatricians, and developmental biologists are conservative or hostile to women's rights, the inherent sexism of modern US society affects perceptions and behaviors of everyone raised here at this time in history, male or female, conservative or liberal. As sociologist Allan Johnson (1997: 41) writes, "[s]ince the [social system] we're participating in is patriarchal, we tend to behave in ways that create a patriarchal world from one moment to the next." This sexism can slip out in a variety of ways either in direct hostility or much more benevolently (Glick and Fiske 1996; Hebl et al. 2007), like a well-meaning doctor telling a healthy, pregnant woman who wants to have a glass of wine on her birthday not to – after all, what kind of mother would risk her baby's health? – perhaps without realizing that he or she recommends a glass of wine to pregnant patients following amniocentesis. The difference, of course, is about the proper role of a mother and (often subconscious) beliefs about morality. Glassner (1999: xxvi) discusses anthropologist Mary Douglas's work on risk: "Dangers get selected for special emphasis, Douglas showed, either because they offend the basic moral principles of the society or because they enable criticism of disliked groups and institutions." Choosing to have a drink to celebrate a social occasion while pregnant can be read as selfish, whereas having a drink because a doctor said it might prevent dangerous contractions after a medical procedure is seen as following doctor's orders as any mother (even if she as yet has no children) should do.

Selfishness is deemed antithetical to motherhood (Hays 1996). While seeping across social categories, this is especially ubiquitous among middle- and upper-class women who perform "intensive mothering," but somewhat less characteristic of working-class women from backgrounds where children's needs can be viewed as second to the parents' or family's needs (Hays 1996), suggesting an interesting class lens for the treatment of alcohol use by women of different backgrounds. Golden (2005) traces how middle-class, white mothers were initially portrayed as unwitting victims who hurt their children unknowingly through their alcohol consumption compared to later media reports highlighting FAS among less-advantaged women, predominately of indigenous, black, and Latina women, who were portrayed as choosing their desire for alcohol over their love of their children. Hays's assertion that the overinvestment in the mother–child relationship is so extreme precisely because society

demands a bulwark against selfishness in an era of family disinte-
gration and capitalism run rampant provides an explanation for the
vehemence of reactions to mothers who appear to reject self-sacrifice,
even for non-consequential actions.

Bell, McNaughton, and Salmon (2009: 158) "suggest that the
current assessment of the state of the evidence regarding the health
'risks' attached to foetal [sic] alcohol exposure, childhood exposure
to tobacco smoke and childhood overnutrition should be viewed as
an ideological project as much as an empirically driven one." They go
on to point out that "each issue has stimulated the creation of large,
well-funded and politically powerful movements that have sought to
denormalise these behaviors and even enact legal sanctions against
those who place their children 'at risk'" (2009: 160). The societal
consternation and its attendant need to control "bad mothers"
(Bell, McNaughton, and Salmon 2009; Glassner 1999; Hunting
and Browne 2012) thus permeates the "medico-moral discourse,"
reaching into grant-funding institutions, doctors' practices, and the
media (Bell, McNaughton, and Salmon 2009). It also affects the
penal code.

Writing on the intersection of health guidelines about substance
abuse and alcohol consumption during pregnancy and the law,
Seiler (2016: 624) states that, "[a]ll of these laws may be grounded
in concepts of health protection, and one might presume that the
focus on reporting infant outcomes reflects a nonpunitive approach
to mothers." It does not. In Tamara Loertscher's drug case, the
Wisconsin Solicitor General Misha Tseytlin told the court that the
law's purpose is to provide "voluntary health and social services for
mothers in need of help," and yet Ms. Loertscher was sent to jail for
child abuse of her fetus, even though she was seeking medical care
and trying to become drug free.

Roberts and colleagues (2017) studied states by counting the
number of punitive, supportive, or mixed alcohol and pregnancy
policies they had implemented between 1970 and 2013; they find
that alcohol policies concerning pregnant women are becoming
increasingly punitive. Punitive policies attempt to control women's
behavior by reporting their "abusive behaviors" (typically after the
child is already born) and removing their children or terminating
their parental rights. Supportive policies seek to provide women
with information (in their definition, this includes warning signs in
restaurants and bars) and substance-abuse treatment programs that

prioritize pregnant women. Mixed policies include both punitive and supportive policies. Evidence suggests that punitive policies, as we saw with drug cases, cause women to be more cautious and delay prenatal care and substance-abuse treatment, thus undermining rather than aiding efforts to improve fetal and neonatal health (see also Jessup et al. 2003; Roberts and Pies 2011). After showing that punitive policies are positively associated with state policies that "restrict women's reproductive autonomy," Roberts et al. (2017: 6) conclude that "a primary goal of pursuing such policies appears to be restricting women's reproductive rights rather than improving public health." Goodwin concurs; she makes the case that fetal protection laws serve to "preserv[e] patriarchy and the subordination of women" (2020: 197), and she also argues that "promoting health and safety is simply a pretext or proxy for class and racial discrimination" (2020: 147). The targeting of black women in the United States for crack use, and Native American and Native Canadian women for alcohol use, during pregnancy supports this.

In addition to the concrete instances of punitive actions toward women (e.g., losing custody of their children and/or going to jail), it is crucial to point out that in a study of perceptions of women's behavior during pregnancy, those respondents most likely to express support for punitive actions toward pregnant women who engage in strenuous exercise, eat seafood, or drink alcohol reported that they were motivated by concerns *other than* a belief that the mother's actions would hurt the fetus (Murphy et al. 2011). This is striking. While there was an association with beliefs that the behavior was dangerous for the mother, but not the fetus, the strongest association was with negative feelings about pregnant women who drink. The authors report that respondents who believed that these behaviors were indeed detrimental to the fetus were *less*, rather than more, likely to endorse punitive measures directed at pregnant women engaging in these actions (Murphy et al. 2011). Taken together, the evidence above, from a psychological study, courtrooms, and state policies, suggests that the desire to punish women who ignore admonitions not to drink while pregnant is more about controlling women's non-normative behavior than it is about a genuine desire to ensure healthy babies.

The extension of warnings about alcohol and monitoring of *all* pregnant women's behavior, not just those abusing alcohol, as well as the tendency to punish rather than help those women who are

indeed suffering from an addiction to alcohol, is an indication of the patriarchal underpinnings at play. The Surgeon General and CDC's targeting of pregnant women for alarms about alcohol not only neglects the higher rates of harm caused by men who have imbibed (see Armstrong 2003 on gendered rates of assault and vehicular accidents while under the influence of alcohol) but puts all women, not just those at risk of having babies with FAS, under increased surveillance – both by the state and by the benevolently sexist bartender, waiter, or neighboring restaurant patron. While this is worse and leads to more consequential penalties for poor women and for women of color (Bell, McNaughton, and Salmon 2009; Seiler 2016), it leads to costs, both societal and psychological, for all women. Striving to convince women that even one drink during pregnancy is selfish and disqualifies them from the "good mother" category perpetuates sexism and the unequal treatment of women. In an era of increased restrictions on women's bodies and behavior, attacks on their autonomy, and continued harassment, it is as important as ever to challenge messages to women that come from a place of social control, perhaps especially when they are coming from a trusted source of medical knowledge.

Given the CDC's misguided warning on FAS, it would make sense for them to issue more appropriate warnings in line with the fact that FAS researchers are not looking for effects, even neuro-developmental ones, below seven drinks per week or two drinks in a row. Thus, instead of total abstention, the CDC and the Surgeon General could use existing research to advise people in general, including pregnant women, that they can safely drink light amounts of alcohol but that more frequent drinking and larger amounts of alcohol in one sitting should be avoided. Binge drinking is not healthy and presents risks, such as impaired decision making, to anyone of any age, class, sex, or pregnancy status, so there is no need to focus warnings about binge drinking on pregnant women. Even if public health officials issue a conservative recommendation well below thresholds where researchers start to look for the mildest forms of fetal alcohol spectrum disorders, public-health sanctioning of light drinking during pregnancy would profoundly affect how Americans view pregnant women who drink and how pregnant women think about their own behaviors. It would also encourage women to ask questions and do their own research into drinking while pregnant. It may even open the door to pregnant women

discussing their drinking behavior more honestly with their medical care providers.

Slippery slope

In addition to prosecuting women for numerous legal behaviors, such as drinking and taking prescription drugs or refusing to follow medical recommendations during pregnancy, women are scrutinized for a plethora of trivial actions before giving birth. Following advice in pregnancy books, from friends, or in the media, women worry about doing too much exercise, using computers or photocopiers at work, cooking with a microwave, changing the cat litter, taking a bath, painting their nails, or dyeing their hair. In her book, *Expecting Better: Why the Conventional Pregnancy Wisdom Is Wrong – and What You Really Need to Know*, author and economist Emily Oster (2021) reviews the research on several of these topics and disputes many of the classic recommendations. While she advises against smoking, based on solid evidence, her discussion of many other substances, including alcohol and caffeine, is far more nuanced. She recognizes that the advice on what to eat when pregnant can be maddening. Women report feeling like they would have to eat all day long to get every nutrient in the amounts recommended by books such as *What to Expect When You Are Expecting* (Murkoff 2016). And the list of what not to eat is controversial and culturally dependent. Unpasteurized cheeses, lunch meats, raw eggs, and sushi all make the list of *verboten* foods for mothers-to-be in the United States. Oster (2021) challenges some of these recommendations, and Druckerman (2012) mentions that some French women report not being told of any food restrictions during pregnancy. She writes of women eating steak tartare and unpasteurized cheese, and a friend who said her doctor told her to eat oysters and sushi as long as she washed things well and ate in good restaurants. My children's French grandmother repeatedly told me while pregnant that I should consume red wine because it was "good for the baby." Druckerman (2012: 25–6) writes, "[t]he French pregnancy press doesn't dwell on unlikely worst-case scenarios. *Au contraire*, it suggests that what mothers-to-be need most is serenity."

Contrast this to what Lyz Lenz (2020: 2), an American mother of two, writes in her book *Belabored* about what she was made to feel

while pregnant: "[e]verything endangers your child. High heels. Cold medicine. Working. Not working. Painting your nails. Not painting your nails. Eating too much. Not eating enough. Breathing. Living. Everything is a threat. You are the threat." The mother creating the future child is seen as the threat. Lenz was asked by a supermarket cashier if she should be purchasing salmon.

Lyerley questions what these admonitions actually accomplish:

> The explicit aim of all these restrictions, of course, is to safeguard the health and well-being of the fetus. For a great many such restrictions, though, the exposure or activity carries no actual evidence of harm, and sometimes carries evidence of safety. Far from being based on a balanced exploration of risks and benefits, restrictions are often based on an imagined or theoretical risk without due consideration of data supporting safety or even possible benefit. Take that worry about sushi, for instance. Warnings to avoid it are based on the speculative risk of foodborne illness from parasites. But as Stephen Shaw, an op-ed contributor to the *New York Times* artfully noted, the risks are unfounded for a panoply of reasons. Sushi is flash-frozen to destroy parasites; it is shellfish, not sushi, that is responsible for the vast majority of food-related illnesses; and most species of fish used for sushi are unlikely (by virtue of their size or habitat) to have parasites. "The risk of falling ill from eating [seafood excluding mollusks]" notes Shaw, "is 1 in 2 million servings; by comparison, the risk from eating chicken is 1 in 25,000." All of this prompts the question of why sushi got selected for restriction, and not, say, lettuce, as happened in the United Kingdom. (Lyerly et al. 2009: 38)

Recall that Murphy and his team (2011), mentioned above, did not just look at perceptions and desired consequences for women who drank alcohol during pregnancy but also measured attitudes about women who ate seafood while pregnant and also women who engaged in strenuous exercise. Of course, the safety of exercise during pregnancy depends on numerous factors: how fit the woman was before pregnancy, what type of physical activity her body is used to, the temperature outdoors or of the gym where she is working out, how many fetuses she is carrying, what stage of pregnancy she is in, if the sport is likely to cause injuries (e.g., a contact sport) or is low impact (e.g., swimming), to name a few. While people are quick to pronounce judgment, the decision is the woman's. Taking something healthy – exercise – and making women fearful to do it, perhaps

simply because they are afraid of being judged doing it visibly pregnant, is both a shame and a violation of women's autonomy. As Oster (2021: xix) writes, "being pregnant [is] a lot like being a child again. There [is] always someone telling you what to do." Similarly, Garbes (2018: 7) notes that the attention to what pregnant women ingest is "infantilizing and oppressive" and concludes that all questions about pregnancy are political.

Several years ago, I was eating lunch with three colleagues from work, two other women and a man. All of us were parents. At the end of our meal in the university cafeteria, I offered to get anyone at the table coffee, tea, or dessert on my way to get some. My friend who was pregnant with her second child asked me to get her a cup of tea. The man at our table immediately exclaimed, "You can't have tea! There's caffeine in it!" I, the pregnant woman, and our other friend were shocked. Unfortunately, instead of putting him in his place and telling him he had no business commenting on what a grown woman could or could not eat or drink, we tried to justify her actions to him. I said, "She's past her first trimester," and our other friend stated, "There's so little caffeine in tea." The power of social control.

> The dominant idea of a "good mother" in North America requires that women abjure personal gain, comfort, leisure, time, income, and even fulfillment; paradoxically, during pregnancy, when the woman is not yet a mother, this expectation of self-sacrifice can be even more stringently applied. The idea of imposing any risk on the fetus, however small or theoretical, for the benefit of a pregnant woman's interest has become anathema. A second cup of coffee, the occasional beer, the medication that treats a woman's severe allergies but brings a slight increase in the risk of cleft palate, the particular SSRI that best treats a woman's severe recalcitrant anxiety disorder but brings a small chance of heart defects – all are off limits, or nearly so, to a "good mother." (Lyerly et al. 2009: 40)

Women are routinely told what to do or not do, by friends and by strangers, while pregnant – as well as being touched on the belly without their permission (Waggoner 2017). This is more than just busybodying. It reflects people's assumption that a woman's unborn child is a collective good that gives every passerby the right to weigh in. Women are refused alcohol in restaurants and told to order decaffeinated coffee in cafes by well-meaning but misguided

employees (Abrahamson 2019; Golden 2005; Lenz 2020). They are shamed on the internet. The singer Pink was trolled for a picture of her consuming a decaf coffee while pregnant and, when actor Gwyneth Paltrow was seen having beer and sushi near the end of her pregnancy, half the comments chided her for the beer but did not care about the sushi, and half chastised her for the sushi but did not seem concerned about the beer. The latter example shows how arbitrary this is and the former how ridiculously far it goes. These incidents cause women to feel embarrassment and also fury. They also don't happen to men.

Lyerly et al. (2009) perspicaciously point out that while women are expected to avoid all kinds of food and activities while they are pregnant, they are rarely advised to stop having sexual intercourse as this would, presumably, inconvenience their male partners. They also effectively argue that we accept all kinds of risk toward children, but not fetuses.

> The pursuit of zero risk to the fetus in these ways, then, holds pregnant women to a standard to which we do not hold prospective fathers. More than that, it holds them to a standard we don't impose on parents of born children. We accept small risks to our children for our own sakes every day. We believe it reasonable to impose the small risk of fatality introduced every time we put our children in the car (safely restrained in a car seat), even if our errand is mundane and optional. Likewise, we recognize as reasonable the decision to live in a city that happens to have high levels of air pollution even if doing so increases the risk of our children later developing cancer . . . we recognize that . . . responsible trade-offs are a fact of life, and that there are times when benefit to one member of a family comes at the price of a risk to another. (Lyerly et al. 2009: 40)

As we have seen repeatedly throughout this chapter, women's perfect maternal behavior is enforced not only informally by the public at large, but formally by the long arm of the state. While public shaming is powerful and frequently leads to self-policing, being locked up is a whole other matter. Michel Foucault (2003 [1976]: 242) argues that "discipline tries to rule a multiplicity of men to the extent that their multiplicity can and must be dissolved into individual bodies that can be kept under surveillance, trained, used, and, if need be, punished." This applies even more to women, who through their bodies produce the nation and therefore who must

be subject to more intensive purity policing (Peterson 1998). The Surgeon General's warning to women who are not yet pregnant but thinking about conceiving and, more recently, the CDC's warning to women who are not intending to conceive demonstrate that for government agencies, all women are potential mothers and are treated according to that role: producers of citizens rather than as citizens themselves. Fixmer-Oraiz (2019: 25) comments that "the policing of pregnancy is explicitly about the policing of all cisgender women of reproductive age – regardless of their ability or desire to carry, birth, or parent children." The benevolent (and sometimes hostile) sexism of denying adult women choices over what to consume thus belies structural violence in the name of the state/Foucault's "biopolitic." Reproduction is not a private act but rather is so intensely politicized because "the coherence and continuity of the group – and the gender hierarchy it imposes – is 'maintained and secured only by limiting the autonomy, freedom of choice and social adulthood of the group's physical and social reproducers' (Vickers 1990: 482)" (Peterson 1998: 42). Fixmer-Oraiz (2019: 29) maintains this is heightened in the post-9/11 era: "[a]s reproductive bodies are imagined to threaten national security, either through supposed excess or deficiency, a culture of homeland maternity intensifies the requirements of pregnancy and parenting as it works to discipline those who refuse to adhere." We must be cautious of allowing the state to set standards for reproduction. As Paltrow (2015: 209) writes, and I hope this chapter has demonstrated, "all pregnant women are at risk of being assigned to a second-class status that will not only deprive them of their reproductive rights and physical liberty through arrests, but also effectively strip them of their status as full constitutional persons."

Daniels (1996) reminds us that in the past there were laws that women could not work at night or more than a certain number of hours in a row in order that they would be healthy for childbearing, their primary role according to the state. Anti-discrimination laws eventually struck down these rules limiting women's paid labor (Daniels 1996). The state's interest in the birth of healthy children has since migrated from the health and safety of women to protectionism of the fetus. Legalized abortion meant that women and fetuses could be positioned as adversaries, but once a woman chose to proceed with a pregnancy, physicians, courts, and the public seemed to believe she was voluntarily giving up her rights to body autonomy and decision making, medical and otherwise (Daniels 1996). Her

"duty to care" could be enforced even if it was not in her best interest. This had led to cases where women go on trial for a crime wholly unrelated to pregnancy, check fraud, for instance, receiving a much harsher penalty than is customary just so that the judge can imprison them for the duration of their pregnancy for fear they may continue drug use unrelated to the charge (Roberts 1997). As more and more women lose the right to abortion, both intentionally and involuntarily pregnant women will be incarcerated. Others will be killed when they are denied cancer treatment or go septic from incomplete miscarriages.

We can imagine a scenario where a woman, perhaps with a high-risk pregnancy, is advised to change jobs or stop working altogether for the health of her fetus. Many women cannot afford to go on extended bed rest, and while employers are supposed to provide alternative, safer jobs to pregnant woman exposed to chemicals, working in hot conditions and so on, they may not comply, or a woman may fear for her job security if she asks. She may work under the table or otherwise not be covered by worker protections. She may already be a mother whose other children depend on her paycheck. Even if not, she has upcoming expenses with a new child on the way. Can we castigate this woman if she continues working? She is in an impossible position, not being irresponsible and making a "selfish" choice. Would we want to allow the state to incarcerate her during her pregnancy to keep the fetus safe? Even when we are not talking about such a vital situation, involving one's capacity to make a living while pregnant, we must be wary of the slippery slope of criminal-izing women for the choices they make while pregnant.

Whether the woman willingly self-effaces for her unborn child or is actively disappeared by technology, popular culture, laws, and medical providers, the missing mother-to-be takes with her all the things out of her control that harm her fetus as well:

> The process of naturalization, in which the fetus exists in an ideological and historical vacuum, diverts attention away from material bodies, from the economic situation of pregnant women, and their access to basic needs like food, shelter, and healthcare. The embryo/fetus exists in a nowhere land – it miraculously receives shelter and food. It exists in an environment somehow immune to racism, sexism, and economic violence – an environment without borders or boundaries. In protecting this "endangered species," the New Right can override and dismiss the material needs of the female bodies that house these cosmonauts, as

well as the needs of children and their families. While the fetus needs "protection" (a thinly disguised alibi for controlling women), it doesn't ask for capital. (Stabile 1992: 196–7)

Doing the right thing for the fetus *and* the woman would mean not only seriously considering whether bed rest is actually appropriate, but also requiring replacing her wages for the entirety of her bed rest, as well as providing a state-subsidized caretaker for her other children if she chooses to go on bed rest. Keeping the larger picture in mind during maternity care could have prevented Samantha Burton's distressing confinement. That requires capital and social investment. Instead, those who support punishing women for their pregnancy outcomes vilify individual women for their lack of commitment to their unborn baby's health. When we punish her, it is not only unjust, it also punishes her entire family, including her other children.

Privileging life inside the womb downgrades the needs and rights of those who are already people and ignores ties between the fetus and the pregnant woman. The obsession with mothers existing entirely for their children, whether born or unborn, is the logic that forced Marlise Munoz to remain connected to life support for 62 days after her death, despite the objections of her husband and parents based on Ms. Munoz's own statements that she never wished to be kept on life support. She died when her fetus was only 14 weeks, and after both mother and baby had been oxygen deprived, like Angela Carder and her baby. As Ms. Munoz's body literally decomposed in the hospital for two months while her husband and parents watched, the fetus developed abnormally (no lower extremities and brain abnormalities) and finally stopped developing altogether. These horrors, and Ms. Munoz is not the only pregnant brain-dead woman to experience this fate, are only allowable in a society that does not understand the connection between fetuses and pregnant women. Several states, including Texas, render advance medical directives invalid when a woman is pregnant. If the Munoz baby had been born alive, the baby's father, Erick Munoz, would have been obligated to parent a severely disabled child as a new widower while also caring for his toddler on his own; the state ignored the fact that neither Ms. Munoz nor Mr. Munoz would have voluntarily continued the pregnancy under these circumstances. Fetuses are portrayed as existing on their own without a broader context surrounding them and despite being located inside women. Pregnant women are actually on their own in

terms of designated responsibility for fetal outcomes, despite being located within society.

Recalling from the previous chapter California's Proposition 65, the law that was supposed to shame businesses that use toxic chemicals into using safer products by forcing them to post signs, we see how an attempt at making companies do the right thing not only failed but ratcheted up the demands on women hoping to conceive and already gestating. Businesses simply posted the signs rather than curtailing their use of harmful chemicals. Philosopher Quill (formerly Rebecca) Kukla points out that even a prestigious prenatal clinic had one posted on the building.

> [T]hese warnings hold women to unreasonable standards of risk management, and they individualise the problem of reproductive risk, focusing on pregnant women's "chosen" behaviour as the primary site where reproductive risk ought to be managed. They enforce the idea that pregnant women do not have the same claim on public space as do other citizens, but rather must negotiate distinctive moral perils in their attempts to live in it . . . the state of California is now a space that pregnant women cannot now negotiate without moral peril. (Kukla 2010: 332)

Situating social problems within individuals, who are then portrayed as either foolishly making bad choices or lacking in morality, rather than as a manifestation of larger societal issues, has consequences. When poverty appears to play a consequential role in FAS among pregnant alcoholics, but we focus only on alcohol, when we ignore the conditions that lead to substance abuse, underemployment, domestic violence, and compromised living environments (high stress, increased exposure to lead and other toxins, failure to meet basic health and nutritional needs, etc.), we take the responsibility for a solution off society and put it on the backs of individual women who are already struggling to cope. As Fentiman (2017: 247) argues in her book, "the unconscious processes of risk construction intersect with American law to make it more likely that mothers, instead of others, are held responsible for their children's health." Indeed, the women who most need help given their alcohol or drug addiction, not only for the fetuses they may carry but also for their own health and lives as well as for any other children they may already be parenting, face increased challenges (e.g., an inability to seek medical help for fear of punishment; losing public housing or

a job and the health insurance that goes with it after being jailed) precisely because of health workers', politicians', and prosecutors' insistence that their behavior is to blame. This is ironic because the National Institute on Alcohol Abuse and Alcoholism (NIAAA) worked hard to change society's view of alcoholism from anti-social behavior resulting from a failure of character in the early 1900s to a disease model in which the alcoholic was to be treated for addiction as a medical problem in the second half of the 1900s (Rotskoff 2002). Yet, after the advent of FAS, and the research on it funded by millions of dollars of NIAAA grant money, pregnant women are ultimately excluded from being ill alcoholics and instead thrust back into the camp of moral failing. In admonishing the mothers of FAS children and babies born testing positive for drugs, all women are warned by their example and cautioned to control their behavior.

Grasping the pernicious links between the healthcare system and the criminal justice system, Seiler (2016) asks public health officials to consider the legal consequences of their health recommendations before making them. She details the price that some women have paid, including incarceration and loss of custody of their children, even when harm to their children is not proven, due to laws written or interpreted a particular way because of public health recom-mendations. Seiler warns that the CDC materials, for instance, do not caution women that they may face legal penalties for admitting their drinking during pregnancy to a doctor or nurse, and Goodwin (2020) believes we need a medical Miranda warning so that pregnant women will know that anything they say to their providers during an appointment can be used against them. Yet a warning once someone is already pregnant may be too late. As we criminalize the state of being pregnant itself, with possible deprivation of liberty from the positive pregnancy test to the birth, women need warnings before conceiving. And they need legal abortion.

In addition to accurate rather than overblown warnings in public health materials, we must change laws that are punitive rather than helpful. Criminalizing substance abuse during pregnancy is not an effective deterrent, and in many cases it denies women their rights. Prosecuting women for failed pregnancies is pernicious. It makes mothers-to-be avoid care when they need it and can send women who have miscarried or lost a baby at birth to jail through no fault of their own. Human rights groups routinely criticized Latin American countries for doing this, and as some of these nations have made

recent progress by releasing women incarcerated for pregnancy loss or by making their abortion laws less stringent, the United States is going in the opposite direction. Rather than becoming as or more draconian, the United States should set an example by actually supporting women through pregnancy, making health care affordable and available, without fear of penalties, and valuing the women who carry babies and not just their fetuses.

From looking at the pressures on women and the penalties they incur for actions before they become mothers, the next two chapters look at moms raising children whom society views as failing at motherhood.

4

"Neglectful" Mothers

Overbearing Americans

While the vast majority of American parents do not engage in full-blown attachment parenting where the baby is worn on the mother's body as much as possible for months and she breastfeeds for years, many do engage in some pieces of attachment parenting, although these vary from family to family (e.g., co-sleeping but not nursing on cue all day long). While the Sears actually do not advocate for jumping to address a baby's cry at a year old as quickly as one would at one month (see Sears website), a large number of US parents do seem to believe that their children need more direct parental attention and quicker response times than many parents in European nations (obviously with some exceptions, as the La Leche League and similar groups can be found in many countries, even if they have fewer adherents). As author and journalist Pamela Druckerman (2012) notes in her book, *Bringing Up Bébé*, she can spot anglophone parents immediately because they hover around their children and talk to them, or even narrate their experiences to them in real time, constantly. She mentions making the "whee" noise for children as they jump on trampolines or waving every single time the child completes a turn of the merry-go-round. By teaching them to wait and sliding them into schedules, French parents, according to Druckerman, help their children become independent sooner with obvious benefits to parents: babies who sleep through the night before they're half a year old, preschool children who eat the same food as adults, and elementary school children who go on overnight

class trips without parents. Druckerman claims she can identify American moms

> by their body language. Like me, they're hunched over their kids, setting out toys on the grass while scanning the ground for choking hazards. They're transparently given over to the service of their children. What's different about French moms is that they get back their pre-baby identities, too. For starters, they seem more physically separate from their children. I've never seen a French mother climb a jungle gym, go down a slide with her child, or sit on a seesaw – all regular sights back in the United States and among Americans visiting France. For the most part, except when toddlers are just learning to walk, French parents park themselves on the perimeter of the playground or sandbox and chat with one another. (Druckerman 2012: 129)

In France, both parents and children are viewed as needing personal space. Most French parents expect to have couple time/ adult time regularly. She quotes the French parenting guide, *Votre Enfant* (Your Child), that entreats parents to teach children that they also have a right to pleasure: "Thus the child understands that he is not the center of the world, and this is essential for his [sic] development" (Druckerman 2012: 187–8). Druckerman explains that, "[i]n France, the dominant social message is that while being a parent is very important, it shouldn't subsume one's other roles"; as several acquaintances tell her, a mother should not be "enslaved" to her child (2012: 130).

Druckerman explains that part of the constant attention American kids receive is due to the belief among US parents that how a child progresses and how fast is directly related to how much parents engage with them. As sociologist Marianne Cooper (2014) notes, middle-class American parents are fixated on giving their child every little edge over others, whereas in France, according to Druckerman, the goal is to let young children discover the world around them. Provided that they are within the normal range of meeting milestones and learning to read, parents and preschool teachers let them grow and develop without the same pushing American parents tend to engage in. In a country where all teens who pass the entrance exam go to university, and without the exorbitant costs of US institutions, French parents can sign a child up for tennis lessons for pleasure or socialization with others rather than to get the holy grail, a sports scholarship to college. Historian Paula Fass (2016) concurs with

Cooper about US parents' obsessive attempts to ensure their children succeed, and she also highlights the consequences for other parents:

> Increasingly fearful that the slightest deviation in oversight will ruin their children's carefully prepared paths into the future, parents yield to their most directive instincts and attempt to manage all parts of their children's lives, whether those children are two months or two years, twelve or twenty: better strict supervision than failure. And this perspective has begun to organize how we view and evaluate the parenting of others. We expect all parents to oversee their children in minute detail, and when they do not, many parents are tempted to call the police. (Fass 2016: 231–2)

Similar works to Druckerman's have appeared about parenting in other countries. Sara Zaske moved to Germany with one small child and had another while living there. In her book, *Achtung Baby* (2017: 9), she explains how, by moving abroad, she realized that like too many American mothers, she had "internalized the impossible cultural expectations of the ideal, self-sacrificing mom who places her children above all else," and who also overplans for and controls them obsessively, despite not having had anywhere near the same amount of supervision growing up herself. She argues:

> We've created a culture of control. In the name of safety and academic achievement, we have stripped kids of fundamental rights and freedoms: the freedom to move, to be alone for even a few minutes, to take risks, to play, to think for themselves – and it's not just parents who are doing this. It's culture-wide. It's the schools . . . It's the intense sports teams and extracurricular activities that fill up children's evenings and weekends . . . Mostly the culture of control is created by average people: our neighbors, friends, relatives, and even complete strangers who feel compelled to shame parents or even call the police if a child is left alone for a few minutes. (Zaske 2017: 10)

Germans are more likely to trust other people to watch out for and help their kids, Zaske believes. She relates how she found a child of about six waiting for a random adult to come along and help her cross a street to get to her home where her mother was waving out the window, and this seemed to be a common occurrence. By the middle of elementary school, most German children go to school by themselves, something that schools encourage. German parents

spend the better part of first grade teaching them how and then let them walk or bike alone. Some second graders even take public transportation independently. This is not unique to Germany. In Japan, young elementary schoolers ride the subway without parents (Lythcott-Haims 2015). In a Policy Studies Institute examination of European children's independent mobility in 2015, Finnish children were the most likely to walk or bike by themselves, any time of day, and often as young as age seven. Germany came in second. Anglophone countries England and Ireland were lower down the list at spots seven and twelve (Zaske 2017).

After moving from Germany back to California, Zaske found that in her state, it was illegal to leave a child under six in a car alone or with another child below age twelve. However, in the not so distant past, Americans did give their children more independence and spend less time one-on-one parenting. I remember being left in a rental car while my parents shopped at a grocery store for a hiking trip in a state across the country from our home in the 1980s. It was also still perfectly normal for young children to walk to school alone and for pre-adolescent siblings to care for younger sisters and brothers after school. Now, some American municipalities have instituted guidelines about how long 11- and 12-year-olds can be left alone at home, whereas Scandinavian children are often allowed to stay home alone starting at age seven (Furedi 2002).

Americans expressed shock and tried to prosecute a Danish woman and the baby's American biological father who left their fourteen-month-old in a stroller in a cordoned-off area outside a restaurant where they could see her through the window in New York City in 1997. After being arrested for child endangerment and disorderly conduct, Annette Sorenson spent three days in jail, and her daughter, Liv, was placed in foster care for four days, despite Sorenson's protest that her behavior was commonplace in Denmark. Charges were eventually dropped when she agreed to leave the country. Yet it was perfectly acceptable in the United States in the 1950s for women to leave their children in baby carriages outside stores while they shopped, as a photo in a widely read American magazine attests (Furedi 2002: 23). Mothers during World War II were also encouraged to start potty training their children by a year and a half (Fass 2016). The pendulum on parenting has definitely swung.

Moms in the 1940s were accused of being too overprotective; in the 1980s, they were reminded that they could not be protective enough

(Douglas and Michaels 2004). For her book, Warner talked to numerous mothers and found that her interviewees "were unanimous in their recollections of having had much more freedom as children than children do now. They remembered walking alone to kindergarten; taking the bus with friends to the beach; being sent out of the house in the morning and not returning home until . . . dinner" (Warner 2005: 236). All this changed rather quickly. "Control, above all, became the guiding principle of 'successful' parenting during the past 30 years. In this way, parents could protect their kids from predators, from unsafe sex, from failure at school. Protection became more important than independence, more important than giving children the freedom to choose their own futures" (Fass 2016: 266–7).

Currently, many American parents cannot fathom leaving a child alone without supervision, in part due to overly heightened concerns about rare and pseudo-dangers (Glassner 1999). "There is little basis to the fears that fuel parental paranoia. Children are far healthier and safer now than at any other time in history . . ." (Furedi 2002: 8). Missing person reports of minors fell 40% between 1997 and 2014, and most are runaways (Ingraham 2015). When children are kidnapped, it is almost always by someone they know, usually a relative. Stranger kidnappings are extremely rare, yet when they happen it is all over the news and social media (Brooks 2018; Glassner 1999; Lythcott-Haims 2015).

> Today our smartphones and 24/7 Internet access amp up the frenzy, alerting us at a moment's notice when anything bad has happened to a child, anywhere in the world. Our fears continue to be fueled by the media, whose ratings go up when they tell scary stories. Parents all over the country have told me matter-of-factly, or wistfully, that kids just can't walk alone anymore. Why? "Because of pedophiles." We *perceive* that our nation is a more dangerous place, yet the data show that the rates of child abduction are no higher, and by many measures are lower, than ever before. (Lythcott-Haims 2015: 15)

Added to these fears are real legal threats. "Today, allowing a child to play outside on his [sic] own is seen as an act of neglect" (Furedi 2002: 5). After her return to the United States, Zaske wrote, "[n]ow whenever I leave my children in the car for a few minutes, I'm more worried about some well-intentioned citizen making trouble for our family than about an evil-minded stranger snatching them. I know

which one is more likely. I've already seen it in action" (Zaske 2017: 196). Feeling the need to constantly monitor their kids, Furedi argues that moms are becoming more neurotic.

In her book, *How to Raise an Adult*, Julie Lythcott-Haims (2015) concurs that the intense media coverage of cases like that of six-year-old Adam Walsh, kidnapped and murdered by a stranger, have contributed to parents' increased supervision. She notes that, thankfully, only 0.01% of missing children are taken by strangers. Yet there is more to this than just fears about children's safety. Like Cooper and others, Lythcott-Haims points out that fears about US children's academic performance also led to parents' over-involvement. She additionally notes something few others have: the advent of the playdate. As more mothers worked and more children attended daycare, parents began scheduling times and locations for their children to meet with others outside of school. "Once parents started scheduling play, they began observing play, which led to involving themselves in play. Once a critical mass of parents began being involved in kids' play, leaving kids home alone became taboo, as did allowing kids to play unsupervised. Day care for younger kids turned into organized after-school activities for older kids" (Lythcott-Haims 2015: 4). Now, more and more kids meet other kids in arranged ways facilitated by parents who drive them to one another's homes; rare are the spontaneous games between neighbor children.

This constant close supervision has downsides not just for moms but for kids as well. As adults in their lives try to make sure all children are risk-free all the time, kids, increasingly dependent and anxious, learn not to take risks. Zaske explains her initial shock that children were encouraged to build fires and use dangerous tools such as chisels and pocketknives at surprisingly young ages by their caregivers and teachers in Germany. German adults explained that this demystified dangerous objects and also taught children how to use them properly, preventing more accidents in the long run. Sociologist Ana Villalobos (2014) found this strategy, which she calls inoculation, among some of her respondents in the United States, including a German woman. On the other hand, as a whole, US culture has moved more and more toward shielding children from all sorts of potential harms. My teenage son and his friends were recently complaining about how, when they were in elementary school, running on the school playground was banned. Ostensibly instituted by school staff to keep them safe, the kids thought this was

a ridiculous measure. Barring running on the playground would have been an unlikely step in Germany, where playgrounds have taller, sharper equipment than in the States. Zaske argues that this is in part to teach children how to gauge risk themselves. Allowing children some distance, both physical and mental, also fosters independence.

A British policy report on children's mobility and traffic concluded the following:

> Since 1971, there has been a large increase in the number and extent of children escorted to all destinations, especially by car. The main escort burden is associated with getting children safely to and from school. Now, for instance, in mid-afternoon, a mother can no longer stay at home playing with her toddler and making tea while her 8-year-old son or daughter comes home with friends. Come rain or shine, she must bundle the toddler into a buggy – or, increasingly, into the back of a car – and go and fetch her child. In 1990, there were three and a half times more children taken to and from school by car than in 1971. (Hillman, Adams, and Whitelegg 1990: 110)

In fact, in Great Britain, only 9% of seven- and eight-year-old children were permitted to travel to school on their own by 1990, compared to 80% in 1971, and less than one in ten was allowed to ride a public bus unaccompanied, despite it being commonplace in the past (Hillman, Adams, and Whitelegg 1990). The authors identify five problems with this: "it entails substantial resource costs; it constrains adult opportunities; it contributes significantly to traffic congestion; it removes a routine means for children to help maintain their physical fitness; and it limits opportunities for the development of their independence" (Hillman, Adams, and Whitelegg 1990: 110). They go on to note that "[t]his change has gone largely unnoticed, unremarked, and unresisted. We have created a world for our children in which safety is promoted through fear" (Hillman, Adams, and Whitelegg 1990: 111).

One German mom interviewed by Zaske explained why she let her eight- and ten-year-olds travel on the subway to their grandmother's by themselves: "I want them to be independent and proud of what they can do. If I'm always with them, they won't be" (Zaske 2017: 122). Another mother told her, "If they want to meet with friends or go to sports, they have to be flexible and be able to do it on their own," putting the onus on the kids to get themselves to activities rather than making it the parents' responsibility (Zaske 2017: 126). Tine Pahl,

a developmental psychologist from Germany who lives and practices in the United States, asserts that children who are "overparented" pay for it as young people when they have trouble managing their lives as adults (Welch 2018), and this is the point of Lythcott-Haims's (2015) book. Data from various studies show a correlation between helicopter parenting and poor mental health outcomes ranging from stress and separation anxiety in younger children to narcissism, rigidity of thinking, self-consciousness, anxiety, and depression in older children and young adults (Schiffrin et al. 2015; Segrin et al. 2013).

Zaske argues that for older teens, allowing them to drink and have sex under the parental roof prepares them to be adults and prevents them from running wild when they turn eighteen and go away to college or turn twenty-one and start drinking legally in the United States. These forays let adolescents test out independence in a safe manner and, she argues, makes them better prepared to be adults. "We American parents have the best intentions: We want to protect our children from danger, to shape them to be good people, to give them the tools to succeed. We're just going about it the wrong way. Many of these things require less interference from parents, not more" (Zaske 2017: 186). Furedi (2002) reminds us that resilience is learned by overcoming adversity.

Neglect

Of course, there are instances of true neglect. Neglect is the most common form of child abuse (Jonson-Reid, Drake, and Zhou 2013; Maguire-Jack et al. 2019). Material neglect, referred to as "basic needs neglect," occurs when parents do not provide suitable shelter, enough food, or weather-appropriate clothing to children. "Supervisory neglect," which makes up almost half of neglect cases, happens when a child is left alone without supervision when they are too young to be safe or to take care of their own needs or when they are left with an inadequate (e.g., other young child) or harmful (e.g., sex offender) caregiver (Coohey 2003; Maguire-Jack et al. 2019). One-third of all cases reported to child services are situations where a child is improperly supervised (Coohey 2003). Neglect can also be medical, which is sometimes classified under basic needs neglect, educational, which can fall under either basic needs or supervisory

neglect, or emotional, which is typically in a category of its own (Coohey 2003; Jonson-Reid, Drake, and Zhou 2013). While some parents neglect their children intentionally or because of mental health or substance-abuse problems, others parents who are simply struggling to provide for their children can find themselves charged with neglect. Neglect is strongly linked to poverty. "Neglect can mean living in dilapidated or overcrowded housing, missing school, wearing dirty clothes, going hungry, or being left home alone. In any case, the definitions are vague enough to give caseworkers ample discretion to decide when living conditions amount to neglect. Very rarely do parents deliberately withhold needed resources from their children. Typically, they simply can't afford them" (Roberts 2022: 66–7). When the heat is turned off in an apartment, a parent can find herself being investigated by social services and lose her children. One-third of children in foster care are there because of their parents' unsuitable housing (Roberts 2022).

Parents who cannot afford safe, consistent child care may leave their child alone or with someone who is not a good caregiver, such as a slightly older child or a questionably responsible neighbor, because they must go to work, attend a court date, or seek medical attention. If the caretaker is irresponsible and leaves the child alone, it is the mother who is charged with supervisory neglect. Someone who was once a fit caregiver may gradually become incapable of providing adequate care, such as a grandmother whose worsening physical disabilities or progressing dementia may make her unable to supervise her young grandchildren. Providing subsidies for child care reduces instances of supervisory neglect (Maguire-Jack et al. 2019).

Leaving children in hot cars is another matter. Frequently, the cases that lead to tragedy are those where a parent forgot the child was in the car altogether and left her or him for several hours or even all day. A typical scenario is one where a mother normally takes her child to daycare but, because of an unusual appointment or meeting, asks the father to drop the child off. Unconsciously following his standard routine, the father simply forgets that his young child is in the car, fails to stop at the childcare provider, parks at work, and accidentally leaves the child strapped in a car seat with the windows of the car up all day. Prosecuting these unfortunate parents does little to deter future cases. Instead, measures such as New Jersey's provision that preschools as well as grade schools call

parents when an enrolled child fails to show up are likely to save more lives. Some car manufacturers are also working on installing a notification/alarm system that signals if a child or pet is left in a hot car.

This is different from a situation when the weather is temperate, and a parent intentionally leaves a child in a car for a short period of time. Kim Brooks, a white middle-class mom, published *Small Animals: Parenthood in the Age of Fear* (2018) after getting in trouble with the law for leaving her four-year-old alone in the car for a very short period of time while she went to buy him a pair of headphones for their airplane flight later that day. Her son had asked to remain in the car and was perfectly fine when she returned, but a passerby had called the police. This incident caused terrible stress for her, her husband, and her parents, whose home she had been visiting that day, and it also generated legal bills after she was charged with contributing to the delinquency of a minor. Most insidious, perhaps, it led her to question herself as a mom. As Austin Berg (2018) of Illinois Policy queries, "[s]hort of harm to her children, can you imagine a worse fate for a mother than being wrongfully pegged as a child abuser?" Lythcott-Haims (2015) also questions how this affects children who see their parents berated or punished by law enforcement for their perceived lack of judgment.

Brooks is far from the only mother to have this experience, and parents who leave children alone in a car even for a short time and even within their line of sight have been charged with neglect or child endangerment, even though no harm has arisen and even though doing so was a non-issue a generation or two ago. Like Brooks, many choose not to fight the charges because they are terrified of social services taking their children away. If they are lucky, and can afford it, they can accept consequences such as probation, fines, and parenting classes rather than jail time. Yet, even in these "fortunate" cases, for many mothers like Brooks who pride themselves on their parenting role, being forced into a state-mandated parenting class is obviously humiliating. It is also a waste of resources. If mothers do not act appropriately contrite and do not jump through every hoop that Child Protective Services (CPS) or a judge set for them, they could face jail time and/or lose custody of their children. Therapists' reports can be used against them, and if they are emotional in the face of a decision against them, caseworkers or judges can use this to further punish them (Roberts 2022).

Brooks did not intend to make a stand or to advocate for a particular style of parenting when she made the decision to leave her son in the car that fateful day. Other parents have. Danielle and Alexander Meitiv, parents from Silver Springs, Maryland had repeated encounters with the law for allowing their children, ages ten and six, to walk home together from a local park unaccompanied. While they did not expect the first encounter with the police, they knew that others were possible after social services became involved, and Alexander Meitiv, under threat of having the children removed from the home by police that day, was forced to sign a document that he would not leave the children unsupervised before Child Protective Services contacted them. Police picked up the Meitiv children walking the two blocks home from the park on another occasion a few months later when the parents suggested they walk after taking a long car trip. Initially, the Meitivs were found responsible for "unsubstantiated child neglect." Danielle Meitiv said, "You try as a parent to do what's right. Parents try so hard. Even though I know [CPS] are wrong, it's a painful judgement" (J. Brown 2019: 31–1). This case became a cause célèbre as Danielle Meitiv spoke with the media and contacted Lenore Skenazy, dubbed "the world's worst mom" for allowing her nine-year-old son to ride the subway in New York City alone and founder of "Let Grow," an advocacy group promoting free-range parenting. All three parents are white, college-educated professionals. While public opinion of their actions was split, they were able to turn their parenting decisions into a type of social protest. Diane Redleaf, founder and former director of the Family Legal Defense Center in Chicago and the legal advisor for Let Grow, advised the Meitivs to pursue legal action. She noted that she had clients who did not have the means or the support necessary to take on the system.

With some exceptions, predominately poor parents of color do not get the kind of media attention that the white, PhD-scientist Meitivs garnered. Redleaf had a very similar case in which Natasha Felix allowed her eleven-, nine-, and five-year-old children and a nine-year-old nephew to play in a park directly next to her home. She could see them from her apartment and checked on them every ten minutes. It took two years before the neglect finding was overturned, during which time she was not allowed to volunteer at her children's schools and could not apply for certain kinds of jobs (Berg 2018; Rosenblum 2019). The Meitivs were also ultimately cleared of neglect. The Child

Protective Services of Maryland also changed their rules so that if a child was not harmed or in immediate danger of harm, parents would not be prosecuted if children were simply playing or walking outside.

Other states have revisited their procedures. In Illinois, for instance, the inadequate supervision rule, Allegation No. 74, could be invoked if "a child is placed in a situation or circumstances that are likely to require judgment or actions greater than the child's level of maturity . . ." (Berg 2018). The wording was very broad and open to interpretation. In 2016, the Family Defense Center initiated a class-action lawsuit for thousands of parents deemed neglectful. This successful court action led to a significant change: "Investigators now must find that a child was placed 'at a real, significant and imminent risk of likely harm' because of a parent's 'blatant disregard of . . . responsibilities of care and support'" (Berg 2018). After a settlement between the Department of Children and Family Services and the Family Defense Center, all parents charged with inadequate supervision can have their cases reviewed under the new standard, and if their actions do not meet it, their names will be removed from the registry (Berg 2018). Not only does this change mean that many parents will be permanently cleared of wrongdoing, it allows state agencies to focus on families and children that actually need help, instead of wasting resources on perfectly capable parents (Berg 2018).

Most states do not set a specific age at which children can be home alone; it varies in the states that do. Illinois is the most conservative; parents there can be found guilty of neglect for leaving children under age fourteen alone for "an unreasonable period of time." While most judges might not find a few hours after school an unreasonable period of time, it is still troublesome that children this age are in middle school and many schools only provide after-school care through elementary school. When I asked the director of my son's elementary after-school program whether there were fifth-graders enrolled, she informed me that the majority of fifth-grade parents allowed their children to go home alone by halfway through the year, when most of these children were ten or eleven. Kansas is on the other end of the spectrum, mandating that children only have to be age six before they can be home unsupervised for short periods of time. Other states mention various ages between eight and twelve, do not give a specific age, make rules about not leaving children alone overnight, or leave it up to local municipalities (M. Brown 2019).

Even when no specific age is mentioned in the law, parents can be arrested. A Florida couple lost their two children for a month and faced third-degree felony charges after their eleven-year-old played alone outside at his home for an hour and a half while they were stuck in traffic on the way home and he was locked out of his house. No harm came to him, but he and his little brother, who had not been left alone, were sent to foster care and a relative's house before being returned to the parents who were obligated to take parenting classes and enroll the children in summer camp and daycare for the summer, even though the mother normally spent part of the summer at home with the kids. This case was somewhat unusual in that, like the Meitiv case, both parents were prosecuted, and also because their names did not show up in newspaper reports on the case.

Because women are more likely to be primary caregivers, it is more often women who break these laws, often unknowingly, and face serious consequences. Susan Terrillion left her eight- and nine-year olds at their vacation rental in Rehoboth Beach, Delaware while she went to pick up food. When their dogs got out of the house and ran into the road, a neighbor helped them get them back inside, and then he called the police. Ms. Terrillion was arrested and charged with two counts of endangering the welfare of her children (de Guzman 2016). Tiesha Hillstock was charged with neglect after a police officer found her three-year-old son and nine-year-old nephew at the nearby South Carolina McDonald's with her permission and walked them less than a quarter mile back home. Nicole Gainey from Florida faced a felony child neglect charge that could have landed her five years in prison for allowing her seven-year-old son to walk to a nearby park alone, something she let him do once or twice a week prior to being arrested (Schmidt 2014).

I count myself lucky. When my younger son was in elementary school, I lived in an apartment right across the street from a local park on the other side of which was located my son's school. One April day, the first day that it had truly been warm after a long winter, my son, who was going on eight at the time, saw lots of the kids playing at the park as I walked him home from school. After dinner, he asked me if he could go join them. I was busy doing the dishes and making lunches for the next day, while simultaneously tending to issues with my older son. I decided that my younger one could play in the park on his own, and I could check on him out my window from time to time. I did not want him to cross the street,

however, as it was still rush hour. I walked him across the street and told him I would come back to get him in 45 minutes to an hour. The park was full of kids and parents. It was light out. We lived in a very safe small town. The police rang my doorbell. Two officers stood on either side of my child. They told me that some parents saw my son alone at the park and were worried. I held my breath. They told me to have a good evening and left. I felt fortunate . . . and annoyed. As a divorced, single mom, a run-in with the police could have been bad for all sorts of reasons. I hoped my son was not upset. I told him, truthfully, that because he was short for his age, the parents who called the police probably thought he was a couple years younger than his real age. He seemed to take it in stride. I never let him go to the park alone again that year.

Changing this legislation systematically is crucial. Otherwise, individual parents with means or access to an advocacy group may contest charges (although often even they are afraid to do so because the stakes are so high), but others will be swept up unfairly with little possibility of fighting back and plead guilty to unreasonable charges. In discussing the problems with broad inadequate supervision defini- tions, Berg (2018) highlights that "[r]ules with plenty of wiggle room tend to work against the least powerful among us." This assertion is supported by legal scholar Dorothy Roberts: "the vagueness of the statutes leaves 'a lot of room for discretion by social workers, police, judges, and prosecutors, to determine which/whose failures to supervise or to pursue. This allows race, class, and gender biases to influence decisions in both the child welfare and criminal justice systems'" (Roberts, quoted in Grose 2014). Redleaf also acknowl- edges that these cases are usually gendered:

> moms are the most frequent targets of police and child protection who issue the 'bad parent' label. Some of it is an anti-feminist agenda which blames mothers and expects them to have their eyes on their children at all times, even when that is the last thing kids need. The mother is "neglectful" and the father in this joint decision isn't even investigated. I had one case where a woman parked her car, ran in to get a Starbucks and could see her child the whole time. She was berated by the police. She said her husband did that all the time and was never stopped. (Rosenblum 2019)

Research in 2016 by Ashley Thomas, Kyle Stanford, and Barbara Sarnecka demonstrates that people judge parents who leave children

alone based not on actual safety but rather on moral evaluations, and that these differ for fathers and mothers. Scenarios ranging from a baby left asleep for 15 minutes in a cool and secure car to an eight-year-old left reading a book at a coffee shop a block from the parent for 45 minutes were presented to more than 1,300 subjects. The vignettes varied depending on whether the parent in charge was a mother or father and the reason for her or his absence. These included involuntary circumstances, such as being hit by a car and knocked unconscious while checking the mail, and a variety of voluntary reasons including relaxing, volunteering, working, and having an affair. Children were perceived to be at greater risk when the parent was doing something wrong than when the cause was involuntary and to a lesser degree when the reason was more morally worthy. Children whose parents were having illicit relations were deemed at more risk than children whose parents left them alone to volunteer or work. Yet it was fathers who got the real pass on working; when they left a child for work, the risk was evaluated about the same as if he had been in an accident. Not so for mothers. The fact that people rate a child of a mother who is unsupervised while she runs into work as less safe than the child of a father who leaves the child alone temporarily for the very same reason leads to the conclusion that this is more about enforcing social norms than about protecting children from actual harm. As the researchers point out, a child is probably safer when a parent intentionally leaves, having prepared the child for it, rather than when she or he does not return unexpectedly because of becoming incapacitated, and yet subjects have this perception of risk reversed.

People don't only think that leaving children alone is dangerous and therefore immoral. They also think it is immoral and therefore dangerous. That is, people overestimate the actual danger to children who are left alone by their parents, in order to better support or justify their moral condemnation of parents who do so. This brings us back to our opening question: How can we explain the recent hysteria about unsupervised children, often wildly out of proportion to the actual risks posed by the situation? Our findings suggest that once a moralized norm of "No child left alone" was generated, people began to feel morally outraged by parents who violated that norm. The need (or opportunity) to better support or justify this outrage then elevated people's estimates of the actual dangers faced by children. These elevated risk estimates, in turn, may have led to even stronger moral condemnation of parents

and so on, in a self-reinforcing feedback loop. (Thomas, Stanford, and Sarnecka 2016: 12)

This tells us a lot about the shift in views of parents' supervision responsibilities to their children over the last few decades, and why this just keeps getting worse. At the same time, the fact that dads are given more leeway for working than moms reinforces their traditional roles as the proper ones, revealing how much society still clings to outdated ideas about gender and parenting despite supposed progress. Even in the 1950s, 20% of ten- and eleven-year-olds were on their own while their mothers worked (Fass 2016). Poor women, including many immigrant and black women, have a long history of combining mothering and providing financially for their families. In the late 1800s, over a third of married black women and just under three-fourths of unmarried black women were employed, compared to only 7.3% of married white women and just under one-fourth of unmarried white women (Goldin 1977; Lenz 2020). While increasing numbers of white, working moms among the middle class caused social consternation in the 1960s and 1970s, eventually working mothers became the norm in all social classes. More than half of mothers of infants were working in the second decade of the twenty-first century (Fass 2016). The financial downturn of 2008 pushed some women into the workforce and made many heterosexual dual-parent families relieved that mom had a job when dad was laid off. Between 2007 and 2015, this recession cost five million US families their homes and reduced middle-class wealth by 30–40%, with the brunt borne by families of color and single-mother families (Briggs 2017). About 70% of mothers in the United States worked before the Covid pandemic, over 80% of them full-time (Collins 2019).

While political will to assist families is sorely lacking, with the United States lagging behind other industrialized nations with no paid family leave and little subsidization of child care, the government nevertheless sent a strong message a quarter-century ago that lower-socioeconomic status mothers were supposed to be in the labor force. The Welfare Reform Act of 1996, pointedly named the Personal Responsibility and Work Opportunity Reconciliation Act, cut benefits after two years, even those of single mothers who had small children, as mothers were no longer the "deserving poor" entitled to stay home and receive assistance because of their status as moms. They, like other able-bodied adults, were expected to work

to support themselves and their offspring, babies and toddlers be damned. Of course, working for minimum wage or just above it does not cover the costs of a parent and a dependent, leaving many parents in a bind even when they work. This leads to a conundrum for those who need child care to work but then work only to see a large proportion of their paycheck go straight to daycare or babysitters.

Class and race

As law professor and sociologist Dorothy Roberts (2022) notes in her book, *Torn Apart: How the Child Welfare System Destroys Black Families – and How Abolition Can Build a Safer World*, parents of all races and social classes do the same things, such as having alcohol bottles out in the home, using marijuana, or losing a child temporarily in a public place. The distinction is that some parents are more likely to be investigated and have these acts held against them than others. "[W]hite families don't experience the intensity of policing that CPS [Child Protective Services] concentrate on black communities" (Roberts 2022: 37). And there are certainly differences between middle-class moms intentionally sending kids to a nearby park on their own or leaving them in the car for a few minutes to make an errand more convenient and struggling moms who have no child care and have to go to work. "Low-income mothers often lack the job security, living wages, and access to policies (e.g., maternity leave, health care, vacation and sick days) that would reconcile the tensions between their own work and family commitments. The government does offer some assistance to very poor families, but . . . in no state is this aid enough to pull poor families out of poverty" (Collins 2019: 199). Not only did Thomas, Stanford, and Sarnecka's research highlight gender differences in how we hold moms versus dads accountable, but the authors also recognize the social class implications:

> Perhaps even more troubling, this new social norm serves to enshrine a kind of class privilege: Parents with limited resources simply cannot afford to indulge the irrational insistence that their children be constantly supervised. To routinely subject such parents to the threat of legal action for leaving their children alone, even in objectively low-risk circumstances, does more than simply stigmatize their behavior: It

effectively criminalizes their poverty. (Stanford, Sarnecka, and Thomas 2016)

Criminalizing poverty is nothing new. While removing children from poorhouses, for instance, seemed like a laudable advancement, Fass (2016) argues that it actually served to break up families simply for being poor. This perpetuates itself in today's neglect laws. Women, and it is overwhelmingly women, investigated as perpetrators of neglect – and even more so black mothers: 87–98% of cases involving black children scrutinized mothers versus 71–87% for white children (Jonson-Reid, Drake, and Zhou 2013) – can lose their children because there is not enough food in the refrigerator or the apartment is in disrepair, rather than for intentional neglect such as deliberately withholding food or abandoning their children (Burroughs 2008). Black children are more likely to live in extremely poor neighborhoods where most people are poor compared to white children, increasing the overall vulnerability and lack of support for these children (Jonson-Reid, Drake, and Zhou 2013).

In her article "Too Poor to Parent," director of Workplace Equality at National Women's Law Center Gaylynn Burroughs (2008) details cases of poor, black moms trying to be good mothers and care for their children in adverse circumstances, only to see their kids taken away from them instead of receiving help, even when they asked for it. One mom reached out for assistance from social services because her apartment had become unfit to live in due to leaking sewage from a neighboring apartment. When the caseworker saw that the electricity had also been turned off for failure to pay, instead of getting aid in the form of money to pay the bill and fix up her apartment or providing her with another housing situation, such as the family shelter accommodation she had called to request, the woman's children were sent to foster care and she was left in an unsafe, unsanitary domicile. Obviously, this mom had not committed a crime of abuse. Her inability to provide a safe dwelling was seen as a personal failure that merited her children's removal and the loss of her status as a mother rather than the better solution of aid to keep the family intact. Sometimes, having a child removed can mean that a parent loses their subsidized housing for families with children, and this only delays her ability to be reunited with her child (Roberts 2022). Burroughs notes that 60% of child welfare cases in the United States are cases of neglect and not abuse. She also highlights that

black children are twice as likely as white children to be sent to foster care. Black children in the United States have a 53% chance of undergoing a Child Protective Services investigation before their eighteenth birthday; the rate for all children is 37.5% (Kim et al. 2017). Ultimately, more than 10% of black children, and 15% of Native American children, are removed from their parents' care and sent to foster care prior to age eighteen (Roberts 2022). "Indeed, some critical theorists have long argued that social welfare programs, including child protection, serve the purpose of allowing the state to manage members of oppressed communities without having to convict them of crimes" (Roberts 2022: 163).

The involvement of social services, certainly, can lead to being charged with crimes. Briggs (2017) mentions the case of Maria Luis, a non-Spanish-speaking indigenous Guatemalan woman living in the United States without the proper papers. She took her baby to the doctor for a respiratory infection, but, not speaking the language, she did not comprehend that the doctor wanted her to bring her daughter back for a follow-up visit. When she failed to do so, social services went to her home – with the police. Why they felt the need to bring police to the door of an immigrant woman with two small children who had already shown she cared for her daughter enough to seek out medical care for her is a mystery, one wrapped in all sorts of negative connotations about poor and immigrant mothers. Fearing the police, given her non-regular status, Ms. Luis lied and claimed to be the babysitter. This led to her arrest and subsequent deportation and her children not only being placed in foster care but also being put up for adoption. Ms. Luis was lucky to get her children returned to her in Guatemala, but not every woman in her shoes is as fortunate; unconscionably, some children have still not been returned to their families after being taken from their parents at the US–Mexico border by US agencies.

The disdain for poor women, particularly welfare recipients, is tied in large part to assumptions about race and women who "choose" to have children out of wedlock. In the early 1900s, aid for mothers with children was instituted to support widows, including war widows, who were seen as legitimately bound to the home to care for their children without their deceased husband's income. In reality, "[p]rogressive era . . . widows' and mothers' pensions. . . were often symbolic, functioning more often as subsidies for low-income white mothers rather than eliminating their need to work, [but] they sent

a powerful message that, under ideal circumstances, white mothers should stay at home and care for their children" (Dow 2019: 129). Because black women were viewed as workers who should be gainfully employed, they were not deserving of public aid, unlike white women for whom domestic service jobs were seen as inappropriate (Dow 2019). The denial of these benefits to black mothers in many states communicated that motherhood was not valued the same for them and that they were expected to work outside their homes.

As the twentieth century progressed, greater numbers of divorced and never-married mothers, rather than widows, sought public assistance. Mothers' pensions were replaced by Aid to Dependent Children in 1935. In her book, *Mothering in Black and White*, historian Ruth Feldstein (2000: 70) writes: "As ADC [Aid to Dependent Children] came to support a greater number of families that departed from a white nuclear two-parent model, more and more people concluded that the program itself caused this allegedly deviant behavior. Critics and supporters of ADC invoked images of black women as matriarchs as they repeatedly drew links between the program, promiscuity, and illegitimacy." Poor mothers moved from the "deserving" to the "undeserving" poor category when welfare became associated with non-white women.

President Reagan's popularization of the alleged "welfare queen" took the vilification of poor, black moms receiving assistance to a new level, creating a ubiquitous image of black women who received welfare as swindlers. This stereotype caught on, despite the fact that at the time, more white women than black women received welfare and that welfare benefits rarely met, let alone surpassed, families' financial needs. Reagan also signed the legislation that bills parents whose children have been sent to foster care in order to reimburse the government for their expenses. This cruel act penalizes those who are suffering economically and can delay parents being reunited with their kids as money is going toward the charges instead of toward decent housing and other costs that would help their children (Shapiro, Wiltz, and Piper 2021). Even if they do get their children back, they may spend years paying off thousands of dollars of debt to the government. This is totally cost ineffective as it not only traps poor people in poverty, it costs more to go after the money than the government receives back; the government is recouping at most 41 cents, and in some states less, for every dollar it spends trying to collect (Shapiro, Wiltz, and Piper 2021).

The Personal Responsibility and Work Opportunity Reconciliation Act passed under a Democrat, President Clinton, cut welfare benefits after two years and instituted a lifetime cap of five years total, regardless of whether or not the family had children. Although it allocated additional money for child care, providers have always been hard to find or substandard in certain areas. Welfare reform was deadly; sixteen more babies per 100,000 died in their first year in states where the cap went into effect earlier, and the death rate of adults also climbed, especially among those unable to work because they had multiple children (Briggs 2017). The mobilization of racial stereotypes around welfare allowed this to happen, hurting mothers and children of all races.

> [I]n exchange for getting to believe their families were superior to families of color, white women agreed to be pushed into the labor force, to submit to having no time or resources to care for dependents, and to lose the one program [welfare] that might help them if they had to leave an abusive partner (or even one who was just unloving). (Briggs 2017: 71)

The private lives and mothering of women receiving public assistance have always been scrutinized. From its start, qualifying for benefits meant accepting invasions of one's privacy, adhering to proscribed gender norms, and the judgment of others. Social workers deemed whether mothers were fit by checking to see if women's homes were clean, and they also paid particular attention to any relationships with men. Women who had sexual relations outside of marriage were viewed as "either emotionally unbalanced or greedy (or both)" (Feldstein 2000: 69–70). A boyfriend found in the house during a midnight raid could cost a mother her welfare benefits: "women who were mothers [were] under a microscope, particularly with regard to their sexual behavior. In many places, evidence of a man in her life became yet another way to disqualify a mother from aid" (Feldstein 2000: 70–1). Government aid programs even forbade women on welfare from taking in male boarders, a valuable source of income for unemployed mothers in the early twentieth century.

These judgments about women who receive public assistance and those who are involved with social services continue in the twenty-first century. Reich (2002) studied women who lost custody of their children to foster care and were trying to get them back. She

concludes that women who said they were not dating and did not want to date were more likely to get their children back than women who had boyfriends or new husbands, even when these men posed no credible threat to the well-being of their children. "[D]ominant ideologies of ideal womanhood are deployed to demand a mother's chastity and self-sacrifice. While the policing of mothers' sexuality has been a fixture in US public welfare policy, a current manifestation of this uses sexuality as a litmus test for a mother's commitment to her children" (Reich 2002: 46–7).

This denigration extends to all mothers who struggle financially, whether they receive benefits or not. As Ross and Solinger write:

> motherhood is [treated as] a class privilege, properly reserved only for women with enough money to give their children "all the advantages," a deeply antidemocratic idea. Here we can see how the nobility of white, middle-class maternity depends on the definition of others as unfit, degraded, and illegitimate. In turn, poor mothers have been branded illegitimate because they do not have the resources that middle-class mothers do. (Ross and Solinger 2017: 4)

Between the wage gap, especially for women of color, and the fact that moms are more likely to be single parents than dads, more women than men live in a state of poverty. Poor, single mothers raise children while their lives are challenged by underemployment or the need to work multiple jobs at once, insufficient child care, health problems, unstable relationships with men who are equally poor, and the threat of crime if they live in a particularly disadvantaged community. Thus, "[i]f privileged parents suffer from the pains of high expectations, others suffer from the penalties that accompany bad choices in terrible circumstances or an absence of real choice" (Fass 2016: 222–3).

Welfare benefits have always varied by state, but even in the states with the most generous benefits, they have rarely been enough to live on, and mothers resort to unreported gifts from friends and relatives and work under the table to make ends meet (Edin and Lein 1997). Women transitioning from welfare to work often find themselves offered jobs that pay the minimum wage. Yet minimum wage is abysmally low in the United States, especially given the high costs borne by individuals and families for health care and child care. While states and even certain US cities have been proactive in

raising their minimum wages, the federal minimum wage has not kept pace with costs and is not a wage on which anyone can support a dependent. People who work minimum-wage jobs also sometimes do not have set shifts, creating more problems combining caring for their children with working. Like many others, sociologist Lisa Dodson argues that the benefits of treating low-wage workers accrue not just to the workers but to society and even businesses themselves:

> This "high road" argument counsels investing in better wages, decent schedules, and benefits for low-wage workers because, ultimately, this pays off for companies and the nation . . . millions of children will be better prepared for school, are healthier, and have more stable families, all of which build the nation. Essentially, this is the argument that other nations use to invest public funding in families raising children and guarantee a minimum family income. So there is a defensible set of arguments – albeit not a winning one in the United States, but a compelling one – that we ought to pay people a decent income because it takes care of our people, serves productivity, and upholds the nation as a whole. (Dodson 2015: 278)

Unfortunately, the United States' neoliberal approach leaves too many mothers and their children sinking, to their detriment and the detriment of the nation as a whole. Research on the correlates of inadequate supervision in child welfare cases reveals that mothers who moved or experienced problems with housing or were homeless were more likely to inadequately supervise children than mothers of the same income level who had not experienced housing problems (Coohey 1998), again highlighting the need to provide adequate, stable housing for struggling families. When these children suffer or fail to achieve, it is the mom who is blamed, no matter how strenuous her attempts to do right by her children.

A few years after the 1996 Welfare Reform Act, reporter Katherine Boo (2001) wrote an exposé on Elizabeth Jones's family. Jones, a black, single mother who had given birth to three children as a teen and young adult, had previously received public assistance. She acquired volunteer and work experience, took classes, and eventually became a police officer working from 7:00 pm to early morning, and she also worked a second job as a security guard after dropping the kids off at school until dinnertime. Living in a high-crime neighborhood, she commanded her children to stay inside their home to keep them away from gangs, drugs, and stray bullets, and then

prayed they listened to her while she was at work. She did homework with them despite barely being home, given her two jobs. She researched education opportunities and, at one point, had all three children in different schools. Yet the charter school her youngest attended frequently lacked books, and when teachers did not make it to work, the substitutes did not bother to teach. Her eldest had better luck with his program, but when the school for differently abled children helped him progress, he was mainstreamed back to the school that had been failing him before. As for the girl in the middle, Elizabeth was preoccupied with her falling for boys and ending up pressured into sex or sexually assaulted and possibly pregnant, her own experience of being raped in junior high looming large.

Between the high cost of living in DC and expenses, including student loan debt and a car payment, Elizabeth was still struggling to get by, despite her two jobs. Her fears for her children's futures were legitimate. None of the three was well served at school. By the end of the article, the reader is seriously worried about the prospects for the children of this hard-working mom trying to "intensive mother," despite all that is stacked against her. What more could we ask of this mother who chose to be sterilized at age 21 because she knew that too many elements of her life, including her own sexuality, were not always under her control? This mother who took a remedial math class in order to help her kids do their homework but was rarely home and never got enough sleep because of her two jobs? This mother who researched all the available schools, filled out applications, talked to teachers, and got her learning-disabled son subsidies to attend a special school, only to watch the educational system disappoint. As Coleman (2015: 399) insists, "[p]erspectives that blame child outcomes on parents are especially problematic when applied to the poor since the social dynamics of poverty make it harder for parents to protect their children and provide them with the assortment of educational, enrichment, and therapeutic opportunities that are available to parents with greater resources."

For every case of a mom who leaves her children in the minivan watching a video while she makes a quick return at a store, there is a woman who is caught between very hard choices. Shanesha Taylor left her two youngest children, a two-year-old and a baby, in the car for 45 minutes during a job interview in Arizona after she was unable to find child care for them. Ms. Taylor, who was on the verge of homelessness, really needed a decent job. After an outpouring of support and over

US$100,000 in donations from well-wishers, her children were returned to her and she was given probation and mandatory parenting and substance-abuse classes in return for pleading guilty to a child abuse charge. Victoria Baker, a mom from Florida, was arrested for leaving her baby in the car for 20–30 minutes while she applied for a job in person, and fellow Floridian Betty Brunson was arrested when she left five children in the car for 15 minutes while picking up a job application. College student and single mom Laura Browder took her six-year-old daughter and two-year-old son to a mall where she had an interview for a job. She bought them food and seated them 30 feet away from her in the food court while she interviewed inside a Starbucks. Moments after saying yes to the job offer, she was handcuffed by police and charged with child abandonment. Taylor, Baker, Brunson, and Browder are all black women.

In the summer of 2014, prior to the Meitivs' first run-in with the law, Debra Harell, a black mother from South Carolina, allowed her nine-year-old daughter to spend her days in the park with friends while she worked at a nearby McDonald's. She thought this was a better option than making her sit inside the fast-food restaurant all day or leaving her alone in a home that had recently been burglarized. As her attorney pointed out, no child had been kidnapped from a park in South Carolina in over 20 years, yet Ms. Harrell's daughter was traumatized by being removed from her care for two weeks, and Ms. Harrell was charged with willful abandonment of a child, a charge that could have led to a 10-year sentence (Stossel 2020). Luckily, the governor intervened, and the charges were dropped (Stossel 2020).

Of course, this begs the question, how is a single mom who works at McDonald's supposed to afford child care or summer-camp costs? And when she is arrested, even if she can plead down to a sentence of fines and parenting classes rather than prison time, how is she supposed to afford paying those fines as well as legal fees and missing work for adjudication? Will she have to bring her child to court-mandated parenting classes which will either happen while she is supposed to be at work, or at a time she would normally be home caring for her child? Roberts explains that all too many parents lose their children not because they are abusive but because they cannot meet social workers' and judges' requirements.

> As incredible as it sounds, parents' ties to their children are routinely severed for good because the parent failed to fulfill some provision on

the caseworker's list. In other words, parents' rights are usually terminated for non-compliance, not harm to their children. The parents are made legal strangers to their children; their children can be adopted by others; they may lose touch with their children forever. (Roberts 2022: 189)

How would any of the consequences above improve the lives of a mom like Ms. Harrell whose crime is not being able to afford child care, and that of her daughter? What would help them both is subsidized child care, not punishment. Commenting on the Shanesha Taylor case, legal analyst Mark O'Mara writes:

[f]rom one perspective, we're criminalizing poverty. Some . . . parents . . . clearly acted out of economic necessity. In our post-recession economy, good jobs are hard to come by and child care is expensive. For low-wage earners, child care costs can easily eclipse earning potential. In Taylor's case, she had previously been offered a full-time job, but child care costs would have left her with less income than she was able to earn by picking up a few hours here and there. (O'Mara 2014)

Taylor Cumings, a white mom from Indiana, was charged with neglect for leaving her four- and seven-year-old sons home alone while she was at work. She defended herself by arguing that she thought they were responsible enough. "At that time I thought it was the best decision. I know my kids and I trust my kids . . . [t]hey had a phone, they had a safety plan which they followed. They were safe. They ate, they were checked on. They weren't just here all day running around crazy" (Bull 2018). Ms. Cumings admitted that she had tried to find an alternative caregiver but was unsuccessful. One of her children had already been home from school for a fever recently, and she was worried about how much work she was missing at her job with at-risk youth (Bull 2018). Ms. Cumings bemoaned the lack of help that leaves working parents stuck: "[i]f there was a day care, like an emergency day care for sick children or say your kids [sic] suspended or whatever these circumstances are, but we don't have that" (Bull 2018). The United States is the only industrialized country that does not have a nationally mandated number of sick and vacation days (Collins 2019). While 90% of the top quartile of American workers have vacation days, only 50% of the lowest quartile do (Collins 2019). Journalist Haley Bull noted that 11,000

Indiana parents were forced to quit their jobs because of childcare issues prior to the Covid pandemic. She interviewed Sandy Runkle-DeLorme from Prevent Child Abuse Indiana, who opined:

> w]e definitely need more resources out there for families who have children that are not yet ready to be left alone. And that's not even a particular age it's really based on maturity [sic] . . . So what can we do as a community to sort of come together too to sort of help with this issue with families because it is a very very [sic] real concern. (Bull 2018)

Covid, has, of course, exacerbated the difficulties for parents. At the beginning of the school year in 2020, two elementary school-aged girls were photographed sitting on the sidewalk outside of a Taco Bell in California to access Wi-Fi so that they could do their school work. Their Latina mother, Juana Valencia Garcia, was being evicted from her home and had no internet. When her girls' photo appeared online, the school district identified them and started trying to help the family, including providing a hot spot. People donated money on Go Fund Me, and Ms.Valencia Garcia was able to secure new lodging. However, all the publicity had attracted the attention of the police. Ms. Valencia Garcia was lucky not to be charged for anything, given that her children were unsupervised outside the fast food restaurant. If her situation had not garnered national interest, would she have gotten in legal trouble? Certainly, no one was helping this family facing homelessness before her kids went viral. Once she lost her housing, would her daughters have been sent to foster care? Their case drew calls for more internet access for low-income families, which is tremendously important, but there is so much more to this story that we must collectively face as well.

Helping our children and ourselves

There was public outcry in support of Shanesha Taylor and Debra Harell because many recognized the injustice of the system failing them and leaving them in difficult situations without any good choices. Go Fund Me is great, but it does not change the system that will lead to other moms and children finding themselves in these circumstances in the future. Aid to poor families keeps families together by ensuring

that parents can provide decent shelter, health care, and food for their children. It also prevents the need for increased funding for foster care and adoption services, yet the government seems to prefer spending on the latter to the former (Roberts 2022).

Unfortunate mothers live with the threat of being reported to child welfare by abusive partners or landlords trying to bully them. Other times, it is entities who are supposed to look out for these families who turn them in, even when they know that the issue is poverty and not abuse. Like mandatory arrests in calls to police for domestic violence, the Child Abuse and Prevention Treatment Act (CAPTA) has provisions that, while well-intentioned, can end up causing more harm than good. CAPTA requires certain professionals, including teachers and healthcare workers, to report when they suspect child maltreatment. This can lead parents to avoid services, such as taking a sick or injured child to the hospital, out of fear of being reported (Roberts 2022). In order to cut down on this, Harvey, Gupta-Kagan, and Church (2021) argue that school employees should be able to refer families in need directly to resources, rather than turning them in to child protection hotlines. School officials may know that the family is struggling economically, losing their home for instance, but when they report to Child Protective Services, children face being removed from their parents' care rather than the parents getting housing or other economic assistance. Even if this does not happen, the investigation is inevitably stressful for the whole family. Once parents learn that the school has reported them, the trust is broken between school administrators and the family.

> Schools can largely refer children and families to the same services that the family regulation system can – such as mental health services and substance abuse treatment – but without that system's coercive authority and its associated problems. Where some services are tied to the family regulation system's involvement, the law should permit schools to refer families directly. Schools know which families need legal services to defend their housing, access benefits, obtain orders of protection – or any of the myriad of other supports that poverty lawyers can provide. This shift would tie schools to the families and communities that they serve and benefit those families and communities far more than the surveillance and policing they experience under the current family regulation system. (Harvey, Gupta-Kagan, and Church 2021: 2)

Child protection is supposed to be about more than disrupting lives and punishing people; yet policing families is all too frequently the main occupation of these agencies. "Although Anglo-American child protection legislation usually mentions both care (providing supports and assistance to enhance child, parent, and family functioning) and control (investigating and monitoring parents), it is control functions that are legislatively mandated while supports and resources are usually discretionary" (Strega, Krane, and Carlton 2013: 18). Additionally, states must stop billing parents for costs accrued by their children while in foster care. Given that poverty is what often leads to children being removed in the first place, it is nonsensical, but also vindictive, to expect poor parents to pay the government a debt that can be as much or more than their yearly salary. This only serves to keep children separated from parents longer, effectively also increasing the bill, and if parents do get their children back, they have fewer resources to support them (Shapiro, Wiltz, and Piper 2021). "Foster care is a key mechanism for syphoning money from poor families to state bureaucracies and their corporate partners" (Roberts 2022: 146).

We must demand that more of our taxes are used to support families and children. Help for families is much better in many European countries, including minimum wages that are closer to a living wage, particularly when combined with universal health care, subsidized child care, and paid parental leaves. Germany, at least legally if not always in practice, makes child care available for all children ages one to six and heavily subsidizes it (Zaske 2017). By age two, 59% of children go to some type of childcare/preschool program, and these rates jump to 92% at age three, 96% at age four, and 98% at age five (Zaske 2017; OECD data). In the United States, only about a quarter of young children are in professional childcare programs (Glynn 2012; Zaske 2017). The cost of child care in the United States is outrageously high, sometimes costing as much as public college tuition for the year, and while childcare centers in some areas are fantastic, some in poorer areas are poor quality. Unlike in France, where childcare workers are trained and paid well, on this side of the Atlantic we devalue our childcare professionals, the vast majority of whom are women, many of them women of color. The poor wages lead to high turnover in a field where stability of the staff is particularly key for high-quality experiences. Making child care affordable for parents, paying the workers well, and guaranteeing

every child a spot, would go a long way toward preventing situations like the one Shanesha Taylor faced.

In addition to political reforms, we also need to change our mentality. When French women told Pamela Drucker that a mother should not be enslaved to her child, it may sound unkind or frivolous to some, but it is not. While an American mom may pat herself on the back for having her priorities straight and putting her children first in every situation, unlike those French mothers who expect relaxation and adult time, the American mom might be participating in the creation of her own invisible straitjacket. Holding women hostage to their children at every moment handicaps them. Fathers are not subjected to an equal level of responsibility, and they rarely find themselves castigated the same as mothers for "failing." They get to be good parents even if they work, even if they do not attend all their children's events, even if they (gasp) expect some relaxing adult time away from their children. We must ask who benefits from this control of mothers, and why so many of us participate in it.

These gendered standards, and the gendered prosecutions that follow, collectively condemn women – all women. They reinforce the ever-expanding pernicious expectations. Mothers try to meet them, only to exhaust themselves. Moms who have a momentary lapse in which they either forget the expectations or knowingly decide not to play along, face a price – sometimes criminal. And far too many are in positions where it is even harder to meet these expectations – single without another party to share responsibilities, or unable to afford child care or to miss a day of work when a child is off school. Mothers of all social classes and backgrounds self-castigate, even if no ex-spouse or neighbor is there to chide them or, worse, turn them in. This handicaps them psychologically. But they are also handicapped professionally and monetarily. Mothers, much more so than fathers, reduce or quit work when a child is born with health problems and cannot go to daycare, or a pandemic rages and schools are closed. When we urge a single or economically struggling mom to pay for and ferry her elementary schoolchildren back and forth to extracurricular classes during work hours, we should think twice. We are not only asking too much of her, but we are putting more pressure on every mom. There is always another thing a mom could be doing for her child. This feeds the patriarchal motherhood machine and makes it hard for a mother to feel empowered by, or even enjoy, the experience of mothering.

Sadly, seeing moms having trouble coping can lead to negative reactions like criticism and schadenfreude rather than empathy, even by moms themselves. When we take comfort in another woman's downfall because we are nowhere near as bad as she is and therefore feel better about ourselves and our parenting, we would do well to remember the dynamics involved in this scapegoating. They ratchet up the standards for all mothers, hurting not only the "bad" mom but, ultimately, all moms. They contribute to the ongoing perverse belief that mothers are responsible for the well-being of society as a whole, saving us all through their sacrifice (Hays 1996; Villalobos 2014). Given these expectations, when moms "fail," it shakes us. When we are afraid or feel betrayed, we are more likely to lash out and seek to punish. Yet, obviously, moms cannot protect everyone from the vicissitudes of the world. That is not their job, nor is it a task that can be accomplished by individuals. Rather, it is our collective responsibility to make the world better for everyone, including mothers. That is what we should be demanding: more resources for people who parent, as well as more understanding. Ultimately, there is more power in identifying with "bad" moms than in constantly, desperately trying not to be one.

It is a dangerous fantasy to believe that if "they" can be identified and labeled, and then treated or punished, the nation will be somehow purified, made safer for the rest of us. This scapegoating does enormous harm to the women accused of "bad" mothering and serves to intensify already existing social antagonisms, including those of race and class. It also fails as a method of social purification and redounds to the detriment of all women. (Ladd-Taylor and Umansky 1998: 22–3)

The slippery slope reappears. It could be any of us facing unexpected criminal charges one day. Just ask Kim Brooks.

5

Mothers of Maimed and Murdered Children

Much like the warnings about FAS to women who drink a little bit on occasion, the prosecutions of moms who leave their kids in a car for a few minutes are more about enforcing social norms and reminding mothers how easily they can be monitored and rebuked than they are about safety. Yet there are, of course, times when children are truly at risk. And some children do die by the hands of adults. Unlike the potential harms women were prosecuted for in the last chapter, the children mentioned in this chapter are seriously injured or murdered, some by their moms and some not, but the mothers can be prosecuted even in the latter case.

There are different patterns for mothers and fathers who kill their own kids. While both mothers and fathers kill their children while abusing them, fathers are more likely to do so. Mothers are more likely than fathers to kill because of a psychotic break or because they believe they are doing the only thing possible to get their children out of a bad situation. The latter are referred to as "altruistic" murders. That label is problematic as, with the possible exception of a child with a terminal health condition who is suffering terribly, these murders are only altruistic from the perspective of the murderer, not the children (Buiten 2021). As mentioned in chapter 4, sometimes children are killed accidentally, such as being forgotten for hours in a hot car. Fathers and mothers have both done this, but Goodwin (2020) points out that when women are charged with neglect, even if the children are unharmed, the moms' names end up in the press. Fathers, on the other hand, can kill their children through accidental manslaughter and sometimes

remain anonymous. Some believe that mothers who kill children are viewed more sympathetically. This may be due to the higher incidence of psychosis, sometimes brought on by the postpartum state, among mothers who murder. The public may be chagrined rather than vindictive when the cause is loss of sanity. It is also more comforting to believe that a mother was insane and completely out of touch with reality when she killed her baby – otherwise we have to confront that some women do kill their children for less palatable reasons like carelessness, refusal of responsibility, or being overwhelmed (Hager 2015).

Mothers are also almost always exclusively the ones charged for killing newborns immediately or shortly after the birth, cases which drive up the total number of murdering mothers (Buiten 2021). A panicked girl or woman throwing a baby in a dumpster or drowning a baby in the toilet in which she delivered, sometimes after months of pregnancy denial, is a tragedy on all counts. Better sexual education, free birth control, subsidized access to abortion, including for minors, anonymous delivery sites, and hatches for abandoned babies are all ways to cut down the number of these calamities. Mothers are also usually the parent who accidentally starves an infant to death, although in one of the cases below, the father was also charged but received a shorter sentence than the mother who received life in prison. This point leads to another focus of this chapter, "failure to protect" laws. These prosecutions disproportionately affect women, and, in some cases, the person who harmed a child spends less time in prison than the child's mother who did not. The fact that this disproportionate sentencing occurs reflects the view that it is mothers who are responsible for their children; they are held accountable in a way that fathers are not.

Mothers who kill

We've all heard horrific cases in the news in which a mother has murdered her child or children. Susan Smith, who murdered her two young sons by drowning them in her car, comes to mind. Around the same time, a father, Kirk Douglas Billie, whose girlfriend had left him due to his abuse, intentionally drove her car into a canal with two of their three young sons in the back. He jumped out and let them drown. While Ms. Smith's case was all over the news for months,

Mr. Billie only made a local front page and received far less press attention (Jacobs 1998).

Susan Smith had experienced years of sexual abuse from her stepfather and was likely depressed over her failing marriage. She had previously attempted suicide. She killed her boys allegedly to start a life with a new man without the baggage of children, although she claimed she had no motive and was not in a normal state of mind. What is not debated is that to divert suspicion, she claimed that the car was carjacked by a black man. The media fell for that for a while. After all, who wants to believe that a mother could murder her own children by driving them into a lake? Mothers do murder children for financial gain, to please a boyfriend, to prevent their kids from testifying against them in court, and for other reasons that do not fit our conceptions of how a mother should or could behave, but because we count on mothers to preserve us all through their altruism and self-sacrifice, this behavior is doubly troubling and more upsetting than the same horrors perpetrated by fathers.

A different notorious case is undoubtedly about severe mental illness. Andrea Yates drowned her five children in the bathtub of her home, one by one. Ms. Yates believed that she was a horrible mother, and she had already tried to kill herself on multiple occasions. Because she thought she was not doing a good enough job raising them, she was convinced that they were going to end up in hell. The best way to help them was to save them from herself and to send them straight to heaven. She readily admitted what she had done and why. She was also clinically insane when she did it.

Ms. Yates experienced postpartum psychosis, a thankfully rare condition unlike the more common postpartum depression from which she also suffered, after the birth of her fourth child, and she and her husband were told by a doctor not to have any more children as her serious mental health problems would not only reoccur but likely become worse. Given his religious views, Mr. Yates pushed her to have another child anyway, and she went off her psychiatric medication to do so. After the fifth child was born, she again became psychotic and unable to parent. Despite suicide attempts and inpatient psychiatric treatment, her husband expected her to care for all five kids and to homeschool the older ones as well. After being told by a psychiatrist not to leave her alone, he asked his mother to help her when he was at work, but he specifically told her not to come until an hour after he left and to leave an hour before

he returned so that Ms. Yates would not become too dependent on others for assistance. It was during this hour in the morning that Ms. Yates killed the children.

A defense witness, a psychiatrist who had interviewed Ms. Yates in jail, explained how she alternately said she was marked by Satan and that she was Satan and spoke of fulfilling a prophecy. She thought Satan was communicating with her through a movie and that television cartoon characters were speaking to her and to the children. Ms. Yates was also convinced that "the media had put cameras in her house years ago to monitor her behavior as a mother" (Christian and Teachey 2002). In prison, she would not wash with soap (Christian and Teachey 2002). The psychiatrist stated that she had no awareness of her own mental health conditions, even the depression, and that she was one of the sickest, if not the sickest, incarcerated patients she had ever seen (Christian and Teachey 2002). No one disputed Ms. Yates's history of severe mental problems. But Texas law had a finer definition of culpability. The prosecution only had to prove that she knew right from wrong. As she planned her actions and called both her husband and the police after the murders, and even asked when her trial would be, the jurors believed she did know right from wrong, and while she escaped the death penalty, she was sentenced to life in prison. An expert for the prosecution suggested she may have gotten the idea from a *Law & Order* episode that was not actually written until after her crime. In her retrial a few years later, without that testimony, her insanity weighed more heavily, and she was ultimately sent to a secure mental institution where for a while she was held with Dena Schlosser, another psychotic mother, who killed her youngest child, an 11-month-old, by cutting off her arms. Unlike Schlosser, whose brutal, nonsensical act could not be explained by anything other than severe psychosis, Andrea Yates faced questions about her motivations for the murders that went beyond her mental illness.

In an article written just after the first trial and sentencing of Andrea Yates, Anne Taylor Fleming (2002) argues that the prosecution made the case about motherhood, and "motherhood trumped mental illness." They painted her as an overwhelmed mother, angry at her husband for all the expectations he placed upon her. She allegedly wanted to be free of her burdens and to punish him as well.

She was, in short, the ultimate maternal failure turned murderer, the demon mother writ large. She had to be punished – severe mental

instability notwithstanding. The flip side of this demonization of Mrs. Yates is the sentimentalization of motherhood. It is seen as a sacred and sacrosanct sphere. The circle of mother and child is a Hallmark card place, where the selfless mother nurtures her young, no matter her dreams or ambitions, conflicts or terrors . . . Through all of that gauze, it's hard to see a mother like Mrs. Yates as she really is – one of the desperate, destructive mothers that nobody takes seriously until it is too late. (Fleming 2002: 3)

Fleming (2002: 3) notes that the barrage of advice aimed at mothers, despite often being contradictory, ultimately serves to "reinforc[e] the myth of the all-important mother who should be able to meet all of her children's needs – physical, psychological, emotional, and economic – without help or 'interference' from anyone." This leads to enormous guilt, even for "good" moms. Fleming ends her article by warning that "[m]others are tough on themselves – and on each other. And who was tougher on herself than Andrea Yates?" (Fleming 2002: 3). She murdered her kids because she believed her incompetence as a mother was literally damning them for eternity.

"A mother or father who mistreats and kills a child, either through negligence or intent, is telling us something about the society of which they are a part" (Fass 2016: 3). Mothers who kill their children are more likely to be experiencing a psychotic episode when they do so than fathers, although many fathers who kill also suffer from mental disorders including depression (Buiten 2021). Men and women kill their children in about the same numbers in many studies, but men do so more often in other studies, particularly when stepfathers are included. When cases for neonaticide specifically are removed, the totals for mothers decrease. Women are more likely to kill infants they did not want to bear (Buiten 2021). In one-fourth of murders by mothers, the child is under a year old (Bourget, Grace, and Whitehurst 2007). When a child dies from abuse, in the case of a culpable mother, it is usually from neglect, whereas for culpable fathers, it is more likely to be from physical abuse (Buiten 2021); women perpetrate 34% of serious or fatal cases of physical abuse of children (Campbell 2014a). Women will kill their children, and sometimes themselves, but rarely their current or former partner at the same time; men are more apt to murder their girlfriend, wife, or ex-partner along with the children and sometimes themselves (Buiten 2021). In some cases, women attempt to spare their children the pain of a real or imagined situation, including the pain of motherlessness

after a mother's intended suicide (Broome 2021; Buiten 2021). This is not a common reason given by murdering dads who are more likely to kill the children to get back at the former partner for leaving him, getting custody of the children, or starting a relationship with a new partner (Bourget, Grace, and Whitehurst 2007; Buiten 2021; Kirkwood 2013 [2012]). "Wilczynski, who studied filicide in Australia and England, described the main difference between maternal and paternal filicides as women generally kill children because they have too great a responsibility for their care, while men generally kill children as a result of too little responsibility for their care (1995) [sic: Wilczynski 1997]" (Kirkwood 2013 [2012]: 35). For men, children are more likely to be a bargaining chip or collateral damage.

A review of studies of filicide conducted by the domestic violence resource center in Australia (Kirkwood 2013 [2012]) calls attention to the differing motivations of mothers who murder their children: "[An offender's] perception that she would fail to provide for the children is consistent with previous research that has shown social expectations of women to be 'good' mothers play a crucial role in maternal filicides" (Wilczynski 1995 [sic 1997]). Oberman and Meyer (2008) found that mothers who killed their children struggled to be good mothers under exceedingly difficult circumstances" (Kirkwood 2013 [2012]: 68). Not all these women were psychotic and having delusions like Andrea Yates. Some simply could not assure their children's financial and emotional needs.

> Many feminist psychologists and researchers have argued there are links between the social construction of what it means to be a "good" mother and depression. For instance, Lafrance found that women's narratives of depression often contain references to "feeling overwhelmed by the demands and circumstances of their lives as mothers, while at the same time feeling as though they should be able to manage with unfailing patience, kindness and caring concern" (Lafrance 2009: 35). (Kirkwood 2013 [2012]: 72)

Once depressed, some become suicidal and often attempt suicide, but simultaneously believe that their suicide would make their children's lives even worse. They think their sons and daughters would feel abandoned by their mother and be cared for by poor substitutes, including by fathers who had been abusive. This could influence a

woman's perception that her children would be better off going with her to death.

Other women do not intend to kill their children. They can be vilified nonetheless. When Tabitha Walrond was sentenced to five years of probation for negligent homicide of her two-month-old breastfed son who starved to death, the judge said, "The mother is the bottom line. The buck stops here." This despite the fact that the first-time mother had never been told, either at the time of her breast-reduction surgery at age 15 or during her pregnancy or postpartum care at age 19, that she would likely not be able to produce enough milk to feed her baby. Ms. Walrond had also tried twice to take her son to a doctor but was turned away because of lack of insurance. Hundreds of mothers around the world flooded the judge with messages asking for leniency, with several noting that they had also missed signs of starvation in their own breastfed infants (Bernstein 1999). The prosecution alleged that Ms. Walrond was angry at her ex-boyfriend and father of her child for leaving her during the pregnancy and having a baby with someone else. With the help of a psychiatrist they hired, the prosecution argued that she could have withheld milk from the baby *subconsciously* to punish her ex-boyfriend for withholding his time, help, and affection from her. Whether or not Ms. Walrond exhibited "signs of narcissistic personality disorder" or behaved passive-aggressively when her ex-boyfriend and his mother tried to give her parenting advice, including telling her to give the baby formula, there is no proof that she intentionally withheld her milk or otherwise tried to harm her son. Judge Straus's admonition that "the mother is the bottom line" may in fact have been the same kind of thinking that led Ms. Walrond to believe she could make her own choices about how to raise her baby, including how to feed or not feed (formula to) her son, the one domain in her life over which she may have felt control and efficacy. Sadly, this, in concert with poor childrearing knowledge, a lack of information about the side effects of her breast reduction surgery, and an inability to navigate the bureaucracies that could grant her son a Medicaid card, led to tragedy.

Tabitha Walrond lost her baby, but she escaped prison. Tina Rodriguez was not as fortunate. She is serving a life sentence in Texas for the death of her child from starvation more than 20 years ago. Ms. Rodriguez stated that she breastfed her two-month-old, the youngest of four children all under age four, but that she also

supplemented with formula and with cow's milk. The family lived in a shack with no running water, and two of the older three children were also underweight and all appeared neglected. Ms. Rodriguez lost custody of her older three children and received life in prison for homicide. Her husband, Noel Perez Silva, received a 25-year sentence with eligibility of parole once half the term had been served. The defense lawyers never presented evidence that Rodriguez was extremely distraught when she called 911 and they were unable to save her child. Nor did they put coworkers on the stand to testify that she was happy about her pregnancy and had taken her new baby to her place of work to show him off after he was born (Nathan 2019). She was also pregnant with twins when her baby died. Instead of a depressed, worn-out mother living in poverty, physically overtaxed by so many pregnancies in four years, the prosecution painted her as a cruel person who intentionally allowed her child to starve to death. Recently uncovered evidence may indicate that her son had a medical condition that caused his body to not be able to convert carbohydrates into energy, and if that were the case, no matter how much she fed him, he would have died (Nathan 2019). Yet the court denied her appeal.

When the mom gets more time than the attempted murderer

Rebecca Hogue is being tried for first-degree murder through enabling child abuse because her boyfriend killed her two-year-old son while she was at work. She said that when she returned home from her night shift at 4:00 am, she thought her son was sleeping, but in the morning she realized he was not breathing and called 911. Her boyfriend, the only suspect, killed himself a few days later, and the prosecutor's office seems determined for someone to pay for the child's death. While investigators believe Ms. Hogue should be charged with enabling child abuse, they do not concur that she should face a murder charge and said so. In a recording, the detective said that the assistant district attorney responded "Well, we're not going to do that. If you send [an enabling charge], then you torpedo our chances of getting a murder charge" (Gorman 2021). Thankfully, Casey Campbell's four-year-old daughter did not die, but she was seriously burned by Campbell's boyfriend. Like Ms. Hogue, Ms. Campbell was at work when the abuse occurred. She was convicted of felony

child endangerment, while her boyfriend was only convicted of a misdemeanor (Fugate 2001). Her conviction was upheld on appeal.

One of the most well-known cases of injustice in prosecutions of harmed children is that of Tandalao Hall, who received 30 years for failing to protect her children from their father. Her former boyfriend, Robert Braxton, broke their infant daughter's ribs, femur, and toe. She was not home when it happened; she was with her own father, looking for a new apartment so that she could leave Mr. Braxton. Ms. Hall claimed that while she was abused by her boyfriend, she did not know that he was hurting the children. Prosecutors said she never should have left the kids alone with him. Mr. Braxton was given time served for the two years he awaited trial in jail and on probation (Slipke 2020). The Governor of Oklahoma, Kevin Stitt, commuted Ms. Hall's sentence after she served half of it, 15 years behind bars.

"Failure to protect" (FTP) laws are designed to punish parents and those hired to provide care for children who fail to seek aid for a child who is obviously in danger or injured. In some states, it is called enabling or permitting child abuse; in others, defendants are charged with injury to a child by omission. While the laws are written in a gender-neutral manner, prosecutions are normally aimed at mothers who are supposed to be able to predict and prevent abuse of their children by others. As in both Ms. Hall's and Ms. Campbell's cases, in these prosecutions, the mother sometimes receives an equal or longer sentence in prison than the man who abused or murdered her child because she is deemed more culpable for not keeping her child away from a dangerous man. As a mother, she should have known better. The men, even when they are the fathers of the children, are less culpable because as men they are simply not held to the same expectations. Thus courts have repeatedly seen it as justifiable that both the mother and the perpetrator get life in prison. Sometimes the perpetrator of injuries to a child, such as Mr. Braxton, goes to jail for a shorter sentence while the mother who did not participate in the abuse gets more time, particularly if he manages to plead to a lesser charge and she opts for a trial. In eight states, the penalty under "failure to protect" can be life in prison; in another three states, the maximum sentence is 50 or 60 years. Yet in other states it is only six months or one year. Some states provide exemptions for women who were in danger themselves, and others do not or restrict them, depending on whether the abuse toward the child was a first-time incident or ongoing (Campbell 2014a).

Arlena Lindley received a 45-year sentence after her boyfriend, Alonzo Turner, murdered her three-year old son, Titches. Mr. Turner received a life sentence. Ms. Lindley had also been a victim of his abuse; in fact, even prosecutors admitted that she was very afraid of him (Campbell 2014a). On the day of the murder, Mr. Turner began viciously whipping, throwing, and beating Titches after he had an accident. Despite him threatening to kill her if she did anything, Ms. Lindley had tried to grab her son and run out of the house, but Mr. Turner pulled Titches back inside and locked her outside of their home. Her sentence was commuted the second time she went before a parole board after nine years in prison.

In 2014, a Buzzfeed report found 28 abused moms who received substantial prison sentences for not stopping a partner from hurting their children in several reporting states over a decade; thirteen had received 20 years or more, and the other fifteen had been sentenced to at least 10 years. One mother was sentenced to life for FTP, the same sentence as the man who did the killing, and in another case, the murderer got life and the mother got 75 years with a mandatory time served of almost 64 years, essentially equating to a life sentence (Campbell 2014a). BuzzFeed News found another 45 cases against mothers in which there was no proof the mother had suffered abuse and the mom received 10 years or more for the harm her partner did to her child. "[F]athers rarely face prosecution for failing to stop their partners from harming their children. Overwhelmingly, women bear the weight of these laws" (Campbell 2014a). BuzzFeed only found four cases of fathers convicted under FTP laws (Campbell 2014a).

> As one advocate stated, "In the 16 years I've worked in the courts, I have never seen a father charged with failure to protect when the mom is the abuser. Yet, in virtually every case where Dad is the abuser, we charge Mom with failure to protect." While it is true that more women have custody of their children and thus are more likely to have the duty to protect their children, this fact alone does not explain the discrepancy adequately. The overwhelming prevalence of female defendants can be explained best by the higher expectations that women face in the realm of parenting and child care. (Fugate 2001: 274)

Four years after the Buzzfeed report, the District Attorneys Council reported that 47 women were serving time for enabling neglect or child abuse in the state of Oklahoma alone (Slipke 2020). The American Civil Liberties Union (ACLU) obtained court records from

several Oklahoma counties and determined that 93% of people convicted for failure to protect between 2009 and 2018 were women. Half of these women had been abused by the man who abused their child. The staff attorney of the ACLU of Oklahoma, Megan Lambert, argues that these laws "criminalize women" and prevent them from seeking help (Slipke 2020). She underscores the unfairness of the justice system: "[o]ne in four women convicted of failure to protect received a longer sentence than the actual child abuser . . . We are not seeing this law used where women are intentionally – as the statute says willfully or maliciously – allowing their children to be abused" (Slipke 2020). Differences between malicious mothers versus those trapped in horrible circumstances are ignored, and victims are penalized.

Unfortunately, any woman who has experienced abuse already has a strike against her. Even though the perpetrator of the violence is the one to blame, she is judged for making a bad choice to be with him in the first place. One woman I taught in prison who was serving a multiple-decade sentence for murder was pregnant when her partner attacked her. She defended herself by grabbing a knife and stabbing him once. She called 911 and stayed with him, but after waiting hours for care in the emergency room, he died from that single wound to the heart. At her trial, the judge told her that she should never have moved in with him; the judge admonished, "You should have known better." The key here is that the judge was not suggesting that she should have known better than to stab someone; he was blaming her for choosing to live with her boyfriend and thus bringing the attack and its consequences, including her legal ones, on herself.

This phenomenon is even worse for mothers who are tasked with ensuring their children's well-being. Even when a mother has never been violent toward her partner or children, she is viewed with suspicion and loses her claim to be a good mother simply for having been on the receiving end of violence. "Despite being the victims, abused mothers are often perceived and characterized as 'bad mothers' because their ability to shelter, care for, protect, and provide a safe and secure environment for their children is called into question and deemed deficient, regardless of whether their children have witnessed or experienced abuse themselves" (McDonald-Harker 2020: 256). Rather than receiving sympathy and assistance, the victimized mother undergoes criticism "given the precarious situation in which she has placed her child(ren). Locating the problem

primarily with the women and their mothering shifts attention away from larger societal and cultural forces, and removes responsibility from the men who inflict violence" (McDonald-Harker 2015: 324). It is not patriarchy, violence against women, or the feminization of poverty that must be addressed; these societal ills can be ignored if we make it all about the individual woman's bad decisions. She is rendered deviant, criminalized without having committed a crime (McDonald-Harker 2015).

Additionally, mothers who have experienced domestic violence are assumed to have poor parenting skills or to be too stressed out or broken to mother well. Yet studies of the behavior of abused moms demonstrate that this is not always the case (McDonald-Harker 2015, 2020). Some mothers who have never experienced violence do not cope well with stress, are overly authoritarian/punitive, and so on, and some mothers who have been victimized are very patient, protective, and nurturing moms. As one of McDonald-Harker's (2015: 350) respondents stated, sometimes it is a case of a "good mother in a bad situation."

For those who have never encountered domestic abuse, it is easy to think that when a woman finds herself in this circum-stance she should immediately leave. "Masochistic expectations of mothers, coupled with ignorance regarding barriers to leaving abusive relationships, means that a failure to leave is conflated with a failure to protect" (Singh 2021: 183). The barriers are numerous. Domestic violence makes it hard for women to report their abusers. In addition to the psychological control, they face real structural impediments to getting out of their relationships. They can lose their source of revenue and their housing if they leave or if their partner goes to jail and they have limited or no income and little family support. This drives some women to go back after trying to make an initial break. It is worth noting that abusers sometimes purposely cut their victims off from family and friends as a means of control. This serves to harm the partner further psychologically, to hide the abuse from others, and to make it less likely the woman will have help to which she can turn down the road. Women also correctly perceive that their children may be taken from them even if they have not committed any acts of violence themselves. Paradoxically, these laws consequently impede mothers who are abused from reaching out to authorities for help for fear of losing their children (Fentiman 2017).

When Wanda Lee Tate's husband pleaded guilty to multiple counts of severe child abuse, for example, Ms. Tate also lost parental rights. Although no one contested the fact that she was abused and feared him, when she sought to regain her parental rights, "the Court stated, 'that even animals protect their young.' The Court then declared that she needed to take responsibility for her own actions and that 'the natural maternal instinct that any mother should have . . . should have overcome her fear if she is to be a fit mother' and refused to return her parental rights" (Mahoney 2019: 442).

Mahoney (2019), Roberts (2022), and Strega and Janzen (2013) all write of women experiencing violence prosecuted for neglect or child maltreatment based on their "allowing" the child to witness the mother's abuse even when the child had never been abused by anyone. This happened to Shawline Nicholson. After she broke up with her boyfriend, he attacked her, the first time this had ever occurred. She called the police. At the hospital, she found out that Child Protective Services had taken her children and neglect charges were being filed against her as "she was not able to protect them given that her boyfriend had beaten her" (Mahoney 2019: 450). Nicholson did get her children back but was listed by the state as a neglectful parent. She was ultimately part of a class action law suit in which the Federal Court found that the practice of removing children from a parent's care because the parent suffered abuse is unconstitutional (Mahoney 2019). A case reported by Roberts (2022) had a worse outcome. The mother lost her children for failure to protect them from seeing her being beaten by her husband, and the family court gave her abusive husband custody of their daughter. Investigations of children who witness a parent's abuse have swelled caseloads in Australia, Canada, and the United States. In Canada, exposure to violence became the largest substantiated maltreatment category in the 2000s, and a broadening definition, such as seeing a mother's injuries after the fact or going with her while she receives medical care, instead of simply being present during the assault, is part of the reason (Strega and Janzen 2013).

Making women responsible or penalizing them for the violence directed at them is a form of revictimization. People cannot control others' violence, yet "women are routinely required to monitor and manage the behavior of violent men and ameliorate the consequences of violence . . . exculpating and absenting the actual perpetrators of violence" (Strega and Janzen 2013: 55). Social workers often ignore

violent fathers and stepfathers altogether and deal only with the mother; she is obliged to take parenting courses, undergo drug screening, and is the one responsible for executing the protection plan, even though she is not the cause of the problem in the first place (Maiter, Alaggia, and Mutta 2013; McDonald-Harker 2015; Roberts 2022). The demands of these requirements, such as having to go to parenting classes rather than work, can put her in a precarious economic situation, compounding the loss of financial support or housing she may have had with the abusive partner. This cascades problems as her economic troubles can subsequently lead to child protection employees or judges removing her children from her care (Roberts 2022). Often her assailant is not required to do any of these things. Protection plans can also conflict with the mom's obligation to make sure the children see their father when the court has not terminated his right to spend time with them (Strega and Janzen 2013). Social workers can remove her children because she allowed them to see their father, but if she does not facilitate their contact with their dad, the court can also penalize her for that reason and even give him full custody. Abusive men continue to have rights, while abused women have responsibilities (Strega and Janzen 2013).

The fact that fathers, either the abusers themselves seeking visitation with their children even when they are not allowed near the mom, or fathers who were out of the household when the abuse was committed by a boyfriend or stepfather, sometimes prevail in court in their custody bids, leads women to have a real fear that doing anything that could lead to authorities investigating their household could result in them losing their children, either temporarily or permanently. This is similar to how mandatory arrest laws for domestic violence that were intended to help victims have actually cut down on people calling the police when they need them. When a woman depends on her husband for a visa to be in the country, or relies on her boyfriend for revenue or a domicile, she likely does not want him to be arrested and convicted of a crime. In some jurisdictions, both people are arrested, leaving no one to care for the children; this, obviously, depresses the number of calls to the police by domestic violence victims (Fentiman 2017). Public nuisance ordinances that hold landlords responsible when there are too many calls to the police on their property can also hamper women's ability to call 911 for help. They risk being evicted because of the problems they "bring" to the property and consequently the landlord (Fentiman

2017). Women justifiably worry that if they involve law enforcement, once their abusive partner is released he will retaliate and she, or her children, will face worse violence. "Using FBI homicide reports, one study found that the rates of domestic partner homicide increased almost sixty percent in states with mandatory arrest laws" (Mahoney 2019: 448).

The fear of increased risk when leaving a violent partner is well founded. The most dangerous time in an abused woman's life is when she leaves her abuser. Women are at the most risk of being murdered when they get a restraining order or move out. Once he realizes he is losing control of her, the abuser will go to his furthest lengths, such as Hannah Clarke's husband, Rowan Baxter, who, after she left him and moved in with her parents, doused her and their three children in gasoline, set them on fire, and killed himself at the scene. As we saw in the different patterns between mothers and fathers who commit filicide, fathers are more likely to do it for revenge and jealousy, telegraphing the message that if they cannot have the children, then no one will. Victims of abuse have multiple, legitimate reasons to be scared of reaching out for help.

Yet judges and juries do not necessarily understand the dynamics of abuse and hold it against a mom in "failure to protect" cases. The law uses the standard of "a reasonable person." Failing to take the complexities of her life into account, prosecutors, judges, and juries do not see her as acting reasonably even though, in her head, and perhaps in reality in that particular situation, she was doing what was best to protect the children from further harm. Simply by virtue of dating or living with a man who abused her, "jurors may draw upon unconscious stereotypes and biases about motherhood and determine that abuse in this case happened because the women were 'bad mothers,' whose character and conduct were far below that of the ideal self-sacrificing, protective, and nurturing mother" (Fentiman 2017: 199). Prosecutors and judges also replace "reasonable" with "ideal" and label her criminal for not meeting the idealized standard (Fugate 2001; Singh 2021).

Rather than treating abuse suffered as a mitigating factor, "[p]rosecutors often use the violence a mother endured as evidence against her. Since she was battered, they sometimes argue, she should have left the relationship, taking herself and her child to safety" (Campbell 2014a). For instance, one judge asserted that it would have been easy for a woman to move with her children into her

mother's home a few blocks away. Aside from the fact that several people already lived in that home, her husband, who murdered their daughter, obviously would have known where to find her (Singh 2021). Some women only lived with the abuser for a few weeks and/or were making strides to move away from him by saving money or looking for a new apartment (Fentiman 2017), yet this is often not enough to help them in court.

Ms. Lindley had tried to move out repeatedly, but Mr. Turner would kidnap her to bring her back; he once threw her in the car trunk and she believed she would be murdered. He also threatened to kill her family. Yet neither the prosecutor nor the judge gave her credit for trying to end the relationship on multiple occasions, nor did they consider the level of terror in her life when weighing her actions. "Archaic associations between femininity and suffering mean that the good mother is required to be self-sacrificing to the point where she will die for her child" (Singh 2021: 194). This is precisely what Carmen White, the prosecutor in Ms. Lindley's case, expected. She stated that if a partner threatened her child, "I would sacrifice my life 10 times out of 10." She claims that the law makes it clear to mothers what their duties are (Campbell 2014a). Ms. Lindley stated, and a witness attested, that she did try to direct M. Turner's rage at herself rather than at Titches, but was unable to successfully do so. She attempted to pull her son away from Mr. Turner and run out the door, only for him to grab the child back and lock her outside. When Ms. Lindley failed to call 911, she may have been paralyzed by fears of escalating the situation even further. She told her friend that she wanted to but had been afraid that Mr. Turner would kill Titches and/or her if she did. After all, that is exactly what he had just threatened to do.

While harm of a child can often impel a mother to leave an abuser, extricating oneself from a violent relationship can bring other problems, financial or legal, as we saw above. As discussed, there is also the fear that admitting there is violence in the home to outsiders will bring social services to remove children from their mother's care, perhaps permanently. Others realize that their abuser is likely to escalate his violence even further when he realizes that he has lost control of her and she is leaving for good. This, certainly, is not to say that women should not leave. That is exactly what they need to do for their sakes and their children's, but it is simplistic to think that it is easy, and it is problematic for people who have never been

in such dire straits, and fearful of themselves or their children being murdered, to assume how they would act in the situation.

> "Mothers are held to a very different standard," said Kris McDaniel-Miccio, a law professor at the University of Denver whose expertise is domestic violence. She said that the lopsided application of these laws reflects deeply ingrained social norms that women should sacrifice themselves for their children. From a different perspective, White [the prosecutor in the Lindley case] agreed, saying that severe punishments generally fit "what people believe" should happen to mothers who shirk their duty to their children. (Campbell 2014a)

But much as some people clamor for the death penalty for a murderer mom, especially until they realize the extent of her mental condition, we need more education around the uphill battle faced by women who are abused to permanently get themselves and their children out of harm's way "[a]s evidence suggests that the general public find women more culpable for failing to protect their children if they have experienced violence" (Singh 2021: 190).

And even when moms make every effort, they may still be made to pay. "Historically, even when a mother does try to intervene and fails, it is typically seen as inaction by the police and courts. Frequently, these cases involve mothers with limited resources; namely, mothers who work and need to leave their children in the care of their partners" (Mahoney 2019: 441–2). Numerous women have been convicted after unsuccessfully trying to obtain help in the past from authorities and/or despite trying to leave the abuser, as Ms. Lindley did. Fugate (2001) mentions a case where a woman called the police on numerous occasions, obtained an order of protection, and at one point fled to her mother's home; yet none of this helped her in court when it came to defending herself against charges that she had not adequately protected her children. Women have been sentenced to prison even though they were terrified because they knew that their husbands had murdered other women, and when their husband killed their child and then threatened her that he would kill her and the rest of her family if she reported the murder (Fugate 2001). In one case where a woman was terrorized by her husband who tortured and murdered her daughter from a previous relationship and threatened to kill her as well, to which she replied that he could kill her after he assisted her in calling help for the girl, a prosecutor claimed that the mother should have slit her husband's throat while

he slept (Mahoney 2019). Obviously, this "solution" could easily have led her to face murder charges.

Aleen Estes Waldon's one-year-old son was seriously injured and required a blood transfusion for internal bleeding after his stepfather hit him repeatedly with a belt. Although he hit her in the face with the belt when she tried to stop him, she was convicted of assault with a deadly weapon, even though she never touched the belt herself (other than when the perpetrator smacked her face with it). Mahoney argues that:

> [w]hen a mother has learned that she is unable to stop the abuse, it is unreasonable to insert a 'resistance requirement' compelling her to carry out a narrow set of actions (stopping the violence, removing the child, and calling the police) that she knows will almost always make the situation worse by further angering the abuser, increasing the level of violence, and lengthening the attack. (Mahoney 2019: 454)

In Ms. Campbell's case, where she discovered her daughter burned by her boyfriend after she returned home from work, she went out with him to play darts that evening and did not take her child to the ER until 2:00 am. While from the outside this may appear incredibly negligent and uncaring, Ms. Campbell claims she was afraid of further upsetting the abuser and that she took her daughter for help when she felt it was safer to do so after her boyfriend was asleep. The jurors were unmoved as she received a heavier sentence than her boyfriend who injured the child and failed to take her to the ER immediately after burning her.

As Ms. Lambert of the ACLU of Oklahoma argues, these statutes are supposed to be reserved for caregivers who "willfully or maliciously" allow children to be hurt. Yet this is not how they are used in practice. "Courts seldom bother to separate four types of 'doing nothing': (1) being absent and not knowing about the abuse; (2) knowing about the abuse but being unable to do anything about it; (3) attempting to do something unsuccessfully; and (4) knowing about the abuse and not caring" (Fugate 2001: 292). Fugate, like Jacobs (1998), maintains that only the latter should be punished. As we have seen, women have been tried for all four types. Being at work seems to already prejudice judges and jurors against women: "expectations of maternal selflessness mean that engagements in paid work outside of the home are employed effectively by prosecutors to

convince juries that women are both morally and legally culpable" (Singh 2021: 184).

Nancy Barrientos Perez had only lived with her boyfriend, Juan Carlos "Rudy" Marquez, for six weeks when he killed her three-year-old son while she was at her job at a hot-dog stand. Knowing that he had been violent and previously injured her child, leaving bruises and bite marks, Ms. Barrientos Perez, who said she feared that Mr. Marquez would retaliate if she tried to get help, asked his mother to watch her son for four days until her boyfriend left on a pre-scheduled trip to Mexico. Mr. Marquez went to his mother's home, removed the boy, and beat him to death in the home he had recently begun sharing with Ms. Barrientos Perez. Finding that leaving the child under the care of a third party was not sufficient, the judge sentenced Ms. Barrientos Perez to 25 years to life in prison. The court determined that she did not take protective action for her child, and consequently, decided that she aided and abetted Mr. Marquez's abuse of the three-year-old. After fleeing to Mexico, Mr. Marquez was extradited to the United States and sentenced to 64 years to life. At his trial, the prosecutor said of Ms. Barrientos Perez, "[s]he is a horrible woman. She is the scum of the earth. She is filth. . . . But on this date, Feb. 16, she wasn't there when her boy was killed. The man at the end of the [defense] table is to blame for the fatal blow" (Orange County Register 2015).

Fugate identifies three common stereotypes in "failure to protect" cases:

> the All-Sacrificing Mother, the All-Knowing (and thus All-Blamed) Mother, and the Nurturing Mother/Breadwinning Father. As demonstrated through judicial rhetoric, these stereotypes require much of women, while often relegating men to a supporting role. Moreover, like other invidious dichotomies, they allow judges – and society – to place women into neat categories of "good" and "bad" mothers without regard for the messiness of moral ambiguities. And bad mothers – as western culture teaches – deserve to be punished. (Fugate 2001: 289–90)

These mothers are transgressive both for working and for not adequately protecting their children. "The expectation of maternal omnipresence plays a key role in prosecution contentions that the mother ought to have foreseen a risk of harm (and been there to prevent it)" (Singh 2021: 184). Singh (2021) argues that today, well

into the twenty-first century, women are tasked not only with being the primary caretakers of children but also with managing men's violence. Risk is viewed as masculine, and, in performing femininity, good mothers are not supposed to take risks. Therefore, if she left her toddler home with her boyfriend or spouse so she could work and earn money, even if this money is needed to pay the electric bill to keep the child warm or is set aside to help both mother and child move out, if the caretaker abuses or kills the child, she is at fault. "If anything undesirable happens to a child, her mother is culpable. This culture is so pervasive that . . . women are blamed for the actions of men; the cultural and legal focus is on their failure to stop the violence, rather than on the infliction of harm" (Singh 2021: 185).

Singh also points out that the way risk is assessed is based on white, middle-class mothers whom we designate as the norm, and therefore does not account for women making difficult decisions between two bad options in dire economic and social circumstances. Women who "get it wrong" by leaving the child home with a dangerous man, for not being economically privileged enough to have better options, get punished. "Mothers who are charged . . . have simultaneously failed as women, in that they have failed to avoid or manage the risk of male violence, and failed as mothers, as they have not been omnipresent thereby ensuring their child's welfare at all times" (Singh 2021: 190).

Ethnic, cultural, and racial differences also affect women's willingness or ability to come forward. Women from minority groups face heightened pressure from family members not to turn in abusive men, given the treatment of men of color by the police and the risks of deportation for immigrant men. As noted in the previous chapter, black families undergo a disproportionate number of Child Protective Services investigations, as do Asian and Native American families in the United States and Canada, and Aboriginal families in Australia (Kim et al. 2017; Maiter, Alaggia, and Mutta 2013; Nixon and Cripps 2013). The history of discrimination for all ethnic minorities and the legacy of massive child removal of indigenous peoples for colonial/white savior motives weigh heavily on these groups. When mothers already feel like criticized outsiders, they may be fearful of confirming pathologizing stereotypes about their racial, ethnic, or religious groups, as well as of experiencing the conse-quences of biases in the child welfare system (Bernard 2013; Maiter, Alaggia, and Mutta 2013).

Fathers off the hook

Given their gendered roles, breadwinners and risk-takers, men, as mentioned above, are rarely prosecuted for failure to protect when their wives or girlfriends injure or kill their child. Mahoney (2019) details two cases, both from 1993, to underscore the different gendered standards to which mothers and fathers are held. Walter Zile beat and killed his stepdaughter, stored her in a closet, and then buried her in an unmarked grave. The mother, Pauline Zile, was home, but in another room, when the murder happened. She too had been a frequent victim of Mr. Zile's abuse, but this was not presented at her trial. Like her husband, she was convicted of first-degree murder, even though she did not participate in the assault. Prosecutors sought the death penalty for her, but she received life in prison. On the other hand, Jessica Schwarz murdered her stepson. He was found nude and bruised in the family's pool at 6:00 am. His injuries were not all fresh, and 17 witnesses recounted how she had emotionally and physically abused the boy and told people how much she did not like him. Child Protective Services (CPS) had been called to investigate previously. Despite this, the father, David Schwarz, testified that he had never seen any bruises or other signs of abuse. In this case, the murderer got life in prison, but, unlike in the Zile case, Mr. Schwarz got no time at all.

> Although there are some differences between these two cases, there is no legal explanation as to why one parent was found culpable and the other was not charged with any crime. Pauline Zile saw her child being abused. David Schwarz claimed to have no knowledge of his son's abuse, in spite of his son's behavioral problems, hospitalizations, and CPS investigations. Given how FTP laws have been applied to mothers, this claim of ignorance should not have released David Schwarz from all responsibility. Mothers have been prosecuted under FTP laws without having seen the abuse. Judges have told the mothers that they should have realized that the abuse was happening; the bruises were visible and the warning signs were present. Here, the court system viewed the woman as responsible for the child, but the father as blameless and a second victim. (Mahoney 2019: 443–4)

Men are much more likely to get off by claiming they did not know about the abuse, a tactic that rarely works for women, even if they

were at work or in another room when the abuse occurred, and even if the abuse may have been a first-time occurrence, as with Tandalao Hall's daughter.

Fugate (2001) compares two cases from the mid-1990s, one in which a live-in girlfriend was convicted under "failure to protect" as a culpable "custodian" of the child when her boyfriend beat one of his sons to death and had her conviction upheld, but in the other, a live-in boyfriend, who regularly babysat the children and did household tasks for the family, had his conviction reversed because he was deemed to not have a familial relationship with the children, including the baby his girlfriend murdered. In another case, a live-in boyfriend whose girlfriend murdered her daughter admitted he had hoped to adopt the child someday, yet a judge did not see him as responsible for the child's welfare. It does not always go this way; sometimes men are held accountable as caregivers and not just paychecks, as in a case where a boyfriend referred to himself as the child's "stepfather." But the disparities continue. In 2009, when "the husband . . . admitted that he had witnessed his wife use physical violence against their children and that he had felt powerless to intervene, he does not appear to have been indicted for neglect," despite two children being abused and a protective order filed by Child Protective Services on behalf of the children against their mother (Perrone 2012: 658). On the other hand, in 2010, a mother had her infant taken away for four days and a case of neglect filed against her because the father slapped the baby in the face and she lived with him, despite the fact that she had notified authorities immediately, unlike the father in the previous case who did not mention abuse until after the fact when he filed for divorce (Perrone 2012).

If these prosecutions served to keep children safer, and if children's well-being rather than punishment was the goal, fathers would experience the same rate of FTP prosecutions and the same penalties as mothers. Clearly, something beyond children's welfare is at play in these cases, something about the role, and the control, of women. As Villalobos argues (2014: 230), mothers are not simply supposed to have their children's backs, they are supposed to be "watching our backs." When they don't, they harm not only their kids but society as a whole, thus being doubly deviant. The mother, not the father, has let us all down, and for that she must pay extra. "Under an expanded duty scheme, the assumptions and stereotypes underlying the prosecution of failure-to-protect cases – that women have a greater

capacity for nurturing and therefore a heightened duty to protect – will continue to produce a gender disparity between those convicted (women) and those acquitted (men)" (Fugate 2001: 275). In addition to gender bias affecting the outcome of trials, Fugate (2001: 288) also warns that "[t]he fact that the judiciary is overwhelmingly white, male, and privileged may lead courts to empathize more readily with male defendants (or have difficulty sympathizing with female defendants)" (Fugate 2001: 287–8). The preconceived notions that judges have about defendants may not be visible in trial records and therefore will not be likely to give her grounds for appeal (Fugate 2001).

Singh (2021: 188) also makes the case that subjecting mothers to FTP laws when they are victims of a new partner is noticeably unfair because of the legal system's "decision to exonerate disengaged or absent fathers. These fathers appear to evade culpability merely on the grounds that they may have a difficult relationship with the mother" (Singh 2021: 188). Titches Lindley's father, William Wade, for example, had concerns that his son was being abused. He tried reaching out to Child Protective Services and the police. At one point, he called Ms. Lindley directly and asked to check up on his son and if his son was being hurt, but despite not getting an answer and hearing commotion that sounded like a fight in the background, he did not insist on seeing the boy (Campbell 2014a). He was never indicted under a "failure to protect" law.

Costs beyond those convicted

Mr. Wade did ask the judge to go easy on Ms. Lindley, asserting that she was a "perfect mother" (Campbell 2014a), but to no avail as she received 45 years instead of the ten that the prosecutor had requested. Ms. White, who prosecuted Ms. Lindley, says that, despite not asking for that much, 45 years is a fair sentence. She claims that FTP laws provide justice for the children who are the victims (Campbell 2014a). However, the feelings of at least some child victims do not seem to support this. Ms. Hall's son wrote to the parole board: "[T]he lonely directionlessness of growing up without my mom made me angry for a long time. I was angry that my mom was taken away from me for no reason. I still am." The victim of repeated rapes, Colin Grant, also feels his mom should not

be in prison for not stopping his abuse. His stepfather received 15 years in prison for repeated forced sodomy, while his mother got 20 years for not reporting it, even though she walked in on one of the rapes. She is still incarcerated. This caused him to spend the rest of his childhood, from age thirteen to eighteen, in group homes and shelters. Mr. Grant claims retrospectively that he would have rather continued to endure the abuse than have his mother go to prison, and he is asking for her sentence to be commuted (Campbell 2014b). When Ms. Hall was interviewed after her release from prison, she said of her incarceration, "You're not only breaking that person but you're breaking the kids, you're breaking the family" (Slipke 2020).

Failure to prevent child abuse becomes enabling child abuse becomes the same as actually doing the abusing, thus leading to the same penalties. If it is not fair, and if it hurts the surviving children, why are we still meting out these harsh punishments?

> Criminalising abused women for failing to protect their children is one of the more blatant examples of what Stanko terms the "explicit message of the 'criminology of the self' warning us [women] to be good citizens by avoiding men's violence" (Stanko 1997: 490). The responsible mother is diametrically oppositional to constructs of the vulnerable victim, allowing legislators to presume (and later prosecutors to allege) that women stay in abusive relationships out of fecklessness, betraying dangerous ignorance around the dynamics of abusive relationships. (Singh 2021: 182)

It does not help that women often do not do a good job defending themselves in these cases (Campbell 2014b). Not only are there questions of legal representation when poor women must resort to public defenders rather than private lawyers, but they may be wracked with guilt, suffering from mental health disturbances that impair their memory or affect their self-presentation, still deathly afraid that their abusers will come after them if they testify truthfully, or simply not understand that a judge or their peers could opt to punish them so harshly. Sometimes the guilty men opt to plead down while the mothers go to trial, assuming their difficult circumstances and attempts to leave or get help will free them, only to find that they incur the wrath of judges and juries (Campbell 2014b). Initiatives to get help can be read incorrectly by social workers as well. For instance, if a mother moves with her children frequently, Child Protective Services may view this as creating instability in their

lives rather than as trying to protect them from a violent person (Strega, Krane, and Carlton 2013). "When women in these abusive situations are prosecuted for another person's actions (that they may not even know about), their prosecution is furthering the cycle of distrust of 'the system' and alienating the people who need the most help" (Mahoney 2019: 438).

Women in general have trouble making their voices heard and being taken seriously. This is all the more true of women who carry the stigma of victims of domestic violence. Yet the legal system itself further silences them. Because women are more likely to have been judged harshly when they were victims of abuse, some lawyers decide not to present evidence of it in court. This is a double-edged sword, as Singh (2021: 192–3) explains in a case in England in which attorneys for the perpetrator and for the mom both wanted the judge to exclude evidence of domestic violence from the open court proceedings for fear of detrimentally influencing the jury. "While this was to [the mother's] advantage, as she could not be condemned on account of the abuse she herself had suffered at the hands of [her husband], effectively this served to silence her. During the remainder of the trial she could not put her actions or omissions in context" (Singh 2021: 192–3). When grieving mothers have unexplained gaps in their testimony, it seems highly suspect to the members of the jury who may then deem her a liar, resulting in them not being convinced that the perpetrator is predominately culpable and treating the mom more severely (Singh 2021). Of course, women also silence themselves when they fear retribution from an abuser who may sooner or later get out of prison. "Allowing juries to presume guilt from a failure to incriminate one's partner permits mother blaming to flourish" (Singh 2021: 190).

As we near the conclusion of this chapter, we return to the beginning of the book and the power and perniciousness of intensive mothering. "Failure to protect" prosecutions are a consequence of

> patriarchal constructs of the ideal mother . . . [T]he impact of neoliberal privatization of care has led to expectations of intensive mothering, which re-emphasizes the demand for maternal omnipresence and selflessness (Hayes 2005). The naturalization, then later normalization, of these conventional constructs of mothers have ultimately led to a contemporary culture of mother blaming which means that when tragedy befalls children, mothers are presumed blameworthy. (Singh 2021: 184)

Singh points out that at the same time FTP penalties were being enacted against mothers in England, the government was slashing social spending, including for domestic violence shelters. All too often, states are ready to sacrifice mothers for symbolic gains (e.g., tough-on-crime campaigns) rather than spend money to actually support families by preventing and solving problems.

Even in a "society of saints" there will be deviants

As highlighted in earlier chapters, in the United States the culture is oriented toward punishment more so than rehabilitation. Two neonaticide cases in different countries underscore the differences for women and families when the criminal justice system is seeking outcomes in which offenders make progress rather than just penance. A French woman, Veronique Courjault, who experienced pregnancy denial/dissociation, gave birth and smothered three of her five children, one in France and two in South Korea where her husband was working. She burned the first baby's body in the fireplace, and the second two infants were placed in the family's freezer where the husband eventually found them. Convicted in France, she spent four years in prison of an eight-year sentence for murder of three minors and was then released to her family still under psychiatric care. On the other hand, there is the example of American Lindsey Lowe who, after undergoing pregnancy denial/dissociation, smothered the newborn twins she gave birth to in the bathroom at her parents' home and placed them in a laundry basket, which her father later discovered. Her sentence for two charges of first-degree murder, first-degree pre-meditated murder, and aggravated child abuse was a minimum of 51 years in prison. She will not be eligible for parole until she is 77 years old (Jaffer 2017 [2014]). While Ms. Lowe's situation was more fraught – she was engaged to one man but pregnant by another, and Tennessee, the state in which she resided, had safe-haven laws for the abandonment of newborns – compared to Ms. Courjault's – who seemed to have no reason to kill her babies other than fear of not being able to parent more than two children – the disparities in sentencing are still worlds apart. After all, Ms. Courjault murdered infants on three separate occasions, and while Ms. Lowe killed two babies, they were born at the same time, making it all part of the same act. In both cases, the women behaved

bizarrely. Neither thought to dispose of the bodies in a place that others would not find them, as one would normally do when trying to conceal a crime (Jaffer 2017 [2014]). This may indicate that they were not in a normal state of mind at the time, although how altered is hard to prove. No one around them, friends, parents, or sexual partners, noticed that they were pregnant, lending some credence to their claims of pregnancy denial/dissociative disorder.

In these types of cases, the woman is only a danger to her own babies and to herself, given lack of medical care. Not all psychiatrists agree on how neonaticide offenders with a dissociative disorder should be treated; some argue it varies on how extreme the pregnancy denial versus awareness actually was. Finnish neonaticide researchers Dr. Hanna Putkonen and Dr. Ghitta Weizmann-Henelius believe that long prison sentences are "useless," and other mental health professionals concur and recommend probation for women who did not know they were pregnant and panicked (Jaffer 2017 [2014]). France is not the only country to go light on these women in the criminal justice system. "Recognizing that childbirth is a time of unique biological change and peak prevalence for mental illness, most Western countries have developed infanticide legislation that provides probation and mandated psychiatric treatment" (Spinelli 2001: 811). Colombia, England, Finland, and Turkey differentiate maternal infanticide and murder. In Canada, convicted women face a maximum sentence of five years. A panel of physicians judges all infanticide cases in Sweden (Jaffer 2017 [2014]). "In contrast, the United States considers infanticide under general homicide laws. Sentencing is arbitrary, and penalties range from probation to life in prison. And yet the United States has the fourth-highest rate of infanticide of 21 developed countries" (Spinelli 2001: 811). Jaffer (2017 [2014]) points out that Kansas has chosen to eliminate the insanity defense entirely in these cases. Whether or not we accept the insanity defense in Ms. Lowe's case, given that she experienced dissociation and amnesia but not psychosis, we should think seriously about what is to be gained by having her spend most, if not the rest, of her life in prison. Her punishment is unlikely to prevent future newborn murders by other post-parturient women.

Equally troubling are the cases where victims of domestic violence lost their child at the hands of a child abuser and then went to prison for as long as the murderer. "Criminalising abused women for 'allowing' their children to come to harm obscures the reality that

intimate partner violence remains endemic, not a rare social problem experienced by a small minority of women" (Singh 2021: 199). The women in many of the cases above are by no means model mothers. They did sometimes turn a blind eye to abuse; they did often try to help the abuser cover up his actions; they did usually wait too long to call 911. In certain cases, some type of penalty may be appropriate, but if the mom did not actively participate in the abuse, she should not receive the same conviction as the actual perpetrator, and it is usually best if she can continue raising her children. If she tried to get help, whether successfully or unsuccessfully, that should be a mitigating factor at sentencing. Balancing "a duty to protect" with an understanding of the psychology of domestic violence, including women's genuine fear for themselves and their children and their concern that reporting significant others will bring social workers to remove their children from their care, is a difficult task. Victims need to see that law enforcement effectively deals with their abusers. When perpetrators are not charged or not convicted, or when restraining orders are not granted (as happens sometimes when an abuser has been exceedingly controlling but has not yet been physically violent), why would a victim of abuse seek help? Men are often granted partial custody or visitation rights to children if they have only directed violence at the mother but not the children. This can place her in an unsafe situation, and the children could also become victims of kidnapping, abuse, or murder. Consequently, judges need to be very careful about under what conditions they grant violent partners access to children. In nineteen cases of child murder over the course of a decade in the United Kingdom, all the mothers had said the fathers were dangerous, and yet all the filicidal dads had unsupervised access granted by the courts (Singh 2021).

Adequate spending for education and support of victims is crucial. Domestic violence survivors need shelters that take them, their children, and also their pets, as abusers routinely threaten animals to keep victims quiet. They may also require job training and daycare for their kids. Economic support is at least as, if not more, important than the typically mandated parenting classes or therapy sessions. Overall, we need a culture that not only teaches young people about healthy relationships and proper boundaries but that also castigates people who do not treat their partners well. While some abusers hide their violence, others do it out in the open, confident that neighbors and friend will not interfere.

By problematizing the behaviour of mothers rather than the behaviours of perpetrators, policy makers divert attention away from the political, social, and economic forces that contribute to male violence, including patriarchy, misogyny, and women's social and economic inequity. Consequently, policy preferences focus on making abused women "better" mothers and not on significant contributing factors, such as the lack of safe and affordable housing. (Nixon and Cripps 2013: 180)

Northern European countries do a better job with supportive interventions for families in trouble and can provide an alternative model (Strega, Krane, and Carlton 2013). Another step would be concentrating social workers' limited resources on cases where there is violence in the home and not wasting resources on children playing alone in their backyards.

While this chapter deals with terrifying and tragic circumstances of grievously injured and murdered children who needed intervention by other family members, doctors, counselors, and social workers to protect them, the point is not the *faits divers* aspect of these cases. Some people need genuine help. They may be abused, suffering from severe mental illness, or simply out of resources, material and/or emotional, and at their wits' end. Those around them, rather than pointing the finger, must support them in getting help. It is vital to recognize how the higher standards to which we hold mothers affect behavior. The particular manifestations of cultural ideas about motherhood play a role in why some women commit filicide (e.g., killing their children because they think they are not good enough mothers to raise them correctly or because they are convinced that children could not possibly have a worthwhile life after the suicide of their mother). How we set up motherhood, and how society and the criminal justice system handle those who "fail" at it ultimately affects not just "those" women (who can all too easily become us) but how we look at and treat *all* mothers.

[C]onventional expectations of mothers as enshrined in "failure to protect" provisions allow both moral and legal focus to be shifted on to the woman who failed to prevent the harm rather than the man who caused it. In scrutinizing mothers who fail to prevent harm, rather than the abuser who inflicted it, this ideology has a disciplinary effect on women which, due to media reporting of crime, reaches far beyond the confines of the courtroom. (Singh 2021: 184)

Yet, rather than recognizing the dangers, all too often the media consumer finds these terrible stories strangely comforting. The subtle *Schadenfreude* involved has a dark side.

> The spectacle of the deadly mother may have reassured "us" that, whatever our failings, at least we were nothing like "them." For a few moments we could believe that, despite the increasingly high standards of perfection emanating from the new momism, we were, indeed, good mothers . . . But in reality, these stories justified putting all mothers under increased surveillance. Though we may have thought that these stories were about "other mothers," they contributed significantly to the vigilante culture in which mothers had to be carefully policed because they are, potentially, their own children's worst enemy. (Douglas and Michaels 2004: 170)

It is this attitude toward mothers that allows a woman to be arrested for taking half a valium twice near the end of her pregnancy, permanently losing custody of her older child to her ex-husband, despite small doses of valium being safe during pregnancy (Martin 2015). Casey Shehi, the mother at the center of that case, believed the Alabama law under which she was arrested was for "other mothers" because she was not a drug user. It is this attitude toward mothers that allows a woman who left her child alone in the car for five minutes on a comfortable day to be arrested and publicly shamed. It is this attitude toward mothers that allows an impoverished mom who had been breastfeeding and supplementing with cow's milk to be arrested and sentenced to life in prison after her baby starved. It is this attitude toward mothers that allows a severely abused woman to go to jail longer than the man who injured her child. It is this attitude toward mothers that allows gross miscarriages of justice. It is this attitude toward mothers that separates children from moms who are generally capable of taking good care of them. It is this attitude toward mothers that makes us feel as if we are constantly being watched – because we are.

Kim Brooks, the mom who wrote a book after leaving her son in the car for a few minutes, warns of the

> long-established tradition of mother-shaming, the communal ritual of holding up a woman as a "bad mother," a symbol on which we can unleash our collective, mother-related anxieties, insecurities, and rage. . . . Sanctification and public shaming are two sides of the same

coin. A culture can't venerate and idealize the selfless, martyred mother as much as we do without occasionally throwing an agreed-upon bad mommy onto the pyre. (Brooks 2018: 146)

This is the same point that Anne Taylor Fleming (2002) made about Andrea Yates. There are two extremes, the "selfless, martyred mother" and the "demon mother." Religious imagery here is telling. Most moms are not saints or sinners. Most moms are regular people, and that is good enough for most kids. We need to see the humanity even in those parents who do the unthinkable, and we need to stop making good mothers think they have to be perfect. There is a middle ground, and it's a healthier place to be for all involved.

6

Fighting Back, Fighting for the Future

If we don't value women, we don't value mothers, and if we don't value mothers, we don't value children. Honoring and supporting mothers is one of the best things we can do for children. After all, as Thurer (1994: 157) points out, throughout history, "respect for women directly correlates with mothers' respect for their children." Yet recent steps to criminalize women who want to avoid or delay motherhood or the birth of another child demonstrate beyond a shadow of a doubt that the United States today does not value women. From dwindling abortion rights to threats to reduce access to contraceptives (by not making insurance cover the cost, or by allowing pharmacists not to dispense it, or by restricting it to married couples), women in the United States are losing vital tools that allow them to be free and to be good mothers if and when they choose. Forcing women to bear children against their will is a human rights violation. A woman gives deeply of her body (and her psyche) during pregnancy; she may have ongoing health problems, such as incontinence or a prolapsed uterus, for months or even forever afterwards, and far too many women in the United States die while pregnant, giving birth, or during the first year postpartum. A fetus does not develop into a baby without sacrifice, labor, and risk. A baby needs lots of attention as well as adequate financial support to thrive. Parenting is hard enough when willingly chosen and with sufficient resources. Without those, it can all too often veer toward hardship and even tragedy. It is impossible to value a new human being without first genuinely valuing and supporting her or his mother. As a doctor on Twitter explained after a worried exchange about how

an X-ray could be done on a pregnant woman who had been injured, "a dead mother does a fetus no good."

When we hurt mothers, we hurt children. Most women who have abortions are already mothers. Sending them to jail deprives their children of a mom making the burden of incarceration inter-generational. Criminalizing people should always be a last resort, yet in a nation hell-bent on punishment rather than restorative justice or rehabilitation, we jail an unconscionable percentage of our population. Over ten million children in the United States have seen at least one parent go to jail, with a rate of one in nine for black children (Briggs 2017). Changing gender norms and the growth of the carceral state have meant that an increasing number of these incarcerated parents are mothers. The laws that de-link women from the fetuses they bear and criminalize abortion will only further contribute to this social ill. Over a fourth of US women have abortions between menarche and menopause, and yet more and more states are reclassifying these women as criminals. Twenty-five percent of women, those who have had an abortion and those who will need one, are now "bad mothers" in multiple US states.

This fact reminds us of the central premise of this book: "[i]n many ways, 'bad' moms are not so different from 'good' ones" (Ladd-Taylor and Umansky 1998: 22). Historians Molly Ladd-Taylor and Lauri Umansky continue: "We all struggle under mountains of conflicting advice that cannot possibly be followed in real life. We must all find our way in a society that devalues mothering, sees childrearing as a private family responsibility, and pays little heed to what actually happens to kids" (Ladd-Taylor and Umansky 1998: 22). Despite all the talk about the importance of moms, rather than collectively supporting them, we make their lives harder, to the detriment of them and their children. As this book makes clear, we castigate and criminalize those who will not or cannot meet society's overblown expectations of mothering. It's time to overcome our "fear and scorn [of women's] refusal to stay put inside our notions of what a mother should be" (Brooks 2018: 160). We need an overhaul of motherhood, and that overhaul must take place on several fronts simultaneously: personal, societal, and political.

To improve the conditions under which mothers parent, I suggest a multipronged approach. First, it is high time to lower unnecessary and pernicious expectations of mothers; this means engaging in less criticism of other people's parenting, as well as pulling back

from one's own participation in intensive mothering. Second, a reorientation that involves less focus on individual responsibility and more emphasis on the collective good is imperative. Third, we need to put more attention and resources toward real dangers to children and mothers, such as the crisis of black maternal mortality, rather than obsessing about pseudo-fears that are more about social control than about children's actual needs. Fourth, we need to offer actual help to mothers who are struggling with poverty or substance problems. Fifth, we need to develop a culture that expects fathers and other caregivers besides mothers to play a large role in children's upbringing. And finally, but far from least importantly, we need a plethora of legislation and social programs that do a better job of supporting all kinds of families.

Accepting "good enough" parenting

One place to start assisting mothers is by helping them to crawl out of the shadow of intensive mothering. It is not necessary for children's well-being; in fact, in some ways, it is detrimental. It overwhelms mothers who are trying to do too much. This is true of most mothers but especially those who have too few resources at their disposal. If they are not doing enough to approach this standard, they face judgment, including the dreaded label of "bad mom." It also reinforces differences in expectations for moms and dads. Finally, it leads to competition as parents try to give their own offspring a leg up instead of working to create a system where the vast majority of children thrive and have a good future to look forward to. As Zaske points out, "My experiences in Germany made me question whether the many things that pass today in America as parenting 'truths' are actually cultural, not universal. If they are cultural, we have the power to change them" (Zaske 2017: 12–13).

One of these "truths" is that babies and young children need their mothers to spend a lot of time with them. Yet Huston and Aronson (2005) found that maternal time spent with babies and toddlers does not impact their social or cognitive development; rather, it is the families' and mothers' characteristics which influence their parenting, such as education level, that determine very young children's outcomes. This remains true as children move into and through elementary school. Milkie, Nomaguchi, and Denny (2015)

found that the amount of time that mothers spend with children between the ages of three and eleven had no effect, and this was true whether the mothers were directly engaging with their children or simply present around them. And Schiffrin and colleagues (2015) found no skills benefit to enrolling middle-class preschool-aged children into activities and lessons, although parental time and attention and scheduled activities may be more important for young children in low SES families, particularly if other childcare arrangements are not high quality. Mothers' time with teens did not affect emotional well-being, academic outcome, or substance abuse, and only had a slight effect on lowering the incidence of delinquent behaviors (Milkie, Nomaguchi, and Denny 2015). Fomby and Musick (2018) found only modest effects of mothers' total time with children on children's reading scores and a small decrease in externalizing behaviors among adolescents.

Although not the focus of their study, Milkie, Nomaguchi, and Denny are careful to mention that parents being overly involved with their college students is detrimental. Helicopter parenting of young people this age impedes coping and becoming autonomous and leads to poorer psychological outcomes (Schiffrin et al. 2014; Segrin et al. 2013). In other words, when moms do everything for kids, they are more likely to be harming them than helping them, and there is no reason for moms to spend excessive amounts of time with young children other than the mom wanting to. Her education level and family income have more impact than how much time she spends with the kids. This does not mean that moms don't count, but parenting is more complex than simply being around in the home.

> In sum, this study upends the ideology of intensive mothering and points to three key areas of concern for the development of the next generation. First, it suggests that mothers ease up on practicing more intensive mothering during childhood, especially given that it may end up exhausting them (Fox 2009; Rizzo, Schiffrin, and Liss 2013; Wall 2010). Second, this study suggests that the focus on time spent with children may be somewhat misplaced; adolescents, in fact, may need interactions with mothers and with both parents together to protect them and optimize their future. Finally, this study questions conventional wisdom about what is important for children's well-being, with our findings underscoring the critical importance of economic and social resources and thus the urgency in supporting mothers and families in these ways. (Milkie, Nomaguchi, and Denny 2015: 369)

There is no reason for people (including other moms) to judge mothers for working. To grow up feeling secure, kids require financial and emotional support, and when these two needs are met during their childhoods, adult children report not caring very much about the structure of their family or whether their mom worked or not when they were growing up (Gerson 2015). Helping mothers support their families, especially single moms and low-income moms, by paying them a living wage with benefits, giving them job security, and letting them work stable, predictable shifts, as well as subsidizing daycare, contributes to the first of these requirements. Ideally, we should encourage children to build relationships with multiple adults they are close to and trust, be they dads, other moms, extended family members and fictive kin, community members, teachers, or other authority figures. This gives kids varied sources of social support and more opportunities by broadening their social networks, and helps protect them if the mom leaves, is incarcerated, or dies, furthering the second requirement.

Furedi, Zaske, and others argue that we've attributed too much importance to parents. As long as parents provide "love, food, shelter, and some general guidance," the kids will be alright (Zaske 2017: 202). And while most moms feel judged, and often fear that they are failing at mothering, some women are at more risk of consequences that go beyond feelings of guilt or even being ostracized by other mothers who raise their children differently. Watson describes mothers "coming undone," losing it a little, publicly revealing that they are overwhelmed, admitting to wanting a drink to help cope, and explains that "[c]oming undone is an elite problem, reserved for people whose survival needs are taken for granted," even though "it is also an indication of pain and sadness" (Watson 2020: 17). Only white, married, heterosexual, cisgender moms can safely complain about coming undone without a nagging worry that doing so could cost them. A white, middle-class, married mom can whine in an online post about needing her glass of wine. A mom of color might think twice about publicly stating she needs a substance to get through the day, even if it's just a joke, as families of color are more likely to be reported to social services (Harvey, Gupta-Kagan, and Church 2021; Kim et al. 2017). Instead of relating, others who are not her race may judge, and that judgment could carry more weight for her, as it could for a divorced mom of any race who could see her custody of her kids challenged for mentioning drinking. The witticisms about

whine/wine moms, often on tee-shirts and kitchen towels, and other evidence of moms "coming undone," do not fix anything; rather, they uphold the system as is, who can complain, and why the complaining rarely goes further. Commiserating, for those who can, relieves some tension, but does not "necessarily inspire collective resistance in the form of direct action" (Watson 2020: 16). These "moms undone" pull it back together through individual strategies, such as relying on paid caregivers, usually other women who have fewer resources for coping with the same mothering problems their employers complain about.

Some American moms do parent outside the box of social norms, even doing things the way they do in Europe, despite facing criticism and even criminal sanctions. Lenore Skenazy started Free Range Kids and a blog that turned into an advocacy group, Let Grow, after being publicly castigated for allowing her nine-year-old son to ride the subway in New York City alone. She has a following, posts articles about children and independence, provides support to parents charged for letting their children do things alone, and has developed a curriculum for schools. Her movement has also gotten laws passed. In 2018, Utah passed the Free Range Parenting Law, and Texas and Oklahoma passed Childhood with Reasonable Independence laws in 2021. This bipartisan legislation confines the reasons that Child Protective Services and police can investigate parents to situations in which the child was actually facing real danger. Importantly, Skenazy notes that these laws protect both people who allow their children some unsupervised time by choice and those parents who have to sometimes give their children independence due to necessity.

While it's easy to suggest we leave intensive mothering behind, doing so in practice is hard. Given the dominant ideology, there will be a lot of resistance to suggesting that it's better for some mothers to put less rather than more time into mothering. Fixmer-Oraiz (2019: 159) asks: "[H]ow might we undo the cultural lauding of some mothers at the expense of others, the powerful discourses of risk or crisis that differentially discipline and constrain reproductive decision making, the demands of intensive mothering, pronatalist culture, and compulsory motherhood?" Trans and gender-non-binary people, women who live with disabilities, immigrant women, very young women, poor women, and women of color face this additional layer of scrutiny and control. Inherently, they are not the "right" mother (O'Reilly 2021b). "The exaltation of the caring, juggling mother

[is] inherently ableist and racist. She is a worker who is admired for her agility, flexibility, resilience, emotional stability, and, ultimately, productivity" (Watson 2020: 8). Instead of striving to juggle better, we need to take some of the balls away.

> When mothers are able to see through the mythology, they may see that their "failures" stem not necessarily from personal defects, but from the way society is structured. They may stop blaming themselves. When mothers understand the biases inherent in our cultural conception of good mothering, they may learn to select among the rules and begin to create their own philosophy of child rearing, one that works for them and their children. (Thurer 1994: 300)

Moms need to stop subscribing to a mothering identity that is all-consuming and turning themselves into martyrs. Lythcott-Haims (2015) describes a mother who called her own mom to complain about being wet and cold watching her child play a soccer game. Her mother (with whom she clearly had a good enough relationship to call to vent) told her that if she wanted to teach her child to value sports, she should use the time to work out herself rather than standing around observing her child doing something normal that kids can do on their own with their teammates and coaches. Just as kids do not need a parent to follow them around during the day inside the school building, children do not need Mommy to be constantly hovering on the sidelines after school. Lythcott-Haims empathizes. Like many other mothers who feel as though they need to attend not just every game or recital but also every practice, she had trouble backing off. Ultimately, though, she reminds mothers that "*your kid is not your passion*. If you treat them as if they are, you're placing them in the very untenable and unhealthy role of trying to bring fulfillment to *your* life. Support your kids' interests, yes. Be proud – very proud – of them. But find your own passion and purpose. For your kid's sake and your own, you must" (Lythcott-Haims 2015: 278).

Moving from individual to collective responsibility

Self-righteous mothers who congratulate themselves for their martyrdom have to look down on other mothers who aren't entirely wrapped up in "momming," otherwise they would have to admit

that what they are doing is wasting their own time because it is over the top and not necessary or beneficial for their kids. These overly preoccupied mothers sometimes also claim that their children are their contribution to society. One of the mothers that journalist Jennifer Senior interviewed explained that:

> [T]he evening ritual of guiding her sons through their assignments was her "gift of service." No doubt it is. But this particular form of service is directed inside the home, rather than toward the community and for the commonweal, and those kinds of volunteer efforts and public involvements have also steadily declined over the last few decades, at least in terms of the number of hours of sweat equity we put into them. Our gifts of service are now more likely to be for the sake of our kids. And so our world becomes smaller, and the internal pressure we feel to parent well, whatever that may mean, only increases: how one raises a child, as Jerome Kagan notes, is now one of the few remaining ways in public life that we can prove our moral worth. In other cultures and in other eras, this could be done by caring for one's elders, participating in social movements, providing civic leadership, and volunteering. Now, in the United States, child-rearing has largely taken their place. (Senior 2014: 180)

Philosopher Linda Hirshman (2006) originally titled her book *Get to Work: A Manifesto for Women of the World* and in subsequent editions retitled it *Get to Work and Get a Life Before It's Too Late: A Call to Arms for Women of the World*. She highlights the example of a woman who wrote on BloggingBaby.com that her choice to homeschool was her "'giving back to society,' my 'mark on the world'" (Hirshman 2006: 15). Clearly, this mother's ability to choose to homeschool is not one that parents with fewer financial means can readily choose, and if the neighborhood schools aren't good enough for her kids, as she asserted, why would they be good enough for anybody else's? Yet she is not doing anything to improve the schools to "give back to society." She simply claims that her personal investment in her own two children is her contribution. The rest of the kids in the neighborhood be damned. "Parenting strategies that are based on an all-consuming emotional focus on one's own child are paradoxically often indifferent to children in general . . . Adults who greatly value their own children and lavish them with attention can feel little responsibility for other people's children. There is an important divergence between the private and the public value of children" (Furedi 2002: 122).

Increasingly, parents not only focus on their individual child alone and ignore the needs of kids overall, but they even make choices that they believe aid their offspring to the detriment of other children. Jennifer Reich (2016) studied middle-class parents, mostly moms as they are usually in charge of medical decisions for their kids, who do not vaccinate their children on schedule or at all. Convinced that, as the mother, they are the only people capable of understanding their children as unique individuals, they feel that the one-size-fits-all immunization schedule recommended by pediatricians is flawed and not appropriate for their kids. When too many people are unvaccinated, herd immunity wanes, endangering those who cannot get vaccinated, such as infants and people who have an actual allergy to a vaccine component or other legitimate health reason for not being immunized. Yet these moms firmly believe that their only responsibility is to their own children, not to their neighbors, and they do not feel badly about failing to model concern for others and good citizenship to their children. As Reich (2016: 19) writes "[p]arents tout their commitment to informed individual choice as a way of expressing their commitment to their children, which overrides a commitment to community responsibility and social justice."

These parents are free-riders because what is keeping most of their children healthy is not their consumption of organic food and herbal supplements but the fact that most other parents have immunized their children; while some anti-vaccine parents do not recognize this fact, others do but still refuse to vaccinate their kids (Reich 2016). Not everyone has this choice. At the same time that welfare recipients in some states are sanctioned for not vaccinating their children, privileged parents, by simply signing a form declaring a religious or philosophical exemption, can send their children to public schools unvaccinated without fear of any consequences.

> Vaccine resistance then represents an individual sense of entitlement to use public resources without shared responsibility to others. As parents claim individual expertise and the right to make their own choices, they do so while continuing to claim that their children are entitled to public resources like public education or use of public spaces like parks, while opting out of public obligation. (Reich 2016: 237)

While pre-Covid the anti-vaccine movement was loud but relatively small, it grew dramatically with the coronovirus pandemic as politics

became enmeshed with distrust of public health advocates. As the pandemic stretched from months into years, people, particularly on the political right, fought vaccine mandates and masks in public places, including schools, and ignored warnings to keep a safe distance to limit the virus's spread at social functions. The case of Covid illustrates how these reactions ironically perpetuate the very problems with which mothers struggle. When children transmit Covid infections that could have been prevented through mask wearing, vaccination, or socializing from a safe distance, other children and parents pay. The whole class has to quarantine and stay home from school, making their parents miss work. The teacher goes out sick, and the school has to scramble to find yet another substitute. Nonetheless, some parents, ignoring the needs of children with serious health conditions and kids with an at-risk family member, clamor about individual "rights," arguing that they and their kids are inconvenienced by mask wearing and that their children's smiles need to be "freed." We have lost the unity that comes with a sense of collective responsibility. People no longer feel shame insisting that *only* their kids matter. It's a badge of honor for some parents.

When motherhood is painted as a series of personal choices, it loses its political significance (Fixmer-Oraiz 2019). "[I]deologies of contemporary motherhood are decidedly postfeminist. They adopt the language of feminism (i.e., 'choice' and 'empowerment') in the service of an agenda that depoliticizes women's lives and struggles" (Fixmer-Oraiz 2019: 11–12). Women are held personally accountable for their children's well-being and outcomes. Trying to quell anxiety about the future by taking on additional responsibilities for every detail of one's children's health, education, and extracurricular activities creates other anxieties as it overburdens moms and places too much responsibility on them for how their progeny turn out in the end. Warner explains that:

> [women] *micromanage* as a way of getting things under control . . . as mothers, we have tended, overwhelmingly, to turn our eyes inward at precisely a time when we should be looking outward. We have developed a tendency, as a generation, to *privatize* our problems. To ferociously work at fixing and perfecting ourselves – instead of focusing on ways we might get society to fix itself. This speaks of a kind of hopelessness – a kind of giving-up on the outside world. It's as though we believe that, in the end, *we* are all we can count on. And that our

power to control ourselves and our families is all the power that we have. (Warner 2005: 163)

Warner reminds mothers to ignore the stuff that doesn't have much impact and to instead figure out how to change what counts:

[W]e fixate on those things we feel we *can* control – how our child holds a pencil, whether or not she eats gluten – rather than worry about what we can't control: our economic futures, kids' education, health care costs, whether or not we'll ever be able to afford to retire . . . what we're trying to control is precisely what one cannot control; you can't shape and perfect human beings, pre-program and prepare them so that you can predict the course of their lives. . . . But you can – ostensibly – exert some control over what kind of society you live in. You have the power to elect politicians who can offer to deliver the goods on things like education, public services, and support for families. (Warner 2005: 208)

We see and cope individually, but many of the problems are structural. To address structural problems, we need government to value our families. When you, your neighbor, your coworker, and your cousin are all struggling to find affordable daycare, it is not a personal responsibility. The government has to do something about it. In the meantime, you and your neighbor can trade some child care, your coworker can hire a babysitter, and your cousin can get her elderly parents to help out, but that's not going to make anything better when your children face childcare problems with their own kids.

Lenz reveals the hypocrisy with which our society claims to value moms while making it almost impossible to mother:

Congratulations [mom], you are now more myth than human. More of an idea than an individual. Now the most important thing about you is how you used your uterus. Now you will forever be defined by this relationship. Now people will send you pastel cards with pansies on them telling you *you* are a good mother. People will tell you that what you are doing is so good and noble. Then those same people will vote away your healthcare, your paid maternity leave, your birth control – all while calling you #blessed. "I don't know how you do it all," they will say, while also making it incredibly difficult to do it at all. (Lenz 2020: 2–3)

Many people vote against their own interest, women included. An outgrowth of rampantly individualistic society is the belief that good decisions and hard work always lead to success. It places blame on people individually for outcomes beyond their control. "Mom – however lofty her own hopes for herself, and whatever her financial circumstances, whatever embattled neighborhood she lives in, however scarring her own upbringing, however lousy her educational options – must simply make the right choices" (Douglas and Michaels 2004: 326). This view is trafficked in the media, along with paying lip service to mothers.

> [T]he predominant stories told about motherhood . . . across a variety of media . . . [contain much] that serves to undermine women's power and progress. First, the media idealize and glamorize motherhood as the one path to fulfillment for women, painting a rosy, Hallmark-card picture that ignores or minimizes the very real challenges that come along with parenthood. Second, the media narratives often cast motherhood in moral terms, juxtaposing the "good mother" with the "bad mother," who frequently is a working mom, a lower-income mom, or someone who does not conform to traditional gender roles of behavior, ambition, or sexual orientation. Third, media frame the issues, suggesting how the public should think about them. In particular, by focusing on the individual level rather than the societal level, media stories frame problems facing mothers as "personal problems" rather than problems needing systemic, public policy solutions. (Kinnick 2009: 3–4)

Things are only getting worse for women. Covid magnified all moms' adversities, especially working moms', and attacks on reproductive freedom are undermining abortion rights and even access to certain kinds of birth control. But many mothers are too tired making it through each week to fight the system that is making them tired. When people are exhausted, it's hard for them to pay attention to legislation, organize collective action, and keep up the sustained pressure needed to get the politicians they want into office and the laws they need passed.

Fixing real problems instead of worrying about fake ones

Sociologist Barry Glassner's (1999) book, *Culture of Fear: Why Americans Are Afraid of the Wrong Things*, is about pseudo-dangers

and problems that are given disproportionate weight by the media and by politicians. They use misleading statistics and rely on hyperbole and fear to create or expand matters of public concern. One of the major problems with this is that as we worry about things that are not real or are very unlikely to happen, such as children being kidnapped by strangers, we ignore real threats that affect far greater numbers, like children ingesting lead or other contaminants. We also put the emphasis on individual solutions rather than ones at the local, state, or federal level. Parents should not have to test their own water for dangerous substances and buy water filters or bottled water. Pipes and the water in them in US schools, businesses, and homes should be safe. But safe water cannot be taken for granted for an unconscionable number of Americans.

It is important to look at actual data rather than making assumptions about what is and is not safe. Men's age and their exposure to toxins contribute to miscarriage and birth defects, despite the media showing older male actors and politicians who have had children late in life with little reporting on the risks. On the other hand, women can safely drink small amounts of alcohol during pregnancy even though they are inundated with overblown public health advisories claiming the opposite. As Oster (2021) argues "[t]he key to good decision making is taking the information, the data, and combining it with your own estimates of the pluses and minuses. In some cases, the existing rule is wrong. In others, it isn't a case of right or wrong but what is right for you and your pregnancy." While Oster, Garbes (2018), and I are all comfortable with small amounts of alcohol and caffeine during pregnancy, other women are not. Some pregnant women smoke, overdo substances, or do other things that are not healthy in general, and these women need to be offered real help that takes into account their full life situations rather than being judged or incarcerated. Other women have to do things that are alright for them but not ideal for a fetus. A woman who combats severe depression by taking medication might have to weigh the risk of effects on her pregnancy. Obviously, the woman committing suicide because she went off her anti-depressants would be a worse outcome than the possible effects of anti-depressants on the baby. And as a psychiatrist cited by Garbes (2018: 50), Dr. Elizabeth Fitelson, emphasized, "[y]ou have to pay attention to a mom's capacity not just to bear a child but to take care of a child."

Risk evaluation is, unfortunately, mixed up with cultural notions about morality and proper behavior. Briefly leaving a kid alone in

a temperate car in a safe location is not as dangerous as driving down the street with the child, even properly secured in a child seat, yet the police might charge a mom for doing the former. What is dangerous is sending a pregnant woman to jail where she will receive poor pregnancy care, if any at all, and be subjected to stress and violence. What is dangerous is placing a child in foster care where psychological trauma from the separation is almost certain, and neglect and abuse possible, rather than helping his or her otherwise adequate mom pay the rent or find a job. What is dangerous is kids facing a bleak future in which they cannot afford college or health insurance.

If we truly cared about children and their mothers as we claim, we wouldn't let them die unnecessarily. Yet the United States does poorly by pregnant, birthing, and postpartum individuals. Our overall mortality rate is embarrassingly high for an industrialized nation; rather than decreasing, the deaths of pregnant and birthing women and mothers have been climbing since the late 1980s. There were only 1.7 deaths per 100,000 women in New Zealand, 1.8 in Norway, 3.0 in the Netherlands, and 3.0 in Germany in 2018, compared to 17 maternal deaths per 100,000 in the United States that year (Commonwealth Fund 2020). Out of ten countries, the next highest death rates after the United States were France with 8.7 and Canada with 8.6, only about half of the US mortality rate (Commonwealth Fund 2020). Black women are the most likely to die, at 41.7 maternal deaths per 100,000, followed by 28.3 for Native American women. The rates for Asian, non-Hispanic white, and Latina/Hispanic are 13.8, 13.4, and 11.6 per 100,000 respectively (CDC, *Pregnancy Mortality Surveillance System*). Thus black women die at three times the rate of white women, and in some states, it is even higher. Causes for the racial disparities are subpar access to care and insufficient care when rendered, implicit bias, ongoing structural racism, long-term stress linked to prejudice and discrimination, and prevalence of (poorly treated) chronic health conditions. Black women have the highest incidence of preterm labor and the most low-weight newborns (Ross and Solinger 2017). Infant mortality in the first year of life is 2.3 times worse for black babies than for white ones. Out of 1,000 births, 10.8 black babies die in their first year. The rate is also very high for Native American infants at 8.2 per 1,000 births. For Hispanic, non-Hispanic white, and Asian, the rates are 4.9, 4.6, and 3.6 respectively (CDC, *Infant Mortality*).

While there is progress, especially in some states, with initiatives to decrease maternal and infant mortality, the United States still lacks universal health care, and the disparity in care for those who are well-off and those who are not can be great. One black woman at a maternal mortality conference described how when she had to go off her mother's health insurance while pregnant, instead of seeing her regular obstetrician, she was sent to a clinic for Medicaid patients where the doctor was different at each visit, the visits chronically ran very late causing her to miss her college classes and work, and she felt as if her concerns about pain and something being off were ignored. Providers dismissed her fears and failed to answer her questions for weeks. She went into preterm labor, and her son died a day after being born too early.

If we really wanted to improve the health of mothers, babies, and families, we would not dicker about passing bills that could help quell the maternal health crisis. The Pregnancy Discrimination Act of 1978 was not enough to protect pregnant employees, 250,000 of whom were denied work accommodations each year (NPWF 2021). People of color are more likely to need pregnancy accommodations as they are disproportionately employed in sectors such as housekeeping, warehouse packaging, laundry and dry cleaning, and personal appearance work that require long hours of standing, being on ladders, doing heavy lifting, or exposure to toxic chemicals (NLIRH/NWLC 2014). Sometimes these accommodations are as basic as being allowed to carry a water bottle on the job to stay hydrated (NPWF 2021). In late 2022, Congress finally passed the Pregnant Workers Fairness Act to toughen protections so that expecting parents do not have to choose between losing their income and the health and safety of their fetuses.

Additional funding for maternal and child health will be dispersed through the Health Resources and Services Administration (HRSA). The Healthy Start Initiative is trying to improve low-income and minority women's birth outcomes through measures such as increasing the number and use of birth doulas. The Maternal, Infant, and Early Childhood Home Visiting (MIECHV), which Congress decided to support for another five years, links vulnerable families, such as those with parents who have not graduated from high school, to nurses, educators, and social workers who can provide information about health and infant care and also conduct screenings such as those for child-development delays or for intimate partner violence. It will

sunset in 2027 unless it is reapproved. This should be a permanent program rather than reauthorized every five years. The great majority of eligible families cannot avail themselves of these services. In 2021 in New Jersey, for instance, 5,378 families received MIECHV services, but there were 460,600 families that could have benefited, and in New Mexico only 510 families got this assistance, whereas 111,500 families could have used voluntary home visits based on eligibility criteria (First Five Year Fund website). While additional money has been allotted, the program remains vastly underfunded and needs a much more substantial increase if it is intended to reach all the families that could qualify.

The federal government must also pass legislation to protect abortion and fund abortions for women on Medicaid who request them, and if legislators will not pass universal health care, they should at least mandate that insurance cover birth control, fertility assistance, and measures that make childbirth safer. Other high-income nations have lower rates of maternal mortality in part because they provide postpartum supports such as home visits by nurses/midwives covered by health insurance – as well as paid maternity leave. And people, pregnant or not, need higher wages, healthy workplaces, and a true safety net. The only time black infant mortality dropped to one and a half times that of white women, rather than twice or higher, was between the time President Johnson declared the "War on Poverty" and President Reagan taking office, this despite enormous advances in neonatal intensive care medicine at the end of the twentieth century (Briggs 2017).

As we lose babies and moms that might have been saved, we target individual pregnant women for having a cup of coffee in the morning or a glass of champagne on New Year's Eve. Angela Garbes cautions that:

> [t]he vast majority of resources on pregnancy and motherhood direct our eyes and minds to issues that don't actually matter in the grand scheme of things. The problems we face are much bigger: a culture in which men hold nearly all of the legal and economic power; a society in which whiteness is considered the norm and superior to other races and cultures; an economic system that relies on, but does not adequately value, domestic work that is performed overwhelmingly by women . . . (Garbes 2018: 27–8)

Society continues to chide teen moms and single moms instead of making daycare affordable. Family regulation systems, such as Child

Protective Services, go after moms who struggle to put food in their refrigerators, sometimes removing their children from their care, when, instead, the government should be forcing companies to pay living wages. Covid exposed many cracks in America's veneer. At-risk citizens, the elderly, people of color, and lower-income workers whose jobs were less Covid-safe given exposure to the public, died at alarming rates. While schools in wealthy communities gave chrome-books to all their students, in some areas families remained without internet service. Hence the elementary school sisters sitting on the concrete outside Taco Bell in order to study. And if a mom uses a relative's address to get her child into a better school district, she can be convicted of a felony.

While the pandemic raged, mothers of transgender and non-binary kids were being attacked with a wave of legislation claiming to protect children from moms supposedly enforcing a gender agenda on them. Moms who support their children's gender fluidity or gender-affirming care are finding politicians, as well as ex-spouses, attacking them, arguing that they are manipulating or abusing their children by using their child's preferred pronouns and allowing them to dress the way they feel the most comfortable, even though this is the recom-mended standard of care (Burns 2019). This, not totally surprisingly, is about moms in particular. "Maternal blame appears to be common when it comes to trans children of estranged couples," even though parents have little if any influence on a child's core gender identity (Burns 2019). The authors (Kuvalanka et al. 2019) of a review study examining Family Court cases interviewed ten divorced mothers who affirm their child's trans and gender nonconforming identities. In each of the ten cases, the child's other parent (seven fathers and three mothers) blamed the affirming mother for "causing" the child to be trans, and courts gave a favorable ruling to the non-affirming parent in four of those cases. Three mothers lost custody and another was given shared physical custody but lost legal custody. Only two of the affirming mothers, one of whom had an ex-husband who did not pursue the case and another who had an ex-husband outside of the country, got sole custody. The authors also review another five cases in which three gender-affirming mothers lost custody or received reduced parenting time or legal rights to their child and another got shared parenting time and legal custody with a non-gender-affirming father. This was true even when mothers had sole custody for multiple years and fathers had very little contact with the child prior

to the case. The only one of the latter five cases in which the affirming parent was given sole custody was that of an affirming father whose ex-wife was physically abusive to the children, so it is unclear how much of the judge's decision was about supporting the child's identity and how much of the decision was about abuse. The authors state that many judges have little experience with transgender issues and that threats to masculinity, as when a child assigned male at birth wants to live as a girl, are viewed particularly unfavorably by judges (Kuvalanka et al. 2019).

The impossible position in which this is placing moms and children is heartbreaking. Either way, it can force children to perform gender the way society wants them to, damaging their mental health. If the non-affirming parent wins custody, he or she forces the child to change their clothes and hair and use a name and pronouns with which they don't feel comfortable. And the gender-affirming mother, correctly fearing she could lose custody over this issue, may preemptively back away from allowing her child free gender expression or taking them to a gender-affirming physician or psychologist, or allowing them to play with other trans/non-binary children. If a judge awards joint custody, there is a mental health toll from oscillating between a parent who is affirming of the child and one who is not. Two of the ten children in Kuvalanka and colleagues' study had already talked about suicide. Children with gender dysmorphia are at a higher risk of suicide, particularly when they do not have family support, and yet governors are threatening Child Protective Services investigations against affirming parents in high-profile cases, and state legislatures are passing discriminatory legislation that targets these children and the parents trying to do the best they can for them, rather than protecting the children's rights and well-being and supporting parents who need legal, psychological, and medical assistance for their family members.

While the politicians who persecute transgender kids may claim they are protecting the traditional family and traditional gender norms, they are causing tremendous harm to kids and parents. These are the same politicians who try to cut money for school lunches, programs that aid families with children who are disabled, and child tax credits. They are the same people who do not support expanding healthcare coverage, including the Affordable Care Act which reclassified pregnancy from a preexisting condition to something that insurance plans had to cover, or paid family leave. Feminist

activist Jenny Brown (2019: 34) writes that when conservatives say pro-family, they mean "families instead of government . . . And by 'families' they mean women, and women's unpaid labor." Cut school lunches and moms will prepare them; slash school budgets, and moms will volunteer so the library can still function. Putting greater burdens on already overstretched moms is obviously not a good thing for families. Given how right-wing politicians vote, their pro-family stance is not pro-family at all. At the governmental level, blaming parents is a quick fix, an inadequate and harmful solution for addressing society's ills. "Parenting as a tool of social policy is likely to be ineffective, but it has the merit of being very cheap" compared to improving health, education, and child care (Furedi 2002: 92).

Help instead of punishment for those who need it

The "pull yourself up by your own bootstraps" ideology allows politicians to claim a moral high ground when they deny food and health care to children. They argue that it is incumbent on parents as upstanding citizens to provide these things to their children on their own. And if a parent really fails, then the appropriate stance is not assistance, it is punishment. It's these views that lead many states to deny welfare benefits to a family already receiving assistance in which a new child is born. It is more important to punish the mother for her "bad choices," even if she was coerced into sex, even if her birth control failed, or even if she sought an abortion but could not afford it (another thing the state will not help with) in a state where it was legal or could not obtain it in a state where abortion is illegal, than it is to make sure her children receive adequate support. Even if some see it as the mother's fault that she had a new baby while poor (a terrible premise that flies in the face of reproductive justice assertions that all people, regardless of social class status, have the right to pursue pregnancy and parenthood), no one can claim that it is the new baby's or an older sibling's fault, and yet it is also the children who are made to suffer. And this sets another group of children far behind the starting line as they try to navigate education and other entities that are supposed to put them in a situation where they can succeed.

Given our high expectations of moms, those who seem, at least from the outside, to be doing the worst at it, those who are struggling

with addiction, those who commit crimes and go to prison, and those who have their children removed from their care by CPS are easy to look down on. They also look down on themselves. "Women who mother from prison are typically beset by fears, despondency, guilt, and shame. Many of these women, two-thirds of whom were the primary caretakers of at least one child before incarceration, define themselves as 'bad mothers,' persons who violated the basic norms of caring for their children" (Ross and Solinger 2017: 226). Yet many of these women can do a better job of mothering if they receive help such as housing vouchers, education, job training, and, if needed, assistance for problem drug use.

When mothers are sent to prison on drug charges, rather than getting more effective treatment for addiction, they are at risk of losing their kids. They are more likely to recidivate. And even if they kick their habit, their criminal record can make getting a regular job very difficult. While we need to make treatment programs available and affordable, residential programs can be problematic because they usually do not accept pregnant women or allow patients' children to come along. It is also hard for women to take an extended period of time off work and not lose their jobs. Judges sometimes fail to understand these problems when they mandate that a woman go to drug treatment, and if she cannot comply because she cannot find child care, she ends up in prison. Kids who are separated from their parents undergo trauma, and while some children are adopted into loving families after parental rights are terminated, many others languish in the foster care system, sometimes living in institutional care as teens, and they come out as young adults with little financial or social support. As Goodwin writes, "[r]arely are the well-being and dignity of babies and children a persistent concern of those politicians who most favor punitive interventions in the lives of their mothers" (Goodwin 2020: 191).

In 2016–2017, 1,394 out of the women incarcerated in 22 reporting prisons that house 57% of US female inmates went to prison pregnant, but 28 prison systems, including those in California, Florida, and New York, did not participate in the survey. In the early 2000s, between 3% and 4% of women inmates in the United States were admitted to prison pregnant (Johns Hopkins Medicine 2019). When a woman goes to prison pregnant, in addition to poor quality food and a high-stress and potentially unsafe environment, she may find herself without adequate medical care. Women have miscarried

and lost babies birthing unattended in prison. They have been taken to the hospital wearing leg chains, despite the risk of tripping, and been shackled while giving birth, even though it makes the process harder for both laboring women and medical providers and creates problems if an emergency intervention is needed.

Many women in prison are victims of abuse. Sometimes their crime was at the behest of an abusive partner or they were convicted alongside him because they hid the gun or simply were in the car at the time he committed the crime. As we saw in chapter 5, some mothers have spent more time in prison under FTP laws than the man who actually shook, beat, or burned their children. When a child is killed through abuse, the mom can go to jail for the same amount of time as the murderer. Singh states that "[t]o treat abused women as by-products of the criminal justice process in order to secure a murder conviction (against the person who killed their child) is ethically unjustifiable" (Singh 2021: 200). She also notes that "misogynistic myths continue to influence the drafting of criminal offences" (Singh 2021: 200). Fathers, as we have seen, are rarely prosecuted under FTP laws, even when it's obvious they should have known about the abuse their child endured. This belies arguments that these laws are about children's safety. Rather, they are about surveilling and criminalizing moms.

Moms should rarely, if ever, lose custody simply for financial reasons, yet this happens far too frequently (Burroughs 2008). "Child protective services still justify their terror by claiming to defend children from harms created by structural inequalities but falsely attributed to parental pathologies" (Roberts 2022: 88). Rather than moving a child from their parents' care when the apartment plumbing isn't working, the landlord should be required to fix the plumbing. Schools should be able to direct needy families toward resources rather than being forced to call Child Protective Services. And billing poor parents for the costs incurred when their children are in foster care is beyond vindictive when so many children are in foster care simply for material neglect, the inability of their parents to provide adequate food, clothing, and shelter for them. If we cannot abolish Child Protective Services, as Dorothy Roberts (2022) urges, we can at least make allies rather than criminal enforcers of schools and domestic abuse hotlines, and we can put more resources toward poor families rather than taking away their children and billing them for being poor in the first place.

This general attitude needs to change. As the case of charging parents for their kids' time in foster care demonstrates, instead of going after struggling moms, we need to decide that helping them is a better strategy, and that, ultimately, it is usually far more beneficial for their children, born and unborn as well. Pregnant women who are addicted to substances are often very motivated to get help when they know they won't be thrown in jail or lose their baby for talking honestly to healthcare providers. Moms having trouble providing food, heat, and other necessities for their kids normally want to do right by their children and desire help. Children who have seen their moms be assaulted benefit from individual treatment, but they benefit even more when their mothers obtain supportive services as well (Strega and Janzen 2013). The more we aid a woman to manage her life, the more supportive she can be of her children's needs. Intimidating mothers does not make them better mothers. Too many mothers find themselves in impossible situations. Do you take your child to the doctor for the umpteenth time and lose your job or do you put off their medical care? Do you leave the man who is teetering on abusive behavior if you and your children have nowhere else to sleep on a cold night? Do you let your kids be unattended for a short period of time because you cannot find anyone to watch them while you have a job interview or do you risk losing the job to someone else? "If we listened to the [non-privileged mothers'] stories with the same compassion and empathy we reserve for relatively privileged mothers, what then? We might actually come to terms with the reality that our culture around motherhood is in dire need of an overhaul, and no amount of 'personal responsibility' can save us" (Lenz 2020: 176).

As the online support for mothers like Shanesha Taylor, who left her children in the car for 45 minutes during a job interview, reveals, on a personal level some people understand the hard choices many moms face. They may have been in a similar spot themselves trying to sort out competing demands without assistance. At the societal and judicial level, it's another matter. While groups like the Pregnancy Justice (formerly National Advocates for Pregnant Women) and the Family Defense Center can provide legal assistance to some mothers, they normally come in after someone is already arrested or has lost custody. Changing laws to target only the seriously criminal and abusive while focusing on helping poor and at-risk parents to meet their children's needs would benefit everyone. Fewer tax dollars

would be wasted, and we would get better returns for the money spent. Social workers would be less burdened, and fewer children would be traumatized. More mothers would feel valued instead of blamed and punished.

Fathers and other caregivers

Fathers are not subjected to the same standards and scrutiny as mothers, as this book underscores. Men are not warned about the threats their jobs, leisure activities, and age can cause to their fetuses and children. A man who brings his toddler to daycare in mismatched socks is a good dad trying, while a mother who does this is judged for not being able get her act together and successfully balance work and motherhood. Men do not encounter a fatherhood penalty that negatively affects their wages. Men rarely face punishment for FTP, even in cases where they knew about the child's abuse. The point is not to start subjecting fathers to the detrimental interventions and public shame that mothers are subjected to, but rather to convey the lesser role we as a society give to dads. Fixmer-Oraiz (2019: 149) urges us to really think about "[t]he impossible standards to which mothers are held, deeply inflected by binary gender norms that celebrate fathers for negligible contributions to domestic labor but that simultaneously censure mothers for minute failings in the fulfillment of housework or childcare." To help moms, we need to change this.

Involved fathers are still less likely to subscribe to intensive parenting the way mothers do, so their engagement can help cut down on this overly involved, exhausting style of parenting. Seeing fathers share equally in household tasks when they are young does help boys grow up to be better partners. This is better for everyone. An equal relationship improves couples' sex life and general relationship satisfaction (Ruppanner, Branden, and Turunen 2018). But this means letting go of outdated stereotypes. Fathers have to commit to be truly egalitarian and mothers have to stop gatekeeping, giving up their special position as the "real" parent, something that can be an overarching component of a mother's identity. Even modern mom Kim Brooks fell into this: "They loved Daddy. Daddy was fun. Daddy was terrific. But Daddy was no Mommy. Or so I told myself, buying into one of the lamest tropes of the cult of motherhood" (Brooks 2018: 182). Moms normally

manage the household and delegate tasks to dads. The interviewees in Wall's (2010) study said they read the parenting materials, not their husbands; sometimes they discussed the approach together after she read it, and sometimes he simply followed her lead. Rejecting this view of mother's responsibility and primary role in the family can be hard for moms for both psychological and societal reasons (Faircloth 2021). In a majority of different-sex couples, women earn less than men, making her salary more expendable than his if someone stays home or cuts back to part-time work to accommodate childrearing. Parental leaves are still targeted at mothers more than at fathers, even in some European countries, and this reinforces that parenting is attached to motherhood more than fatherhood. And moms are normally the ones who are judged on the cleanliness of the home and the behavior and appearance of their children, so it makes sense that they may be afraid to relinquish control. If he doesn't do a good job, she still may get the blame.

Despite its costs, the sense of satisfaction from being the primary parent is deeply ingrained. "While many mothers wish for more equity in parenting, it's tough to let go of the power that role also gives us" (Zaske 2017: 203). Watson (2020: 13) admits "[r]ecognizing our complicity in patriarchal divisions of labor has not loosened my own adherence to the ultimately self-defeating goal of juggling motherhood. I lie in bed, dog-tired, frustrated by the ways that my unpaid labour strengthens the backbone of exploitative capitalist flows. Why?" She simultaneously loves and hates her "affective duty," conceding that deep down, despite the unfairness of the system, she wants to be, or at least be seen as, the competent mom who can do it all, be a great worker and a great mom. Her sense of value comes from this identity, so she'll complain to a friend in the same boat, and then they both go home to the status quo. "[A mother] may report burnout or stress, but she still seems willing" (Watson 2020: 14). Although women may be reticent to give up their privileged position as the most important parent, as this book has shown, there is a hefty price to pay for being on a pedestal. It makes the fall greater, and more likely. If fathers come to be seen as equal parents to mothers, rather than occupying a supporting role, not only will it improve disparities in the second shift and foster egalitarian relationships for mixed-sex couples, once fathers do everything that mothers do and it is not mother's special, exclusive domain anymore, mothers will likely be judged less harshly.

Ultimately, fathers and other caregivers, including paid ones, need a bigger role in caring for children in order to take the burden off mothers' shoulders and because it is good for kids; this should be encouraged culturally and politically. Many modern fathers do want a more involved role with their children than their own fathers had. But, at the same time, lots of young men are neo-traditional, believing that when push comes to shove, their job is their primary domain and the home and children are their wife's (Gerson 2015). It's not just social norms. It's also because of systematic discrimination. Women typically earn less than their male partners. When someone has to stay home for a sick child, to raise triplets, or for some other reason, it's more likely to be the one with the lower income, hence the mom. Men may also correctly perceive that if they leave their job promptly at 5:00 to do the daycare pick-up or ask for time off for children's medical appointments, performances during the school day, or to collect a sick child from school, their bosses may find them uncommitted to their jobs and be less likely to promote them or may even be more likely to fire them during layoffs.

There are numerous ways to address the structural and cultural impediments listed above. Famous men and men in high-level positions should publicly take family leave. Even if some, like Secretary of Transportation Pete Buttigieg who took a month-long paternity leave following the birth of his twins, get criticized for it by conservatives and older men, young men may follow their lead. Companies should build family-friendly cultures with more flexible schedules and time off. Government should provide paid leave for employees who become foster or adoptive parents or have a baby, with incentives for fathers to take it, as some other countries have. If only the mom takes leave, this has the detrimental effect of reinforcing her role as primary parent and leaves her career more vulnerable in both the short and long run. Women need opportunities such as being offered management jobs, training in male-dominated fields, and legal protection from discrimination so that their salaries become more in line with men's and they have more bargaining power in the home. We must elect more politicians who favor legislation that is good for families and gender equality. Media need to refrain from portraying dads as bumbling incompetents with their children, and people need to check their criticism of stay-at-home fathers. School nurses and teachers should contact fathers and not assume that mom is the only one on call or who knows what is going on in a child's life.

We have to stop labeling groups for young kids "Mommy and Me," leaving out daddies who want to join. And all men's rooms should have a changing table in them.

People rarely react negatively when told that a grandparent watches a child while parents work (and some of these grandparents are men). No one should automatically condemn a parent when told that a nanny, au pair, or babysitter takes care of a child or that a child attends daycare. There is no evidence to support that any of these supposedly "substitute" caregivers are detrimental to children's development or mental well-being as long as they are good quality care providers. I really love babies and I like older children, but I am not a big fan of toddlers and preschoolers. I remember thinking you couldn't pay me enough money to last a week working in the two-year-old room at my son's childcare center, yet his teacher waxed poetic about the joys of watching young children learn to use (blunted) scissors for the first time. She truly loved that age group and enjoyed and found her job meaningful. I just wish she received higher pay and better benefits for her hard work.

Better social policies

Social policies run through all of the above sections because they are so critical and cannot be disentangled from other solutions. We have to get beyond seeing these problems as individual mothers' and families' issues to solve.

> We know the problems that face new mothers. We've written books and books and books about them. But for all our glossy representation, we've failed to change the system. Women are instead told they need to change – to "lean in" or "wash their faces" as Sheryl Sandberg's and Rachel Hollis's best-selling books, respectively, dictate. But it's a solution that dodges fundamental and structural change. By making the solution individual, something women should do for themselves, we give women yet another job. "I have identified the problem," neoliberalism says, "and it's on you to fix" – by working harder or hiring a housecleaner or using an app to help you accomplish tasks. Each prescription insidiously papers over the problem rather than solving it. And so the most privileged people pay – and "lean in" – their way around deep structural inequities, while those most in need are given one more task to feel like they're failing at. (Lenz 2020: 175)

An emphasis on childrearing as a collective responsibility, supported by national initiatives, would reduce the draining expectations of mothers (and their guilt, stress, and lack of sleep) but also ultimately help us move forward toward a better society that supports all types of families.

A particularly egregious lacuna is the lack of paid family leave which makes the United States the outlier among developed countries. It was a hard-won battle to get even an unpaid family leave passed in the United States in 1993. It allows up to 12 weeks of unpaid leave in a 12-month period for a worker to recover from a serious illness, care for a sick family member, or care for a newborn or adopted child. But workers must have been employed for at least a year to qualify, and they must have worked for a minimum of 1,250 hours during that year. In addition, employees of firms under 50 employees are exempt. Women are more likely than men to work in small businesses that do not employ over 50 people. A few very highly paid employees are also exempt. The consequence is that only about 62% of American workers are eligible for unpaid family leave (Collins 2019). Some mothers have no choice but to return to work two weeks after their babies are born (J. Brown 2019). California, Connecticut, DC, Hawaii, Massachusetts, New Jersey, New York, Rhode Island, and Washington currently mandate paid leave. Colorado and Oregon have passed it but not implemented it yet, and New Hampshire passed a bill making it voluntary for employers, but all state employees will be covered. Some individual employers also give a paid family leave as a job perk. In 2015, 21% of mothers and 13% of fathers had a paid leave (Collins 2019).

Lenz points out the hypocrisy of claiming that babies are important and then not giving parents with newborns any paid time off: "[j]ust as the life of the hypothetical human is prioritized over the welfare of the fully embodied flesh-and-blood adult carrying them in their womb, we prioritize caring for the new baby over offering any support to the new parent" (Lenz 2020: 171). If American society really believed that mothering was important, and important for mothers and infants of all social classes, Americans would put their money where their mouth is. Currently, one in ten mothers of newborns return to work after a month, and 25% are back within two months of the birth (Lenz 2020). Seventy percent of the 90% of fathers who take any leave time use ten days or less after the birth of a child. All lower-income parents can do is cobble together sick days

and vacation days, and when those are used up, it's back to work. Almost half of workers in the private sector in the United States do not even have any paid sick leave. This came to the fore during the Covid pandemic with concern that workers would go to work sick and potentially infect others rather than miss out on pay they could not afford to lose.

Moms in other countries get months of paid leave. Only eight of the 193 countries that make up the United Nations do not mandate paid leave, including the United States (J. Brown 2019). Fifty countries provide more than six months paid leave to mothers, including Bulgaria's year of paid leave, Greece's ten months, England's nine months, and the Czech Republic's seven months. Forty-three give at least 14 weeks of paternity leave (J. Brown 2019). Some, including Germany and Sweden, increase the time given if both parents opt to take it. Not all countries reimburse salary at 100%, but many do, including Estonia, Portugal, Germany, Spain, Poland, the Netherlands, Israel, Costa Rica, and Chile. In several countries, mothers can take their minimum paid leave and then remain at home longer at a reduced rate. For example, in Estonia mothers get almost five months of maternity leave fully paid but can then take an additional 15 months at a calculated rate, and it can be split with a partner. Time at home allows a birth mother to physically recover and any foster, adoptive, or birth parent to start adjusting to the life changes that come with the arrival of the new child. Paid parental leave may reduce the incidence of postpartum depression (Chatterji, Markowitz, and Brooks-Gunn 2011; Lenz 2020). It also supports babies. A year of paid leave reduces infant mortality by 25% and reduces the deaths of children aged one to their fifth birthday by 11% (Ruhm 1998). It is easier for mothers who want to breastfeed to do so if they have sufficient leave time after their baby's birth. Breastfeeding moms need clean, welcoming spaces for feeding and pumping at work and in places such as airports, yet too many still experience criticism for revealing their breasts in public and find themselves sent to unsuitable places, like public restrooms, to nurse.

Before the Covid pandemic, over 70% of US mothers worked (Zaske 2017). The only subsidized child care is for very low-income parents, below 200% or 150% of the federal poverty line, working or in job-training programs. There had been hope that child care would be funded in the United States in the early 1970s. The Comprehensive Child Development Act passed the Senate and the

House only to be vetoed by Republican President Nixon who feared it would weaken the family and make the United States too similar to the communist Soviet Union. In the 1980s, another Republican, President Reagan, cut tens of millions of dollars of funding to daycare centers, the Women, Infants, and Children Nutrition Program (WIC), and support for prenatal care (Douglas and Michaels 2004).

When sociologist Caitlyn Collins studied women in Sweden, Germany, Italy, and the United States for her book, *Making Motherhood Work*, she found that "American women largely believed childrearing was a family's personal responsibility – they didn't expect help. Swedes' views aligned with the social democratic welfare state model; they believed everyone has a responsibility to ensure that children are raised well" (Collins 2019: 214). Close to 60% of Americans think young children's child care should come from family members; only 5% of Swedes believe this. Three-fourths of Americans believe the cost should be borne by parents, whereas only one-fourth of Swedes, who not only have heavily subsidized child care but also receive a check for every child under 16 each month, feel this way (J. Brown 2019; Collins 2019). This despite the exorbitant fees for child care in the United States. In many states, childcare costs more than tuition for a state college. In Washington DC, it costs three times as much to send an infant to daycare as to attend college (Child Care Aware 2019). Yet childcare workers in the United States are very underpaid. This stands in contrast to various European countries where childcare center employees are viewed as professional educators, are paid better, and have better benefits. We need to value professional care providers and show it by paying them good wages with benefits. This will improve their morale, lessen other burdens in their lives, and prevent high staff turnover, which is not ideal for young kids. It will also concretely reinforce that caring work is real work, hard work, and valued work.

Obviously this costs money; but what this costs the state is made up for in the productivity of working parents. The occupational status penalty for mothers is reduced in countries that generously fund public child care (Abendroth, Huffman, and Treas 2014). Aside from economic benefits, as mentioned in the chapter on neglect, subsidized child care would cut down on situations where mothers need to leave children alone to go to work. And it would alleviate a great deal of parental stress. In a study of parents and happiness, mothers and fathers in countries that give paid sick and vacation days

and subsidize child care were happier (Council on Contemporary Families 2016). When Collins interviewed mothers in the United States, they literally sobbed about not being able to do it all; their mental and physical health was failing. Many were working more than 45 hours per week. Yet they rarely pointed to the government or anything beyond their own household as a possible fix. "In the United States, the family continues to operate as a gendered institution that privatizes social costs that are conceptualized in other nations as public responsibilities" (Collins 2019: 245).

My town in New Jersey only had half-day kindergarten until just a few years ago. This was very difficult for working parents. Our solution with our first son was to keep him at home with one of us in the morning (we alternated days) and to send him to afternoon kindergarten followed by aftercare so whichever parent had stayed home with him that morning could still work for at least five hours in a row in the afternoon – with the rest made up at night and on the weekend. Our solution for our second son was to pay for him to stay at his daycare an extra year and do their new kindergarten program for a hefty sum. Both of these solutions required special resources. We were lucky to both have jobs with the flexibility to stay at home in the mornings every other day, and we were fortunate to be able to afford the private, full-day kindergarten. Not all parents, obviously, would be able to avail themselves of these "solutions." "Americans individualize social problems . . . changing jobs, becoming more efficient, and buying [technology] are all individual strategies that approach child-rearing as a private responsibility and work–family conflict as a personal problem" (Collins 2019: 199). They are missing the awareness of Europeans that the state could do more to help. US families need guaranteed spots in subsidized, quality daycare, ideally near or at their worksite, and paid paternal leave with incentives for fathers and female partners to take some of it so that the birth mom does not become circumscribed in her role as primary caregiver to the detriment of her work life. Ultimately, Collins (2019) argues that we must politicize mothers' stress and lobby for what she prefers to call work–family justice rather than work–family balance.

Much of Europe is further along the road to work–family justice than the United States. In addition to having paid sick leave, paid parental leave, and subsidized child care, many children in Europe start public school at age three rather than the United States' age five (or four for those lucky enough to have state-funded pre-K

programs), another thing that makes it easier for women to work, or to have another child if they so desire. Some European countries also subsidize assistants who come to the elderly people's homes not just to provide medical care but also to clean or do shopping; these initiatives would help mothers in the sandwich generation who care for both their young children and their own aging parents. European workers also receive more vacation time. France has 35-hour work weeks. Portugal passed a law that employers may not contact employees after work hours.

There are numerous other ideas that could help families. Means-tested programs that only low-income people qualify for are too readily put on the chopping block when political winds change or a recession strikes, so universal programs are better because they have broad support and politicians are reticent to cut them (J. Brown 2019). Universal health care, which many other developed nations provide, would guarantee a minimum standard of health care, including preventative care, to all Americans and ensure that people could afford their medications. A family whose preterm infant went to the NICU would not be bankrupted before even bringing their baby home from the hospital. Kinnick (2009) suggests allowing workers to choose time off rather than paid overtime, giving all employed Americans a certain number of days off as family care days, eliminating taxes on goods for children such as car seats and diapers, expanding free pre-kindergarten programs, incentivizing employers to provide benefits to part-time workers, finding ways to make it easier for parents who took time off to get back into the paid labor force, and subsidizing college (Kinnick 2009). Briggs (2017) suggests making public school hours better match standard work hours. If the United States had a better social safety net, fewer people, including fewer children, would be food insecure or homeless. Those suffering from poverty and violence or neglect in the home would have improved chances.

> Modest improvements in families' economic well-being, either through increases in income, fewer material hardships, or decreases in out-of-pocket expenses, have frequently been shown to decrease rates of child welfare involvement and substantiated maltreatment. Individual benefit programs that have been linked to reductions in maltreatment have been the refundable Earned Income Tax Credit (EITC), Medicaid expansion, Temporary Assistance for Needy Families (TANF), and other welfare benefits and policies. (Puls et al. 2021: 1 of 10).

Puls et al. (2021) calculated the effect providing additional aid would have on lowering child abuse. Their research was published in the journal *Pediatrics*.

> An additional $1,000 of state spending on the benefit programs included in this study per person living in poverty, a 13.3% increase for that year, would have cost $46.5 billion nationally, and might have been associated with 181 850 fewer reports for suspected maltreatment, 28 575 fewer children substantiated as victims of maltreatment, 4,168 fewer children placed into foster care, and 130 fewer maltreatment-related fatalities (Puls et al. 2021: 4 of 10).

A real social safety net benefits everyone. Not only do many people need it at some point in their lives when they lose a job, get divorced, or have a health issue, even people who never avail themselves of welfare or unemployment benefits gain in the end because more of their community members are doing alright. There would be less substance abuse and less crime. Puls and colleagues (2021: 4 of 10) argue that "[i]n the long run, in addition to helping poor families take care of their children and saving kids' lives, this investment would ultimately save states money in court and medical fees and children who would be less likely to abuse substances or be incarcerated as adults." These benefits could meet temporary needs and help a family re-right itself. Less poverty, less family violence, less crime, less substance abuse; these are the types of arguments that people in Scandinavian countries give when asked why they support high taxes – it makes for a better society for poor and rich alike.

Unlike the broad social support for these policies in many European countries, partisan politics in the United States usually has Democrats and Republicans coming down on different sides of measures that help families. In response to the Covid pandemic, increased tax credits for children in 2021 that gave monthly cash benefits to the majority of families with children and allowed even those too poor to pay taxes to claim the full credit lifted children out of poverty, kept families in their homes, and reduced food insecurity (Hamilton et al. 2022). This was especially true for low-income families and families of color (Hamilton et al. 2022). Yet despite clear gains in helping families weather financial distress, this additional support was allowed to expire and was not refunded in 2022. Republican concerns that these credits would encourage people not to work were

not supported by data (Hamilton et al. 2022), yet they prevailed in Congress.

Ross and Solinger (2017: 96) note that "the politics of 'legitimate' and 'illegitimate' mothers has created real difficulties in building coalitions among women of different races and classes in which they could work together for a national day-care policy, for example, or for birth justice, a subset of reproductive justice" (Ross and Solinger 2017: 96). Some struggling moms are more concerned with preventing immigrants or people of another race from receiving benefits and consequently vote against aid that would also benefit themselves. Others simply do not make the connection that these problems can be solved politically. Or they do, but they are either too disillusioned or too thinly stretched to do anything about it. "It's the oldest trick in the book. Divide a woman against herself. She'll be so busy trying to hold herself together, she won't have time to do anything else" (Lenz 2020: 118). While there are many organizations such as Moms Rising working to improve the situation for mothers, kids, and families, energy and time are in short supply when working and raising children, and it can be tough to do much more than vote, if that. In her article in the *Atlantic*, Helen Lewis (2021) writes that "[i]t's hard to find time to campaign against inequality when you're elbow-deep in diapers, or dinner needs to be on the table."

Some well-off people feel that they can isolate themselves from problems by living in safe communities or sending their children to private schools. This also gives their kids the leg up that they are so desperate for as wealth inequality grows and parents across the spectrum of social class worry that their children will not be able to do as well or better than they did. This is part of the dark legacy of intensive parenting.

> There is a painful irony in educated parents' lavish outpouring of attention on their children. For while a certain minority of young children are receiving an abundance (arguable an overabundance) of gifts and training, it has become apparent that a growing number of American children live below the poverty line . . . A nation filled with loving parents has somehow come to overlook crumbling schools, poor child health care, and deadly addiction. (Thurer 1994: 296)

As discussed earlier, in the United States we have lost our sense of ourselves as a collective. A nation can hardly be considered strong or

moral when so many of its children suffer needlessly. The definition of good parenting must include political and social obligation for improving all kids' lives, not just amassing resources and devoting attention to one's own child. Only focusing on the well-being of our own individual children is morally bankrupt and a cop out:

> [W]e seem to be obsessed with our own children and to ignore everyone else's. The same parents who are in a frenzy about getting their child into the "right" kindergarten oppose child-care legislation. If we are to feel guilty about our performance as parents, let us derive that guilt from an appropriate source – our treatment of the nation's poor children. A more democratic allocation of our money, time, and concern across the population of children (and not just our own) would probably benefit everyone. (Thurer 1994: 296–7)

We need a sense of collective we. *Our* children. It would benefit them and us.

Conclusion

Researching this book, I read some funny stories but, mostly, I read stories of struggle, pain, and injustice. I read numerous articles about many of the criminalized moms in this book, the moms who tried and who were tried. Delving into Debra Harrell's case, the mother who left her nine-year-old child at the park playing with other children while she went to work at McDonald's, I came across an article that sticks with me by writer Anndee Hochman. She titled it "In Defense of a 'Bad' Mother: Debra Harrell's Village Fails Her." It is worth quoting as she touches perceptively on many of the themes of this book.

> This story is about the safety net flipped inside-out – the frayed result of a society that pays lip service to "family values" but refuses to ante up for the supports that families need: affordable, accessible, high-quality child care; public schools that equip graduates to do meaningful and sustaining work; and a living wage. It's about a culture that preaches a fable of self-reliance and then slams a mother for cobbling together her own less-than-perfect child-care plan with no help from the government, relatives or neighbors. It's about the way we exaggerate the risks facing children, despite the actual numbers . . . Finally, and

most shamefully, the Debra Harrell story is about a knee-jerk reaction to parents – especially to the actions of an African-American single mother – that dishes up blame rather than empathy, punishment instead of support. The initial coverage of Harrell's arrest just bolstered the Bad Mom stereotype . . . Better not look to that proverbial village, the one that's supposed to help raise each child. Because the villagers are too busy shaking a finger to offer a helping hand. (Hochman 2014)

Debra Harrell's village *failed her*. Our society fails individual moms; it also fails motherhood writ large.

Most moms try very hard, often too hard. This is not just about driving themselves to the point of exhaustion, a terrible consequence of trying too hard in itself. It can also be more literal. White, wealthy, married actors Felicity Huffman and Lori Loughlin committed fraud and paid bribes to get their children into the universities they wanted. Their actions are shocking, but worth examining for what they tell us about modern-day motherhood. Even rich and famous mothers whose children already have countless assets at their disposal do a calculation in which doing *anything* to help one's child equals being a good mom, and being a good mom trumps breaking the law. Their circumstances are worlds apart from those of black, single moms Tanya McDowell and Kelley Williams-Bolar who used a friend's and a parent's address respectively to get their children into better public schools. All four served time. All went beyond what was legal to help their kids, and the law reclassified them all as criminals.

Ms. Huffman and her husband, actor William H. Macy, would have no trouble paying her US$30,000 fine. The fine for Ms. Williams-Bolar and her father was US$30,500 – the cost of the education they had "stolen" for Ms. Williams-Bolar's daughters. Given her felony conviction, Ms. Williams-Bolar could not become a teacher even though she had almost completed her teaching degree. Her felony and the fine carried weight that Ms. Huffman would not bear. This example, women on different ends of the socioeconomic scale facing similar penalties for their errors as mothers, is important. While Ms. Louglin's and Ms. Huffman's children face the shame of everyone knowing they did not get into college on their own merits, Ms. Williams-Bolar's daughters will share with them the stigma of a mother who went to jail, but they will also pay materially in their daily standard of living, given the reduced opportunities their mother can provide. And it may be precisely because of Ms. McDowell and

Ms. Williams-Bolar that Ms. Louglin and Ms. Huffman did any jail time at all. Prosecutors in the "varsity blues" cases invoked the penalties of the black single moms to petition for the punishments of the elite moms. Without similar sanctions, justice would be revealed to be classist and racist. While no one should pay someone to cheat on their child's SAT, this example is telling in its differences. The inequality facing the regular moms' children is itself a crime. Ms. Williams-Bolar's girls are no less deserving of a quality education than famous actors' children. It's time to fix that.

Children are not the only ones who need a village. Moms need a village: a supportive, accountable, loving village – a village where families are supported and children's opportunities are more equal. May we all live in that village one day.

References

Abel, Ernest L. and Hannigan, John. 1995. "Maternal Risk Factors in Fetal Alcohol Syndrome: Provocative and Permissive Influences." *Neurotoxicology and Teratology* 17(4): 445–62.

Abendroth, Anja-Kristin, Huffman, Matt L. and Treas, Judith. 2014. "The Parity Penalty in Life Course Perspective: Motherhood and Occupational Status in 13 European Countries." *American Sociological Review* 79: 993–1014.

Abrahamson, Rachel Paula. 2019. "Woman Defends Mom-to-be Shamed by Starbucks Barista for Ordering Coffee." *Today*. May 22.

Almeling, Rene. 2009. "Gender and the Value of Bodily Goods: Commodification in Egg and Sperm Donation." *Law and Contemporary Problems* 72(3): 37–58.

Almeling, Rene. 2011. *Sex Cells: The Medical Market for Eggs and Sperm.* University of California Press.

Almeling, Rene. 2020. *GUYnecology: The Missing Science of Men's Reproductive Health*. University of California Press.

Almeling, Rene and Waggoner, Miranda. 2013. "More and Less than Equal: How Men Figure in the Reproductive Equation." *Gender & Society* 27: 821–42.

Armstrong, Elizabeth M. 2003. *Conceiving Risk, Bearing Responsibility: Fetal Alcohol Syndrome and the Diagnosis of Moral Disorder*. Johns Hopkins University Press.

Armstrong, Elizabeth M. and Abel, Ernest L. 2000. "Fetal Alcohol Syndrome: The Origins of a Moral Panic." *Alcohol and Alcoholism* 35(3): 276–82.

Bailey, Lorraine. 2017. "Seventh Circuit Takes Up Wisconsin's 'Cocaine Mom' Law." *Courthouse News Service*, October 26. https://www.courthousenews.com/seventh-circuit-takes-wisconsins-cocaine-mom-law/

Belc, Krys Malcolm. 2021. *The Natural Mother of the Child: A Memoir of Nonbinary Parenting*. Penguin/Random House.

Bell, Kristen, McNaughton, Darlene and Salmon, Amy. 2009. "Medicine,

Morality and Mothering: Public Discourses on Foetal Alcohol Exposure, Smoking Around Children and Childhood Overnutrition." *Critical Public Health* 19(2): 155–70.

Belluck, Pam. 2018. "Far More US Children Than Previously Thought May Have Fetal Alcohol Disorders." *New York Times*, 9 February.

Berg, Austin. 2018. "Settlement Deal Helps Prevent Parents' Nightmares from Coming True." *Illinois Policy*, July 26.

Bernard, Claudia. 2013. "Black Feminist Thinking, Black Mothers, and Child Sexual Abuse," in Susan Strega, Julia Krane, Simon Lapierre, Cathy Richardson, and Rosemary Carlton (eds), *Failure to Protect: Moving Beyond Gendered Responses*. Fernwood Publishing, pp. 107–24.

Bernstein, Nina. 1999. "Mother Convicted in Infant's Starvation Death Gets 5 Years Probation." *New York Times*, September 9.

Best, Joel. 1990. *Threatened Children*. University of Chicago Press.

Bianchi, Suzanne M., Robinson, John P. and Milkie, Melissa A. 2006. *Changing Rhythms of American Family Life*. Russell Sage Foundation.

Bingol, Nesrin, Schuster, Carlotta, Fuchs, Magdalena, et al. 1987. "The Influences of Socioeconomic Factors on the Occurrence of Fetal Alcohol Syndrome." *Advances in Alcohol and Substance Abuse* 6: 105–18.

Bleakley, Laura. 2011. "Redheaded Donors Are Being Turned Away at Sperm Bank." BBC News.

Boo, Katherine. 2001. "After Welfare." *New Yorker*, April 9.

Bordo, Susan. 1993. *Unbearable Weight: Feminism, Western Culture, and the Body*. University of California Press.

Bourget, Dominique, Grace, Jennifer, and Whitehurst, Laurie. 2007. "A Review of Maternal and Paternal Filicide." *Journal of the American Academy of Psychiatry and the Law* 35(1): 74–82.

Bridges, Khiara M. 2020. "Race, Pregnancy, and the Opioid Epidemic: White Privilege and the Criminalization of Opioid Use During Pregnancy." *Harvard Law Review* 133(3): 770–851.

Briggs, Laura. 2017. *How All Politics Became Reproductive Politics: From Welfare Reform to Foreclosure to Trump*. University of California Press.

Brooks, Kim. 2018. *Small Animals: Parenthood in the Age of Fear*. Flatiron Books.

Broome, Judith. 2021. "'Stories Too Painful for the Light of Day': Narratives of Neonaticide, Infanticide, and Child Murder," in Charlotte Beyer and Josephine Savarese (eds), *Mothers Who Kill*. Demeter, pp. 83–102.

Brown, Jenny. 2019. *Birth Strike: The Hidden Fight Over Women's Work*. PM Press.

Brown, Maressa. 2019. "When Can You Leave Your Kids Home Alone? Here Are the Laws in Every State. It's Not as Straightforward as You Would Think." *Working Mother*, March 7.

Buiten, Denise. 2021. "Men and Women Kill Their Children in Roughly Equal Numbers, and We Need to Understand Why." *The Conversation*, January 19.

Bull, Haley. 2018. "Muncie Mom Arrested After Leaving Kids Home Alone Speaks Out." *Fox59*, December 21.

Burns, Katelyn. 2019. "What the Battle Over a 7-Year-Old Trans Girl Could Mean for Families Nationwide." *Vox*, November 11.

Burroughs, Gaylynn. 2008. "Too Poor to Parent." *Ms. Magazine*, Spring.

Campbell, Alex. 2014a. "He Beat Her and Murdered Her Son – And She Got 45 Years in Jail." *Buzzfeed*. October 2.

Campbell, Alex. 2014b. "How a 12-Year-Old Rape Victim Lost His Mom to 'Failure to Protect' Law." *Buzzfeed*. October 7.

Campo-Engelstein, Lisa, Santacrose, Laura Beth, Master, Zubin, and Parker, Wendy M. (2016) "Bad Moms, Blameless Dads: The Portrayal of Maternal and Paternal Age and Preconception Harm in US Newspapers." *AJOB Empirical Bioethics* 7(1): 56–63. DOI: 10.1080/23294515.2015.1053007

Carlen, Pat and Worrall, Anne. 1987. *Gender, Crime and Justice*. Open University Press.

Cassella, Carly. 2019. "Men Have a Biological Clock, Too, and 40 Years or Data Say They Need to Pay Attention." *Science Alert*. May 18.

CDC (Centers for Disease Control). *Pregnancy Mortality Surveillance System*. https://www.cdc.gov/reproductivehealth/maternal-mortality /pregnancy-mortality-surveillance-system.htm#:~:text=About%20the %20Pregnancy%20Mortality%20Surveillance%20System%20(PMSS),-CDC%20conducts%20national&text=The%20Pregnancy %20Mortality%20Surveillance%20System%20(PMSS)%20defines%20a %20pregnancy%2D,or%20aggravated%20by%20the%20pregnancy.

CDC (Centers for Disease Control). *Infant Mortality*. https://www.cdc.gov /reproductivehealth/maternalinfanthealth/infantmortality.htm

Chatterji, Pinka, Markowitz, Sara, and Brooks-Gunn, Jeanne. 2011. "Early Maternal Employment and Family Wellbeing." National Bureau of Economic Research Working Paper No. 17212. https://www.nber.org/papers/w17212

Child Care Aware. 2019. *The US and the High Price of Child Care 2019 Report*. https://www.childcareaware.org/our-issues/research/the-us-and -the-high-price-of-child-care-2019/

Choiriyyah, Ifta, Sonenstein, Freya L., Astone, Nan M., Pleck, Joseph H., Dariotis, Jacinda K., and Marcell, Arik V. 2015. "Men Aged 15–44 in Need of Preconception Care." *Maternal & Child Health Journal* 19: 2358–65.

Christian, Carol and Teachey, Lisa. 2002. "Yates Believed Children Doomed." *Houston Chronicle*, March 6.

Cline, Foster W. and Fay, Jim. 1990. *Parenting with Love and Logic: Teaching Children Responsibility*. Pinon Press.

Cohen, Stanley. 1972. *Folk Devils and Moral Panics: The Creation of the Mods and Rockers*. MacGibbon and Kee.

Coleman, Joshua. 2015. "Parenting Adult Children in the Twenty-First Century," in Barbara J. Risman and Virginia Rutter (eds), *Families as They Really Are*. W. W. Norton, pp. 390–401.

Collins, Caitlyn. 2019. *Making Motherhood Work: How Women Manage Careers and Caregiving*. Princeton University Press.

Collins, Patricia Hill. 2000. *Black Feminist Thought: Knowledge, Consciousness, and the Politics of Empowerment*, 2nd edn. Routledge.

Commonwealth Fund. 2020. *Maternal Mortality and Maternity Care in the United States Compared to 10 Other Developed Countries*. Issue Briefs, November 18.

Coohey, Carol. 1998. "Home Alone and Other Inadequately Supervised Children." *Child Welfare* 77: 291–310.

Coohey, Carol. 2003. "Defining and Classifying Supervisory Neglect." *Child Maltreatment* 8: 145–56.

Coontz, Stephanie. 1992. *The Way We Never Were: American Families and the Nostalgia Trap*. Basic Books.

Cooper, Marianne. 2014. *Cut Adrift: Families in Insecure Times*. University of California Press.

Cooper Owens, Deirdre. 2018. *Medical Bondage: Race, Gender, and the Origins of American Gynecology*. University of Georgia Press.

Council on Contemporary Families. 2016. "Parenting and Happiness in 22 Countries." CCF Brief prepared by Jennifer Glass, Robin Simon, and Matthew Andersson.

Crane, Cheryl and Christopher, Karen. 2018. "'Parenting Like a White Person': Race and Maternal Support among Marginalized Mothers," in Tiffany Taylor and Katrina Bloch (eds), *Marginalized Mothers, Mothering from the Margins*. Advances in Gender Research, Vol. 25. Emerald Publishing Limited, pp. 171–93.

Crenshaw, Kimberle. 1994. "Mapping Margins: Intersectionality, Identity Politics and Violence against Women of Colour," in Martha A. Fineman and Roxanne Mykitiuk (eds), *The Public Nature of Private Violence: The Discovery of Domestic Abuse*. Routledge, pp. 93–118.

Daniels, Cynthia R. 1996. *At Women's Expense: State Power and the Politics of Fetal Rights*. Harvard University Press.

Daniels, Cynthia R. 2006. *Exposing Men: The Science and Politics of Male Reproduction*. Oxford University Press.

De Guzman, Dianne. 2016. "Mom Arrested for Leaving Her Kids, Ages 8 and 9, Alone at Home for 45 Minutes." SFGATE, August 24.

deMauss, Lloyd. 1974. *The History of Childhood*. Harper and Row.

Dodson, Lisa. 2015. "Employing Parents Who Can't Make a Living," in Garth Massey (ed.), *Readings for Sociology*, 8th edn. Norton, pp. 276–84.

Dotti Sani, Giulia M. and Treas, Judith. 2016. "Educational Gradients in Parents' Child-care Time Across Countries, 1965–2012." *Journal of Marriage and Families* 78: 1083–96.

Douglas, Susan J. and Michaels, Meredith W. 2004. *The Mommy Myth: The Idealization of Motherhood and How It Has Undermined Women*. The Free Press.

Dow, Dawn Marie. 2019. *Mothering While Black: Boundaries and Burdens of Middle-Class Parenthood*. University of California Press.

Dozier, Raine. 2015. "The Power of Queer: How do 'Guy Moms' Disrupt Heteronormative Assumptions about Mothering and Family," in Barbara J. Risman and Virginia Rutter (eds), *Families as They Really Are*. W. W. Norton.

Druckerman, Pamela. 2012. *Bringing Up Bébé: One American Mother Discovers the Wisdom of French Parenting*. Penguin.

Edin, Kathryn and Lein, Laura. 1997. *Making Ends Meet: How Single Mothers Survive Welfare and Low-Wage Work*. Russell Sage Foundation.

Ehrenreich, Barbara. 1983. *The Hearts of Men: American Dreams and the Flight from Commitment*. Doubleday.

Faircloth, Charlotte. 2021. "When Equal Partners Become Unequal Parents: Couple Relationships and Intensive Parenting Culture." *Families Relationships and Societies* 10(2): 231–48.

Fass, Paula S. 2016. *The End of American Childhood: A History of Parenting from Life on the Frontier to the Managed Child*. Princeton University Press.

Feldstein, Ruth. 2000. *Mothering in Black and White: Race and Sex in American Liberalism 1930–1965*. Cornell University Press.

Fentiman, Linda C. 2017. *Blaming Mothers: American Law and the Risks to Children's Health*. New York University Press.

First Five Years Fund. 2023. "MIECHV in Your State." https://www.ffyf.org/issues/miechv/

Fixmer-Oraiz, Natalie. 2019. *Homeland Maternity: US Security Culture and the New Reproductive Regime*. University of Illinois Press.

Fixmer-Oraiz, Natalie. 2022. "The Policing of Pregnancy and Homeland Security Are Intimately Enmeshed." *Washington Post*, August 4.

Fleming, Anne Taylor. 2002. "Maternal Madness." *New York Times*, March 17.

Floyd, R. Louise, Decouflé, Pierre, and Hungerford, Daniel W. 1999. "Alcohol Use Prior to Pregnancy Recognition." *American Journal of Preventive Medicine* 17(2): 101–7.

Florey, Charles du V. and Taylor, D. 1992. "Introduction." *International Journal of Epidemiology* 21 (Issue Supplement), pp. S6–S7.

Fomby, Paula and Musick, Kelly. 2018. "Mothers' Time, the Parenting Package, and Links to Healthy Child Development." *Journal of Marriage and Family* 80(1): 166–81.

Foucault, Michel. 2003 (1976). *Society Must Be Defended: Lectures at the College de France 1975–1976*. Picador.

Fox, Bonnie. 2009. *When Couples Become Parents: The Creation of Gender in the Transition to Parenthood*. University of Toronto Press.

Free Range Kids website http://www.freerangekids.com/faq/

Frey, Keith A., Navarro, Shannon M., Kotelchuck, Milton, and Lu, Michael C. 2008. "The Clinical Content of Preconception Care: Preconception Care

for Men." *American Journal of Obstetrics and Gynecology*. Supplement (December).

Frey, Keith A., Engle, Richard and Noble, Brie. 2012. "Preconception Healthcare: What Do Men Know and Believe?" *Journal of Men's Health* 9(1): 25–35.

Friedan, Betty. 1963. *The Feminine Mystique*. W. W. Norton.

Fugate, Jeanne A. 2001. "Who's Failing Whom? A Critical Look at Failure-to-Protect Laws." *New York University Law Review* 67: 272–308.

Furedi, Frank. 2002. *Paranoid Parenting: Why Ignoring the Experts May Be Best for Your Child*. Chicago Review Press.

Garbes, Angela. 2018. *Like a Mother: A Feminist Journey through the Science and Culture of Pregnancy*. Harper Collins.

Garcia, Lorena. 2015. "'This Is Your Job Now': Latina Mothers and Daughters and Family Work," in Barbara J. Risman and Virginia E. Rutter (eds), *Families as They Really Are*, 2nd edn. Norton, pp. 411–25.

Geronimus, Arline T. 1997. "Teenage Childbearing and Personal Responsibility: An Alternative View." *Political Science Quarterly* 112(3): 405–30.

Gerson, Kathleen. 2015. "Falling Back on Plan B: The Children of the Gender Revolution Face Unchartered Territory," in Barbara J. Risman and Virginia E. Rutter (eds), *Families as They Really Are*, 2nd edn. Norton, pp. 593–608.

Glassner, Barry. 1999. *The Culture of Fear: Why Americans Are Afraid of the Wrong Things*. Basic Books.

Glick, Peter and Fiske, Susan T. 1996. "The Ambivalent Sexism Inventory: Differentiating Hostile and Benevolent Sexism." *Journal of Personality and Social Psychology* 70(3): 491–512.

Glynn, Sarah Jane. 2012. "Fact Sheet: Childcare." The Center for American Progress. August 16. https://www.americanprogress.org/article/fact-sheet-child-care/

Goldberg, Michelle. 2021. "When a Miscarriage Is Manslaughter." *New York Times*, Opinion, October 18.

Golden, Janet. 2005. *Message in a Bottle: The Making of Fetal Alcohol Syndrome*. Harvard University Press.

Goldin, Claudia. 1977. "Female Labor Force Participation: The Origin of Black and White Differences, 1870 and 1880." *Journal of Economic History* 37(1): 87–108.

Goodwin, Michele. 2020. *Policing the Womb: Invisible Women and the Criminalization of Motherhood*. Cambridge University Press.

Gorman, Reese. 2021. "Trial for Norman Mother Charged with 'Failure to Protect' Begins Wednesday." *The Norman Transcript*, October 26.

Gray, Ron, Mukherjee, Raja A., and Rutter, Michael. 2009. "Alcohol Consumption During Pregnancy and Its Effects on Neurodevelopment: What Is Known and What Remains Uncertain." *Addiction* 104(8): 1270–3.

Green, Fiona Joy and O'Reilly, Andrea. 2021. "Pandemic Mothering," in Andrea O'Reilly (ed.), *Maternal Theory: Essential Readings*, 2nd edn. Demeter, pp. 913–25.

Grose, Jessica. 2014. "Parents Are Now Getting Arrested for Letting Their Kids Go to the Park Alone." *Slate*, July 15.

Hager, Tamar. 2015. "Legal and Medical Maneuvers: The Attitude of the Medical and Legal Systems to Ellen Harper Who Murdered Her Infant Daughter in 1878," in Joanne Minaker and Bryan Hogeveen (eds), *Criminalized Mothers, Criminalizing Mothering*. Demeter, pp. 184–210.

Hamilton, Leah, Roll, Stephen, Despard, Mathieu, et al. 2022. *The Impacts of the 2021 Expanded Child Tax Credit on Family Employment, Nutrition, and Financial Well-being: Findings from the Social Policy Institute's Child Tax Credit Panel Survey (Wave Two)*. Brookings Global Working Paper #173. April. https://www.brookings.edu/wp-content/uploads/2022/04/Child-Tax-Credit-Report-Final_Updated.pdf

Hartnett, Caroline Sten and Brantley, Mia. 2020. "Racial Disparities in Emotional Well-Being during Pregnancy." *Journal of Health and Social Behavior* 61(2): 223–38.

Harvey, Brianna, Gupta-Kagan, Josh, and Church, Christopher. 2021. "Reimagining Schools' Role Outside the Family Regulation System." *Columbia Journal of Race & the Law* 11(3): 1–36.

Hayes, Mary. 2005 "Criminal Trials Where a Child is the Victim: Extra Protection for Children or a Missed Opportunity?" *Child & Family Law Quarterly* 17(3): 307–28.

Hays, Sharon. 1996. *The Cultural Contradictions of Motherhood*. Yale University Press.

Hebl, Michelle R., King, Eden B., Glick, Peter, Singletary, Sarah L., and Kazama, Stephanie. 2007. "Hostile and Benevolent Reactions Toward Pregnant Women: Complementary Interpersonal Punishments and Rewards that Maintain Traditional Roles." *Journal of Applied Psychology* 92(6): 1499–1511.

Hillman, Mayer, Adams, John and Whitelegg, Joan. 1990. *One False Move . . . A Study of Children's Independent Mobility*. London: Policy Studies Institute.

Hirshman, Linda R. 2006. *Get to Work: A Manifesto for Women of the World*. New York: Viking Penguin.

Hochman, Anndee. 2014. "In Defense of a 'Bad Mother': Debra Harrell's Village Fails Her." WHYY. PBS/NPR. July 28.

Hoffman, Saul D. 1998. "Teenage Childbearing Is Not So Bad After All . . . Or Is It? A Review of the New Literature." *Perspectives on Sexual and Reproductive Health* 30(5): 236–43.

Howard, Grace. 2014. "The Limits of Pure White: Raced Reproduction in the Methamphetamine Crisis." *Women's Rights Law Reporter* 35(3–4): 373–405.

Hunting, Gemma and Browne, Annette J. 2012. "Decolonizing Policy

Discourse: Reframing the 'Problem' of Fetal Alcohol Spectrum Disorder." *Women's Health and Urban Life* 11(1): 35–53.

Huston, Aletha. C. and Aronson, Stacey Rosenkrantz. 2005. "Mothers' Time with Infant and Time in Employment as Predictors of Mother–child Relationships and Children's Early Development." *Child Development* 76: 467–82.

Ingraham, Christopher. 2015. "There's Never Been a Safer Time to Be a Kid in America." *Washington Post*, April 14.

Ishizuka, Patrick. 2019. "Social Class, Gender, and Contemporary Parenting Standards in the United States: Evidence from a National Survey Experiment." *Social Forces* 98(1): 31–58.

Jack, Brian W., Atrash, Hani, Coonrod, Dean V., Moos, Merry-K., O'Donnell, Julie, and Johnson, Kay. 2008. "The Clinical Content of Preconception Care: An Overview and Preparation of This Supplement." *American Journal of Obstetrics and Gynecology. Supplement B*: S266–S279.

Jacobs, Michelle. 1998. "Requiring Battered Women Die: Murder Liability for Mothers Under Failure to Protect Statutes." *Journal of Criminal Law and Criminology* 88(2): 579–660.

Jacobson, Joseph L. and Jacobson, Sandra W. 1994. "Prenatal Alcohol Exposure and Neurobehavioral Development: Where is the Threshold?" *Alcohol Health and Research World* 18(1): 30–6.

Jaffer, Nabeelah. 2017 (2014). "The Babies in the Freezer." *Pacific Standard*.

Jessup, Martha A., Humphries, Janice C., Brindis, Claire D., and Lee, Kathryn A. 2003. "Extrinsic Barriers to Substance Abuse Treatment among Pregnant Drug Dependent Women." *Journal of Drug Issues* 33(2): 285–304.

Johns Hopkins Medicine. 2019. "First of Its Kind Statistics on Pregnant Women in US Prisons." News Release, March 21.

Johnson, Allan G. 1997. *The Gender Knot: Unraveling Our Patriarchal Legacy*. Temple University Press.

Jones, Kenneth Lyons, Smith, David W., Ulleland, Christy N., and Streissguth, Ann P. 1973. "Patterns of Malformation in Offspring of Chronic Alcoholic Mothers." *Lancet* 1(7815): 1267–71.

Jonson-Reid, Melissa, Drake, Brett, and Zhou, Pan. 2013. "Neglect Subtypes, Race, and Poverty: Individual, Family, and Service Characteristics." *Child Maltreatment* 18(1): 30–41.

Kallianes, Virginia and Rubenfeld, Phyllis. 2015. "Disabled Women and Reproductive Rights," in Carol Joffe and Jennifer Reich (eds), *Reproduction and Society: Interdisciplinary Readings*, pp. 219–32.

Keith, JJ. 2014. *Motherhood, Smotherhood: Fighting Back Against the Lactivists, Mompetitions, Germaphobes, and So-Called Experts Who Are Driving Us Crazy*. Skyhorse Publishing.

Kelly, Yvonne, Sacker, Amanda, Gray, Ron, Kelly, John, Wolke, Dieter, and Quigley, Maria A. 2009. "Light Drinking in Pregnancy, a Risk

for Behavioural Problems and Cognitive Deficits at 3 years of Age?" *International Journal of Epidemiology* 38: 129–40.

Killian, Caitlin and Thomas, Emma M., 2020. "Fetal Alcohol Syndrome Warnings: Policing Women's Behavior Distorts Science." *Journal of Applied Social Science* 14(1): 5–22.

Kim, Hyunil, Wildeman, Christopher, Jonson-Reid, Melissa, and Drake, Brett. 2017. "Lifetime Prevalence of Investigating Child Maltreatment among US Children." *American Journal of Public Health* 107(2): 274–80.

Kinnick, Katherine. N. 2009. "Media Morality Tales and the Politics of Motherhood," in Ann C. Hall and Mardia J. Bishop (eds), *Mommy Angst: Motherhood in Popular Culture*. ABC-CLIO, pp. 1–28.

Kirkwood, Debbie. 2013 (2012). *Just Say Goodbye: Parents Who Kill Their Children in the Context of Separation*. Domestic Violence Resource Centre Victoria. Discussion Paper #8 2012. [Online version published 2013].

Kroløkke, Charlotte. 2021. "For Whom Does the Clock Tick? Male Repro-temporality in Fertility Campaigns, Scientific Literature, and Commercial Accounts." *Anthropology & Aging* 42(1): 81–96.

Kukla, Rebecca. 2010. "The Ethics and Cultural Politics of Reproductive Risk Warnings: A Case Study of California's Proposition 65." *Health, Risk & Society* 12(4): 323–34.

Kuvalanka, Katherine A., Bellis, Camellia, Goldberg, Abbie E., and McGuire, Jenifer K. 2019. "An Exploratory Study of Custody Challenges Experienced by Affirming Mothers of Transgender and Gender-Nonconforming Children." *Family Court Review* 57(1): 54–71.

Ladd-Taylor, Molly and Umansky, Lauri. 1998. *"Bad Mothers": The Politics of Blame in Twentieth-Century America*. New York University Press.

Lafrance, Michelle N. 2009. *Women and Depression: Recovery and Resistance*. New York: Routledge.

Lareau, Annette. 2011 (2003). *Unequal Childhoods: Race, Class, and Family Life*. University of California Press.

Lenz, Lyz. 2020. *Belabored: A Vindication of the Rights of Pregnant Women*. Bold Type Books.

Let Grow website. https://letgrow.org/

Lewis, Helen. 2021. "The Pandemic Has Given Women a New Kind of Rage." *The Atlantic*. March 10.

Liedloff, Jean. 1975. *The Continuum Concept: In Search of Happiness Lost*. Knopf.

Luker, Kristin. 1996. *Dubious Conceptions*. Harvard University Press.

Lundberg, Ferdinand and Farnham, Marynia. 1947. *Modern Woman: The Lost Sex*. Harper & Brothers.

Lyerly, Anne Drapkin, Mitchell, Lisa M., Armstrong, Elizabeth Mitchell, et al. 2009. "Risk and the Pregnant Body." *Hastings Center Report* 39(6): 34–42.

Lythcott-Haims, Julie. 2015. *How to Raise an Adult: Break Free of the Overparenting Trap and Prepare Your Kid for Success.* Henry Holt.

Macvarish, Jan. 2010. "Understanding the Significance of the Teenage Mother in Contemporary Parenting Culture." *Sociological Research Online* 15(4): 3.1.

Macvarish, Jan and Billings, Jenny R. 2010. "Challenging the Irrational, Amoral, and Anti-social Construction of the 'Teenage Mother,'" in Simon Duncan, Rosalind Edwards, and Claire Alexander (eds), *Teenage Parenthood: What's the Problem?* Tufnell, pp. 47–69.

Maguire-Jack, Kathryn, Purtell, Kelly M., Showalter, Kathryn, Barnhart, Sheila, and Yang, Mi-Youn. 2019. "Preventative Benefits of US Childcare Subsidies in Supervisory Child Neglect." *Children & Society* 33(2): 185–94.

Mahoney, Amanda. 2019. "How Failure to Protect Laws Punish the Vulnerable." *Health Matrix* 29(1): 429–61.

Maiter, Sarah, Alaggia, Ramona and Mutta, Baldev. 2013. "Double Jeopardy: Racialized Families and Failure to Protect," in Susan Strega, Julia Krane, Simon Lapierre, Cathy Richardson, and Rosemary Carlton (eds), *Failure to Protect: Moving Beyond Gendered Responses.* Fernwood Publishing, pp. 125–45.

Mamo, Laura. 2005. "Biomedicalizing Kinship: Sperm Banks and the Creation of Affinity-Ties." *Science as Culture* 14(3): 237–64.

Martin, Emily. 1991. "The Egg and the Sperm: How Science Constructed a Romance Based on Stereotypical Male–Female Roles." *Signs* 16(3): 485–501.

Martin, Karin A. 2003. "Giving Birth Like a Girl." *Gender & Society* 17(1): 54–72.

Martin, Nina. 2015. "Take a Valium, Lose Your Kid, Go to Jail." *ProPublica*, September 23.

May, Ashley. 2016. "Study: Parents Spend More Time with Children Now than They Did 50 Years Ago." *USA Today*, September 30.

May, Philip A., Chambers, Christina D., Klberg, Wendy O., et al. 2018. "Prevalence of Fetal Alcohol Spectrum Disorders among First Graders in 4 US Communities." *Journal of American Medical Association* 319(5): 474–82.

Mazrekaj, Deni, Fischer, Mirjam M., and Bos, Henny M. W. 2022. "Behavioral Outcomes of Children with Same-Sex Parents in the Netherlands." *International Journal of Environmental Research and Public Health* 19(10): 5922–33.

McCormack, Clare, Hutchinson, Delyse, Burns, Lucy, et al. 2018. "Maternal and Partner Prenatal Alcohol Use and Infant Cognitive Development." *Drug & Alcohol Dependence* 185: 330–8.

McDonald-Harker, Caroline. 2015. "Mothering in the Context of Domestic Abuse and Encounters with Child Protective Services: From Victimized to 'Criminalized' Mothers," in Joanne Minaker and Bryan Hogeveen (eds), *Criminalized Mothers, Criminalizing Mothering.* Demeter, pp. 323–54.

McDonald-Harker, Caroline. 2020. "Abused Women's Mothering

Experiences," in Lynn O'Brien Hallstein, Andrea O'Reilly, and Melinda Vandenbeld Giles (eds), *The Routledge Companion to Motherhood*. Routledge, pp. 255–65.

Milkie, Melissa A., Nomaguchi, Kei M., and Denny, Kathleen E. 2015. "Does the Amount of Time Mothers Spend with Children or Adolescents Matter?" *Journal of Marriage and Family* 77(2): 355–72.

Mitchell, Elizabeth W., Levis, Denise M. and Prue, Christine E. 2012. "Preconception Health: Awareness, Planning, and Communication among a Sample of US Men and Women." *Maternal and Child Health Journal* 16(1): 31–9.

Moore, Lisa Jean. 2007. *Sperm Counts: Overcome by Man's Most Precious Fluid*. New York University Press.

Murkoff, Heidi. 2016. *What to Expect When You Are Expecting*, 5th edn. Workman Publishing.

Murphy, Amy O., Sutton, Robbie M., Douglas, Karen M., and McClellan, Leigh M. 2011. "Ambivalent Sexism and the 'Do's and 'Don't's of Pregnancy: Examining Attitudes Towards Proscriptions and the Women Who Flout Them." *Personality and Individual Differences* 51: 812–16.

Naffine, Ngaire. 1997. *Feminism and Criminology*. Polity.

Napierski-Prancl, Michelle. 2019. *Mothers Work: Confronting the Mommy Wars, Raising Children, and Working for Social Change*. Lexington Books.

Nathan, Debbie. 2019. "A Baby's Death, a Flawed Autopsy, and a Mother Locked Up for Life." *The Appeal*. April 22.

Nixon, Kendra and Cripps, Kyllie. 2013. "Child Protection Policy and Indigenous Partner Violence: Whose Failure to Protect?" in Susan Strega, Julia Krane, Simon Lapierre, Cathy Richardson, and Rosemary Carlton (eds), *Failure to Protect: Moving Beyond Gendered Responses*. Fernwood Publishing, pp. 166–88.

NLIRH/NWLC (National Latina Institute for Reproductive Health/National Women's Law Center). 2014. "Accommodating Pregnancy on the Job: The Stakes for Women of Color and Immigrant Women." Employment Factsheet, May.

NPWF (National Partnership for Women and Families). 2021. "The Pregnant Workers Fairness Act." Factsheet, February.

Oberman, Michelle and Meyer, Cheryl L. (2008). *When Mothers Kill: Interviews from Prison*. New York University Press.

O'Mara, Mark. 2014. "Does Leaving Children Alone Make Parents 'Criminals'?" *CNN*, August 7.

Orange County Register. 2015. "Many Convicted of Torturing, Killing 3-Year-Old Boy," June 15.

O'Reilly, Andrea. 2021a. "Empowered and Feminist Mothering," in Andrea O'Reilly (ed.), *Maternal Theory: Essential Readings*, 2nd edn. Demeter, pp. 607–28.

O'Reilly, Andrea. 2021b. "Normative Motherhood," in Andrea O'Reilly

(ed.), *Maternal Theory: Essential Readings*, 2nd edn. Demeter, pp. 477–91.

Oster, Emily. 2021. *Expecting Better: Why the Conventional Pregnancy Wisdom Is Wrong – and What You Really Need to Know*, 4th edn. Penguin.

Paltrow, Lynn M. 2015. "*Roe v. Wade* and the New Jane Crow: Reproductive Rights in the Age of Mass Incarceration," in Carol Joffe and Jennifer Reich (eds), *Reproduction and Society: Interdisciplinary Readings*. Routledge, pp. 209–16.

Paltrow, Lynn M. and Flavin, Jeanne. 2013. "Arrests of and Forced Interventions on Pregnant Women in the United States, 1973–2005: Implications for Women's Legal Status and Public Health." *Journal of Health Politics, Policy and Law* 38(2): 299–343.

Pascus, Brian. 2019. "Pregnant Woman Who Lost Unborn Child in Shooting Will Not Be Charged." *CBS News*, July 3.

Perrone, Jaime. 2012. "Failing to Realize *Nicholson*'s Vision: How New York's Child Welfare System Continues to Punish Battered Mothers." *Journal of Law and Policy* 20(2): 641–75.

Peterson, V. Spike. 1998. "Gendered Nationalism: Reproducing 'Us' versus 'Them,'" in L. A. Lorentzen and J. Turpin (eds), *The Women and War Reader*. New York University Press, pp. 41–9.

Puls, Henry T., Hall, Matthew, Anderst, James D., Gurley, Tami, Perrin, James, and Chung, Paul J. 2021. "State Spending on Public Benefit Programs and Child Maltreatment." *Pediatrics* 148(5): e2021050685.

Reich, Jennifer A. 2002. "Maternal Sin and Salvation: Child Protective Services and the Policing of Mothers' Sexual Behavior." *Journal of the Association for Research on Mothering* 4(1): 46–57.

Reich, Jennifer A. 2016. *Calling the Shots: Why Parents Reject Vaccines*. New York University Press.

Rich, Adrienne. 1976. *Of Woman Born: Motherhood as Experience and Institution*. W. W. Norton.

Riggs, Damien W., Pearce, Ruth, Pfeffer, Carla A., Hines, Sally, and White, Francis Ray. 2021. "Men, Trans/Masculine, and Non-binary People Negotiating Conception: Normative Resistance and Inventive Pragmatism." *International Journal of Transgender Health* 22(1–2): 6–17.

Rizzo, Kathryn, Schiffrin, Holly H., and Liss, Miriam. 2013. "Insight into the Parenthood Paradox: Mental Health Outcomes of Intensive Mothering." *Journal of Child and Family Studies* 22: 614–20.

Roberts, Dorothy. 1997. *Killing the Black Body: Race, Reproduction, and the Meaning of Liberty*. Pantheon.

Roberts, Dorothy. 2022. *Torn Apart: How the Child Welfare System Destroys Black Families – and How Abolition Can Build a Safer World*. Basic Books.

Roberts, Sarah C. M. and Pies, Cheri. 2011. "Complex Calculations:

How Drug Use During Pregnancy Becomes a Barrier to Prenatal Care." *Maternal and Child Health Journal* 15(3): 333–41.

Roberts, Sarah C. M., Thomas, Sue, Treffers, Ryan, and Drabble, Laurie. 2017. "Forty Years of State Alcohol and Pregnancy Policies in the USA: Best Practices for Public Health or Efforts to Restrict Women's Reproductive Rights?" *Alcohol and Alcoholism* 52(6): 1–7.

Rose, David. 2007. "Pregnant Women Told a Glass of Wine a Day is Fine – and Too Dangerous." *The Times* (UK), 11 October.

Rosenblum, Gail. 2019. "New Non-Profit Let Grow Urges Parents to Land Those Helicopters and Let Kids Be Kids." *Star Tribune*, July 12.

Ross, Loretta J. and Solinger, Rickie. 2017. *Reproductive Justice: An Introduction*. University of California Press.

Rotskoff, Lori. 2002. *Love on the Rocks: Men, Women and Alcohol in Post-World War II America*. The University of North Carolina Press.

Ruhm, Christopher J. 1998. "Parental Leave and Child Health." Working Paper 6554. *National Bureau of Economic Research*.

Rupp, Nathan Black. 2019. "When Is She a Woman? Gendered Subject Forming Language in TRAP Laws." *International Journal of Legal Discourse* 4(1): 87–108.

Ruppanner, Leah, Branden, Maria, and Turunen, Jani. 2018. "Does Unequal Housework Lead to Divorce? Evidence from Sweden." *Sociology* 52(1): 75–94.

Schiffrin, Holly H. and Liss, Miriam. 2017. "The Effects of Helicopter Parenting on Academic Motivation." *Journal of Child and Family Studies* 26(5): 1472–80.

Schiffrin, Holly H., Erchull, Mindy J., Sendrick, Erynn, Yost, Jennaveve C., Power, Victoria, and Saldanha, Emily R. 2019. "The Effects of Maternal and Paternal Helicopter Parenting on the Self-determination and Well-being of Emerging Adults." *Journal of Child & Family Studies* 28(12): 3346–59.

Schiffrin, Holly H., Godfrey, Hester, Liss, Miriam, and Erchull, Mindy J. 2015. "Intensive Parenting: Does It Have the Desired Impact on Child Outcomes?" *Journal of Child and Family Studies* 24: 2322–31.

Schiffrin, Holly H., Liss, Miriam, Miles-McLean, Haley, and Geary, Katherine A. 2014. "Helping or Hovering? The Effects of Helicopter Parenting on College Students' Well-Being." *Journal of Child and Family Studies* 23(3): 548–57.

Schmidt, Caitlin. 2014. "Florida Mom Arrested After Letting 7-Year-Old Walk to the Park Alone." *CNN*. August 1. https://www.cnn.com/2014/07/31/living/florida-mom-arrested-son-park/index.html

Sears website. Ask Dr. Sears. "Attachment Parenting Explained." https://www.askdrsears.com/topics/parenting/attachment-parenting/attachment-parenting

Sears, Martha and Sears, William. 1997. *The Complete Book of Christian Parenting and Child Care: A Medical and Moral Guide to Raising Happy Healthy Children*. B&H Publishing.

Segrin, Chris, Woszidlo, Alesia, Givertz, Michelle, and Montgomery, Neil. 2013. "Parent and Child Traits Associated with Overparenting." *Journal of Social and Clinical Psychology* 32(6): 569–95.

Seiler, Naomi K. 2016. "Alcohol and Pregnancy: CDC's Health Advice and the Legal Rights of Pregnant Women." *Public Health Reports* 131: 623–7.

Senior, Jennifer. 2014. *All Joy and No Fun: The Paradox of Modern Parenthood*. Harper Collins.

Shapiro, Joseph, Wiltz, Teresa, and Piper, Jessica. 2021. "States Send Kids to Foster Care and Their Parents the Bill – Often One Too Big to Pay." National Public Radio (NPR), December 27.

Shorter, Edward. 1975. *The Making of the Modern Family*. Basic Books.

Singh, Sarah. 2021. "Punishing Mothers for Men's Violence: Failure to Protect Legislation and the Criminalisation of Abused Women." *Feminist Legal Studies* 29: 181–204.

Slipke, Darla. 2020. "Mother Imprisoned Under Failure to Protect Laws Reflects on First Months of Freedom." *The Oklahoman*, February 3.

Smith, Dana C. 2019. "What to Know About Men, Marijuana, and Miscarriage." *Elemental/Medium*, October 21.

Sokol, Robert J., Ager, Joel W., and Martier, Susan. 1988. "Toward Defining an Overall Fetal Alcohol Dose-Response Relationship in Human Pregnancy." *Alcoholism: Clinical and Experimental Research* 12(2): 339.

Spinelli, Margaret G. 2001. "A Systematic Investigation of 16 Cases of Neonaticide." *American Journal of Psychiatry* 158(5): 811–13.

Stabile, Carol A. 1992. "Shooting the Mother: Fetal Photography and the Politics of Disappearance." *Camera Obscura* 28: 179–205.

Stacey, Judith and Biblarz, Timothy J. 2001. "(How) Does the Sexual Orientation of Parents Matter?" *American Sociological Review* 66(2): 159–83.

Stanford, P. Kyle, Sarnecka, Barbara W., and Thomas, Ashley J. 2016. "We're Really Bad at Judging Risks to Kids: We're Really Good at Judging Parents." *Washington Post*. December 16.

Stanko, Elizabeth A. 1997. "Safety Talk: Conceptualising Women's Risk Assessment as a 'Technology of the Soul.'" *Theoretical Criminology* 1(4): 479–99.

Stossel, John. 2020. "Forbidden Parenting." *Daily Press*, March 5.

Stotland, Naomi. 2015. "Prescriptions: Dr Carolyn Sufrin, Prison Ob/ Gyn," in Carole Joffe and Jennifer Reich (eds), *Reproduction and Society: Interdisciplinary Readings*. Routledge, pp. 217–19.

Strega, Susan and Janzen, Caitlin. 2013. "Asking the Impossible of Mothers: Child Protection Systems and Intimate Violence," in Susan Strega, Julia Krane, Simon Lapierre, Cathy Richardson, and Rosemary Carlton (eds), *Failure to Protect: Moving Beyond Gendered Responses*. Fernwood Publishing, pp. 49–76.

Strega, Susan, Krane, Julia, and Carlton, Rosemary. 2013. "G-d Couldn't Be Everywhere, So He Created Mothers: The Impossible Mandate of Maternal Protection in Child Welfare," in Susan Strega, Julia Krane, Simon Lapierre, Cathy Richardson, and Rosemary Carlton (eds), *Failure to Protect: Moving Beyond Gendered Responses*. Fernwood Publishing, pp. 11–29.

Summers, A. K. 2014. *Pregnant Butch: Nine Long Months Spent in Drag*. Soft Skull Press.

Swan, Shanna H. and Colino, Stacey. 2021. *Count Down: How Our Modern World Is Threatening Sperm Counts, Altering Male and Female Reproductive Development, and Imperiling the Future of the Human Race*. Simon & Schuster.

Tan, Cheryl H., Denny, Clark H., Cheal, Nancy E., Sniezk, Joseph E., and Kanny, Dafna. 2015. "Alcohol Use and Binge Drinking Among Women of Childbearing Age – United States, 2011–2013." *Morbidity and Mortality Weekly Report* 64(37): 1042–6.

Thomas, Ashley J., Stanford, P. Kyle, and Sarnecka, Barbara W. 2016. "No Child Left Alone: Moral Judgments about Parents Affect Estimates of Risk to Children." *Collabra* 2(1): 1–14.

Thurer, Shari L. 1994. *Myths of Motherhood: How Culture Reinvents the Good Mother*. Houghton Mifflin.

Tuteur, Amy. 2013a. The Skeptical OB Blog. February 25. http://www.skepticalob.com/2013/02/attachment-parenting-is-about-the-need-of-parents-for-validation-not-the-needs-of-children.html

Tuteur, Amy. 2013b. The Skeptical OB Blog. March 13. http://www.skepticalob.com/2013/03/natural-childbirth-attachment-parenting-and-policing-womens-bodies.html

US Surgeon General. 2005. "Advisory on Alcohol Use during Pregnancy: A 2005 Message to Women from the US Surgeon General." https://www.cdc.gov/ncbddd/fasd/documents/Surgeon-Gen-bookmark-P.pdf

Van der Zee, Boukje, de Wert, Guido, Steegers, Eric A., and de Beaufort, Inez D. 2013. "Ethical Aspects of Paternal Preconception Lifestyle Modification." *American Journal of Obstetrics and Gynecology* 209(1): 11–16.

Vickers, Jill McCalla. 1990. "At His Mother's Knee: Sex/Gender and the Construction of National Identities," in Greta Hoffman Neiroff (ed.), *Women and Men: Interdisciplinary Readings on Gender*. Fitzhenry and Whiteside, pp. 478–92.

Villalobos, Ana. 2014. *The Motherload: Making It All Better in Insecure Times*. University of California Press.

Waggoner, Miranda R. 2017. *The Zero Trimester: Pre-Pregnancy Care and the Politics of Reproductive Risk*. University of California Press.

Wall, Glenda. 2010. "Mothers' Experiences with Intensive Parenting and Brain Development Discourse." *Women's Studies International Forum* 33: 253–63.

Warner, Judith. 2005. *Perfect Madness: Motherhood in the Age of Anxiety.* Penguin.

Watson, Amanda D. 2020. *The Juggling Mother: Coming Undone in the Age of Anxiety.* University of British Columbia Press.

Waxman, B. F. 1993. "The Politics of Eugenics." *Disability Rag* 14(3): 6–7.

Welch, Sara J. 2018. "Want More Self-reliant, Responsible Kids? Try *Selbständigkeit*, the German Way." NBC News – *Better*, April 11.

West, Candace and Zimmerman, Don H. 1987. "Doing Gender." *Gender and Society* 1(2): 125–51.

Whitworth, Sandra. 1994. "Gender, International Relations and the Case of the ILO." *Review of International Studies* 20(4): 389–405.

Wilczynski, Ania. (1997)."Mad or Bad: Child-Killers, Gender and the Courts." *British Journal of Criminology* 37(3): 419–36.

Worrall, Anne. 1990. *Offending Women: Female Lawbreakers and the Criminal Justice System.* Abingdon: Taylor & Francis.

Wylie, Philip. 1942. *Generation of Vipers.* Farrar and Rhinehart.

Yurkanin, Amy. 2021. "Alabama Mom Faces Felony for Filling Doctor's Prescription While Pregnant." *AL.com*, June 21.

Zaske, Sara. 2017. *Achtung Baby: An American Mom on the German Art of Raising Self-reliant Children.* Picador.

Zelizer, Viviana. 1985. *Pricing the Priceless Child: The Changing Social Value of Children.* Princeton University Press.

Index